W9-CEG-103

unexpected new york

by Sandy Miller
photographs by Juliana Spear

Interlink Books

First published in 2010 by

INTERLINK BOOKS
An imprint of Interlink Publishing Group, Inc.
46 Crosby Street
Northampton, Massachusetts 01060
www.interlinkbooks.com

Text copyright © Sandy Miller, 2010
Photography copyright © Juliana Spear, 2010
Book design by Juliana Spear

Library of Congress Cataloging-in-Publication Data
Miller, Sandy.
Unexpected New York / by Sandy Miller ; photographs by Juliana Spear.—1st American ed.
 p. cm.
ISBN 978-1-56656-805-0 (pbk.)
1. New York (N.Y.)—Description and travel. 2. New York (N.Y.)—Pictorial works. 3. New York (N.Y.)—Social life and customs. 4. Curiosities and wonders—New York (State)—New York. 5. City and town life—New York (State)—New York. 6. Historic buildings—New York (State)—New York. 7. New York (N.Y.)—Buildings, structures, etc. I. Title.
F128.18.M534 2009 974.7'1—dc22
 2009048649

Printed and bound in China

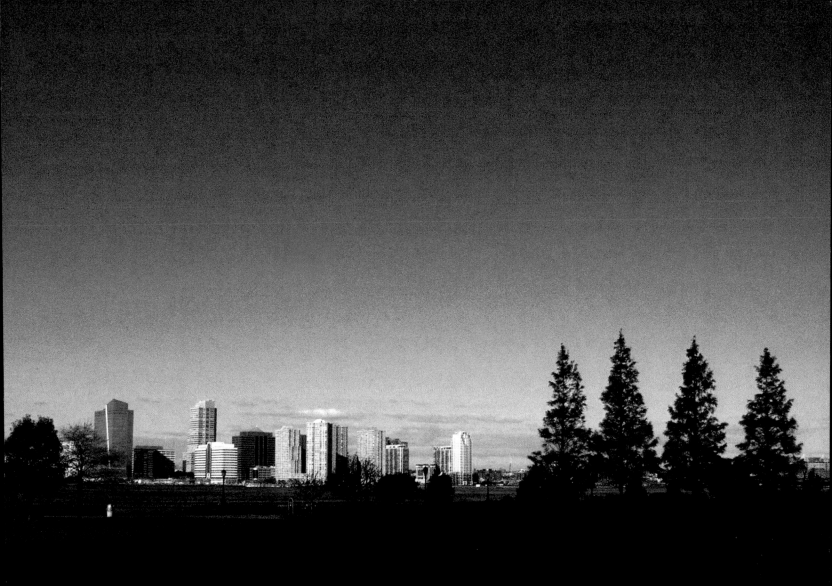

for my parents, Gertrude Miller and the late Milton Miller (who ironically was never late for anything).

—SM

work

play

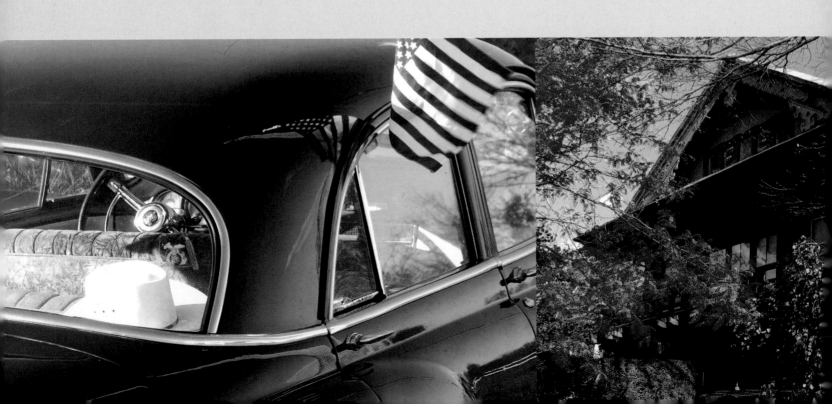

home

nature

none of the above

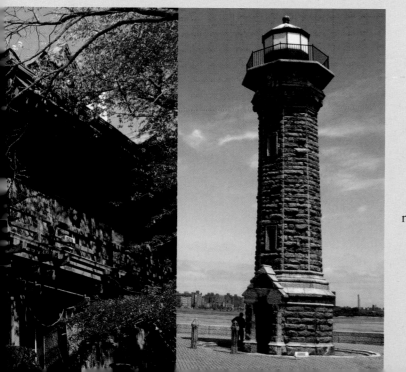

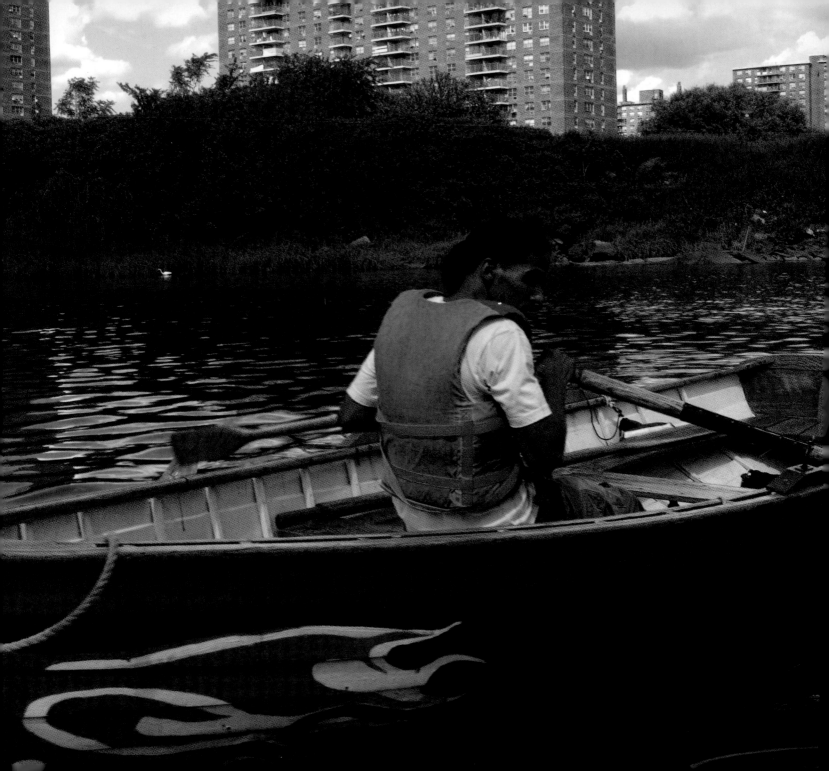

introduction

*U*nexpected New York is about places, activities, events, and sights in New York City that you would not expect to find. Look at a photo in this book, and the last place you would guess it was located would be New York.

Yet, these are not secret or hidden things, nor are they necessarily off the beaten track. They are just not what one immediately thinks of when one thinks of the city. Visitors come to New York to see its tall buildings, bridges, museums, and bright lights, and often the city's other wonders get passed by unobserved, unrecorded, or simply, not remembered.

This is a book that seeks out the "un-quintessential" New York. Think wineries, rolling library ladder companies, and fishing tackle businesses rather than the New York Stock Exchange. Wild peacocks, parrots, and raccoons rather than the Bronx Zoo. Key limes pies, not cheesecake. Fragments of the Berlin Wall and Gaudí-like mosaic benches rather than the Met and the Guggenheim. Chamber music on a barge, not at Carnegie Hall. A statue of Lenin rather than the Statue of Liberty. And so on and so forth.

Nothing included in *Unexpected New York* will ever be used as an establishing shot for a movie about New York, yet everything in this book is as much a part of the city as any of the more typical places and sights.

The entries featured here are by no means exhaustive: this book is just the tip of the iceberg. After all, New York City is ever changing, and the unexpected is everywhere.

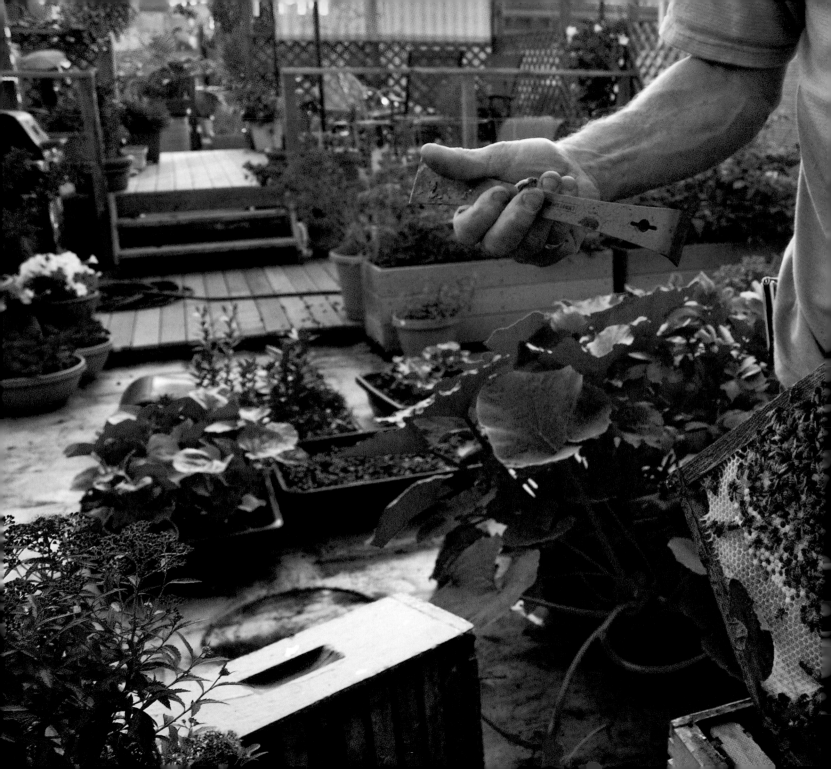

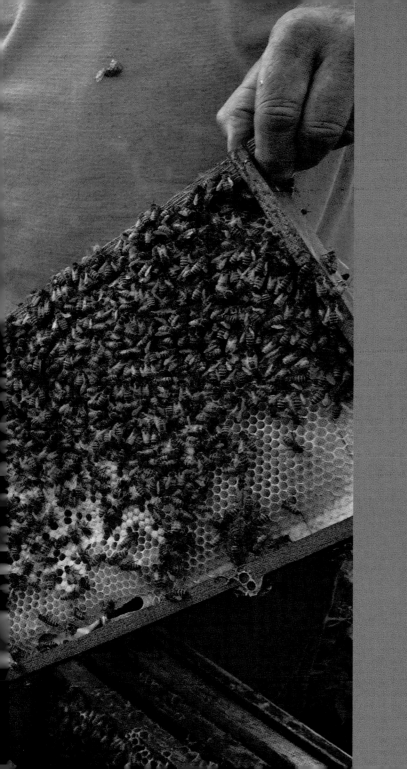

work

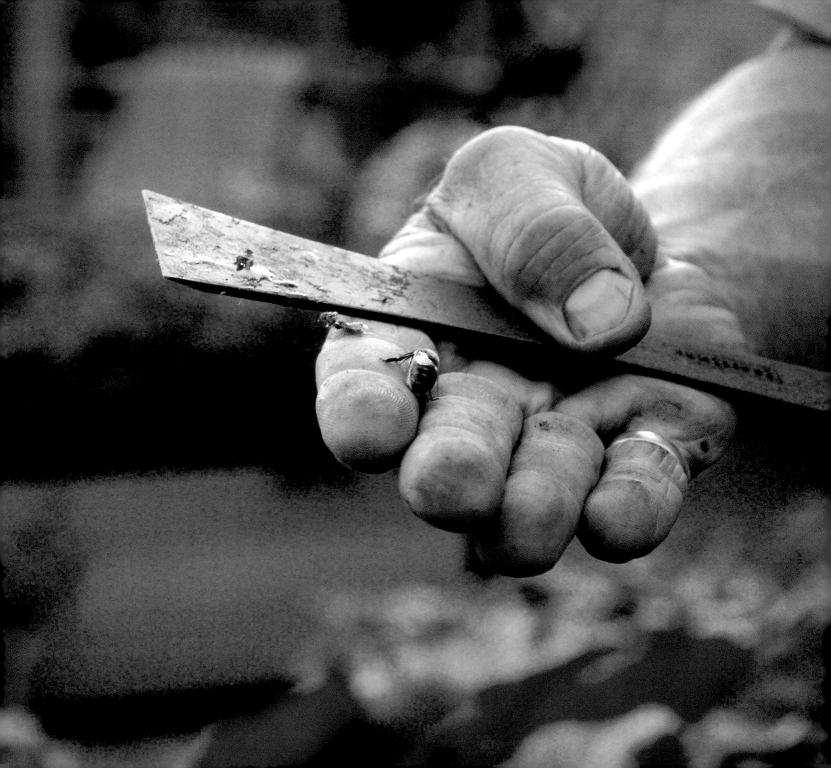

beekeeping

Until just recently—March 2010 to be exact—beekeeping was illegal in New York City. Section 161.01 of The Health Code of the City of New York, which prohibits the possession of wild animals, included bees. Only after many frustrating years of lobbying was that section of the code finally amended to allow the keeping of "non-aggressive honeybees."

Throughout the years of its prohibition (since 1999), one could nevertheless find manifold rooftop hives that were surreptitiously maintained. One well-known New York City beekeeper and purveyor of honey boasted seventeen hives upon several rooftop locations--including a hotel, church, and restaurant--across three boroughs. "The New York City Beekeeping Meetup," an informal group whose purpose is "to turn people on to this exciting endeavor and increase the honeybee population of New York City," claimed upward of 600 members while beekeeping was still an illegal activity.

Though the prohibition against keeping bees was rarely enforced, except when neighbors complained, the law could--and sometimes did--bring a fine of up to $2,000. In light of the fact that other cities—Dallas, Boston, San Francisco, Portland, and Chicago among them—had chosen not to prohibit beekeeping, and even encouraged it as a way to enhance urban pollination as well as to promote locally raised and produced food products (the Obama's even had a beehive installed at the White House), the New York ban had always seemed ill-conceived. The city argued that bees presented a danger to those severely allergic to them—causing death in some cases—even though the number of people severely allergic to bees was probably far exceeded by the number of people severely allergic to, say, peanuts, whose sale, as we all know, is not, and never was, prohibited. In any event, honeybees, as opposed to yellow jackets or wasps, hardly ever sting unless

3

provoked. The lameness of the city's position was ultimately exposed—and the beekeepers vindicated—by the fact that when the health department finally did make beekeeping legal, it did so by unanimous vote.

Ironically, given the fact that beekeeping had been prohibited in the city, honeybees always seemed to thrive here. Many of the wooden structures that one finds in New York, such as wooden water tanks, cornices, and overhangs, seem to replicate the conditions that normally attract bees to trees, and as a result some 200 species have been identified here. Swarms—and therefore complaints—have been so numerous that the New York City Police Department actually employs an officer who is a beekeeping expert and whose job it is to remove unwanted hives from buildings and other places, particularly during the spring months when bees swarm to the city and build hives wherever they can find bee-friendly wooden whatever.

Adding to this sense of irony is the fact that despite poor air quality, the quality of the honey produced here is surprisingly high. It is said to be every bit as good as honey from more bucolic settings. New York City honey is a perfect reflection of the city's flora, boasting the flavors of sumac, linden, and locust. One particular Japanese plant, hardy enough to grow through cracks in the pavement, produces a dark, caramel tasting honey and is considered one of the best honeys made in the city.

Finally, according to one New York City beekeeper who maintains hives in the Berkshires in Massachusetts as well, bees here seem to mirror the work ethic of New Yorkers in general. "It gets light earlier in New York—the eastern morning light—so bees become active in the city earlier than in Massachusetts, like at 5 a.m.," he says. "Also, it's cooler there, so that's another reason bees there don't become active until later."

Which is to say, New York City bees, like most New Yorkers, work longer and harder.

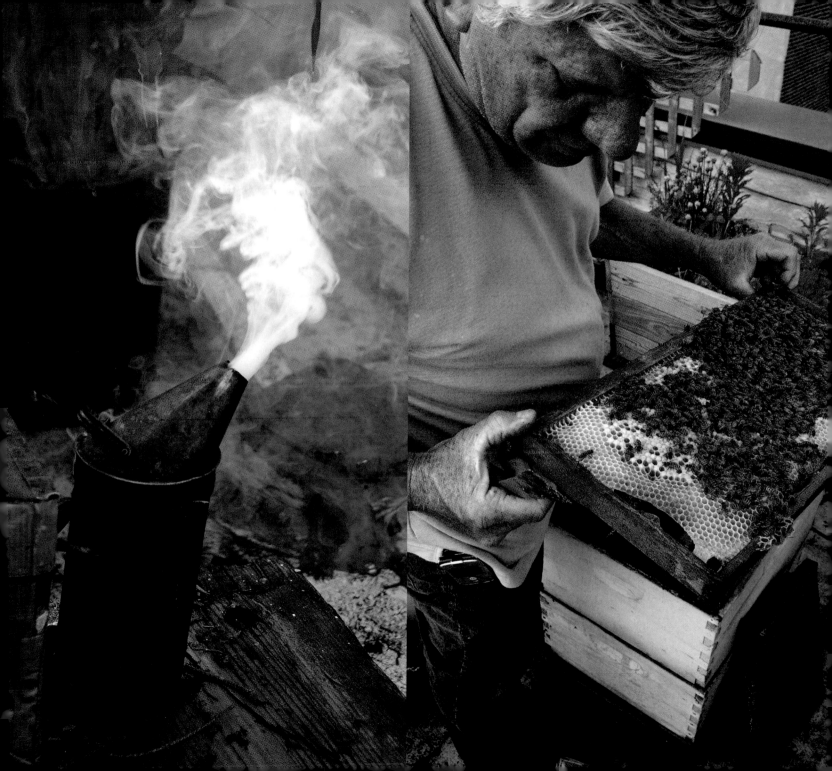

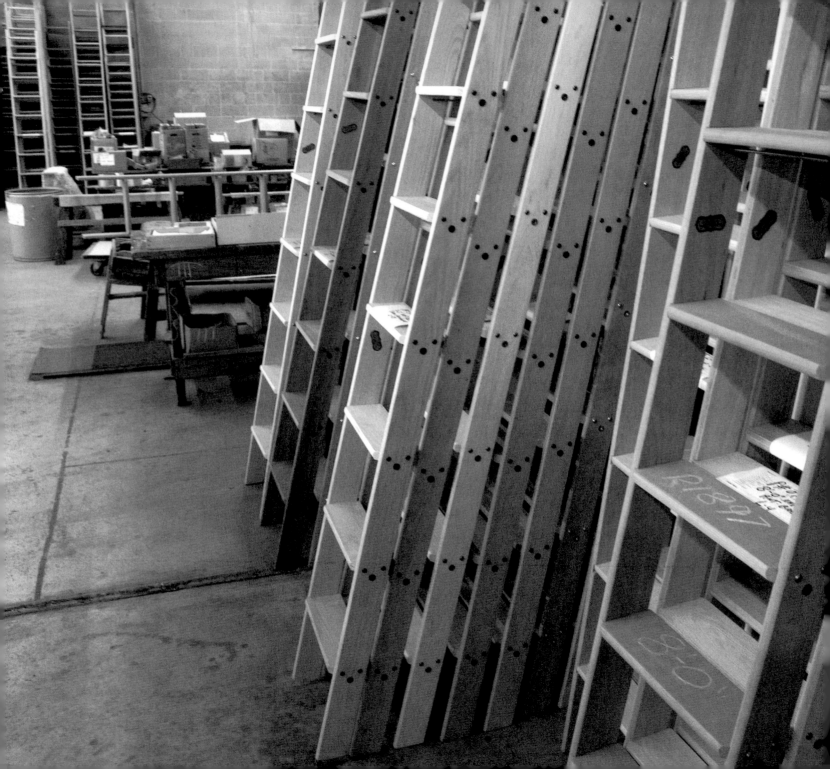

rolling ladders

think Soho, and it's unlikely that a rolling-ladder manufacturer comes to mind. Soho is characterized in the public imagination by galleries, boutiques, restaurants and cafes, swank national retailers, hotels, and upscale anything and everything, alongside a loft-dwelling population of artists, artist manques, and some very wealthy people totally unrelated to the art world. Not by manufacturers of any kind.

And yet the Putnam Rolling Ladder Company has more claim on the imagination than just about any other Soho denizen. For one, it's been there longer. And manufacturing defined Soho for a far greater period of time than any of its contemporary residents, commercial or otherwise.

Putnam has been in business for over a hundred years, though at its present location on Howard Street, at Crosby, for a mere eighty. (It moved to Soho from its original location at 244 Water Street, near the original Fulton Fish Market, during the Depression.) And ever since its founding in 1905, it has been producing its famous "Ladder No. 1"—the customized wooden ladder that runs along a metal track found in libraries, private and public, as well as other locations—with the same design and hardware. In fact, according to its present owner, 87-year-old Warren Monsees, who bought the business in 1950 from its founder, Samuel Putnam, "One of the reasons we've been able to stay in business all these years is that nothing has changed. Same product, made the same way, using the same parts."

What obviously has changed, however, is the customer base. One of Putnam's earliest catalogs lists sample customers as follows: Hardware and Supplies; Architects; Shoes; Druggists; Silks and Ribbons; Groceries; Clothiers; Department Stores; Hosiery, Gloves and Underwear;

Notions; Collars and Cuffs; Laces and Embroideries; and Insurance Companies. Of this original list, architects, who order the rolling ladder for the home libraries of clients, are probably the only survivors. (One of the earliest customers was the famous architectural firm of McKim, Mead & White who ordered the ladder for the libraries installed within the mansions of the day.) Libraries—public and home—have always been a mainstay of Putnam's business, as have bookstores. More recently, wine cellars have emerged as a likely location for the rolling ladder.

Of course, Putnam produces all sorts of ladders, not just the rolling one (the folding ladder, pulpit ladders with shelves, office ladders of various heights and colors, step ladders, and metal ladders). And, in addition to ladders, it manufactures a huge array of stools, with phone companies being the biggest purchaser of one particularly sturdy model, which is just the right height to sit on and comfortably work on the circuits, switches, and other equipment. It was originally designed for Bell Labs and, says Monsees, "I wouldn't hesitate to put five men on it." In the pre-digital age, when switching installations and the like were higher than the equipment now in use, the phone companies were the largest purchasers of the 12-foot rolling ladder, which was installed on a track that ran down the middle of an aisle, with equipment on both sides, and workers would push the ladder up and down the aisle, standing on either side of it to reach whatever height needed reaching.

Putnam Ladder once had many industrial neighbors. Today, though most of the actual production work is done in Bushwick—the wood working and assembly—the hardware is still installed at the Soho location. From the start of the 20th century until the 1950s and '60s, Soho was a major manufacturing center (and it's still zoned for manufacturing). Light manufacturing, warehousing, and other industrial endeavors defined the neighborhood and the activity within its cast-iron facade buildings.

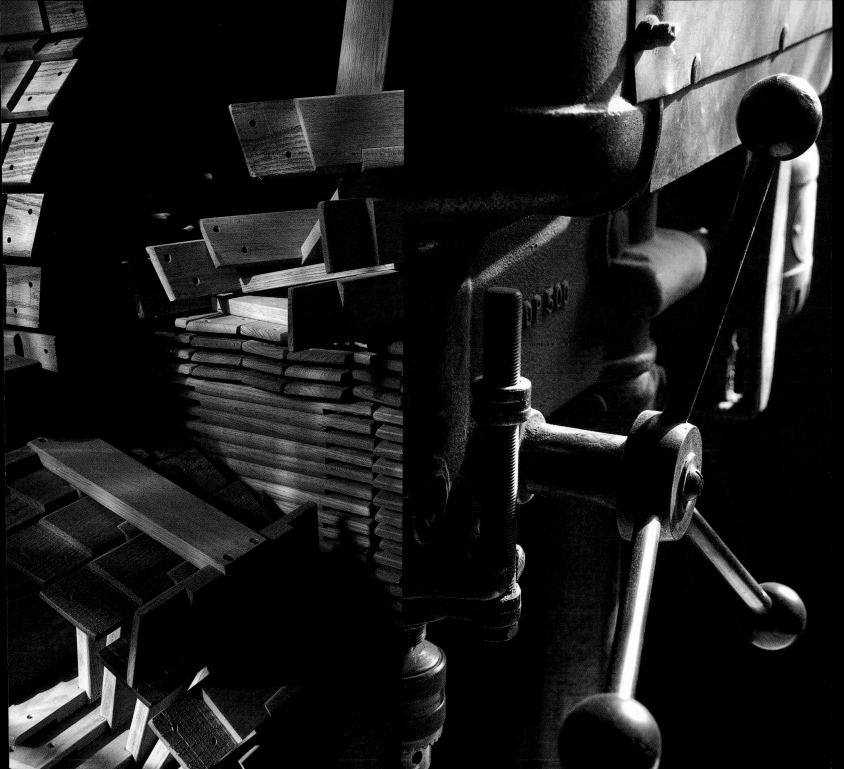

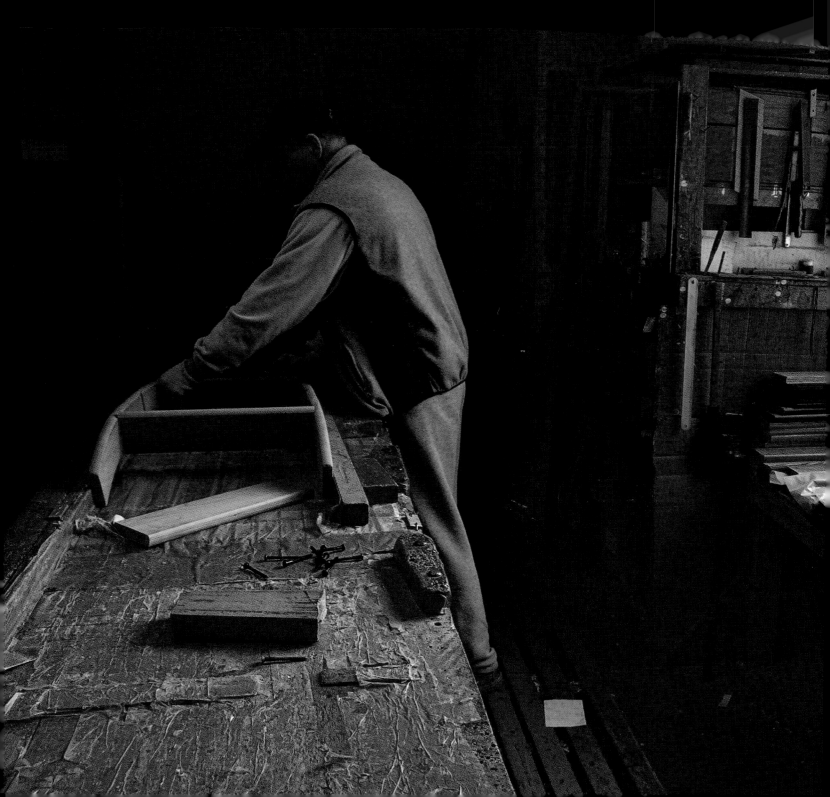

Manufacturing activity in Soho—as elsewhere across the city—began to decline after World War II. In 1960, there were approximately a million manufacturing jobs in New York City, 300,000 in Manhattan alone. By 1990, there were only about 300,000 manufacturing jobs in the entire city; a 70 percent decline in thirty years. Today, there are barely 100,000. Whereas in the mid-1960s one in four New Yorkers worked in manufacturing, today one in forty does.

By the late 1960s into the '70s, artists had moved into the many vacant loft spaces abandoned by industrial tenants, taking advantage of high ceilings and low rents. By the early 1980s, the gentrification artists had initiated had fully taken root. By the end of the 80s it had taken over, and the format of present-day Soho was cast (not as in cast iron!).

That Putnam Ladder remains is a testament to its staying power and commitment to the rare and wonderful products it makes. (There are only a couple of other companies in the country that make a rolling ladder on a track.) God knows, the two buildings Putnam owns within the Soho Historic District are worth gazillions (it does rent out four floors of one of those buildings to the minimalist clothing and accessories designer, Jil Sander). That the company continues making rolling ladders instead of a real estate killing is certainly worthy of praise.

And, too, Putnam Rolling Ladder Company should be lauded for its prescience—a hundred years ahead of its time—in creating the sort of small (25 employees), light manufacturing company that seems to be a model for

the only kind of manufacturing firm sustainable in contemporary New York. The city, even in its manufacturing heyday, was never the center of the large, heavy, assembly-line type of manufacturing that existed in other parts of the country. By comparison, firms here were relatively small. And the prototypical manufacturing firm of New York City today (some 7,000 manufacturing firms do exist here) is becoming even smaller. (Of nearly 250 businesses at the Brooklyn Navy Yard, 70 percent of them have five or fewer employees.) These firms are now called "niche manufacturers"—that is, small companies making a very specific (often esoteric) product for a particular, clearly delineated (often upscale) market.

By that definition Putnam is the ultimate niche—or should we say "nook," as in reading nook—manufacturer.

OAK STEPS

360 PCS

12.2008

slaughterhouses

musa's Slaughterhouse sits in the middle of a busy commercial strip, surrounded by housing, in the Morrisania section of the Bronx. It's located within a building that looks like an auto repair shop, which it probably once was. Customers pop in and out, all hours of the day, seven days a week. Passersby walk blithely past. For its customers and neighborhood residents, it would appear that a neighborhood slaughterhouse is the most natural thing in the world. What kind of neighborhood doesn't have its own slaughterhouse?

In fact, there are nearly a hundred live-animal markets—that is, slaughterhouses—in New York City, making the city one of the largest centers of these markets in the country. Most deal in poultry and fowl (chickens, guinea hens, ducks, pheasants, quails, geese, turkeys) and other small animals (rabbits), but about a quarter of them also slaughter larger, hooved animals (goats, kids, sheep, lambs, cows, calves, deer). The former are regulated by the New York State Department of Agriculture and Markets; the latter by the United States Department of Agriculture.

The number of these neighborhood slaughterhouses (also called abattoirs or *viveros*) has increased in recent years as the number of Muslim residents of the city has increased. Muslims, who must have their meat and poultry slaughtered fresh and according to *halal* rules (a Muslim must do the slaughtering, the name of God must be uttered during the slaughtering, and the throat of the animal must be cut quickly—without severing the spinal cord—with a sharp knife) are among the primary customers of these live-animal markets, along with Latinos, Caribbeans,

and Africans. Orthodox Jews who must have their animals killed according to kosher dietary laws (similar, apparently, to *halal*) have their own markets, and they too account for a good deal of the growth in their number.

It is because of this particular ethnic clientele that the overwhelming majority of the city's slaughterhouses are located in the most ethnically diverse neighborhoods—in the Bronx, Queens, and Brooklyn. Nary a one on either Staten Island or in Manhattan, although this was not always the case. Manhattan was historically the locus for the city's slaughterhouses. The Meatpacking District, to cite an obvious example, hints to that history, though today that area is home to just a handful of meat wholesalers—not slaughterhouses—and is more characterized by its hip restaurants, bars, and stores and its luxury residential lofts and apartments than its meatpacking past. Nowadays it is more known as a place to meet; not for meat.

According to the Yale University Press's *Encyclopedia of New York City*, "In 1906 New York City had 240 sites for slaughtering cattle and hogs. Packers in the city produced the third-largest volume of dressed meat in the country during the 1920s and 1930s, but after the Second World War their share in the market declined as the cost of labor rose and the industry became increasingly dependent on trucking and new technology."

Slaughterhouses cannot easily coexist alongside residential housing and upscale commercial enterprises, and as Manhattan developed—with particular emphasis on upscale housing and commerce—slaughterhouses came under siege. Even though city planners had the forethought to limit slaughterhouses to the outer edges of Manhattan (west of 10th Avenue and east of 2nd Avenue only), even these slaughterhouses on the island's periphery came to be intolerable to the residences and businesses within ear and eyeshot of them.

Tudor City in the East 40s gives one example of this uneasy coexistence. When Tudor City was built in 1928, since it overlooked slaughterhouses to the east, it was designed so that the

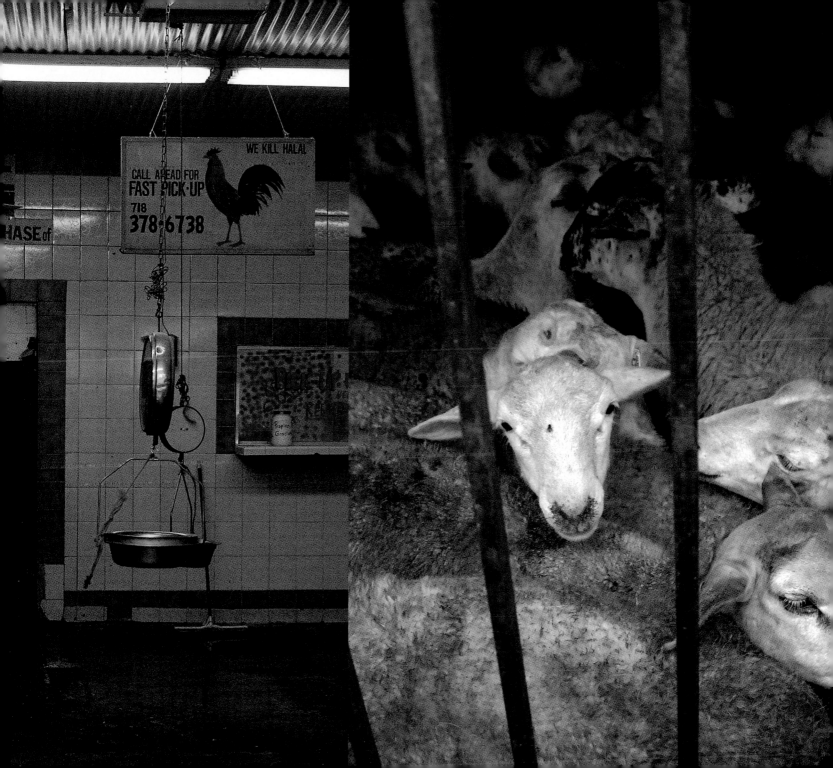

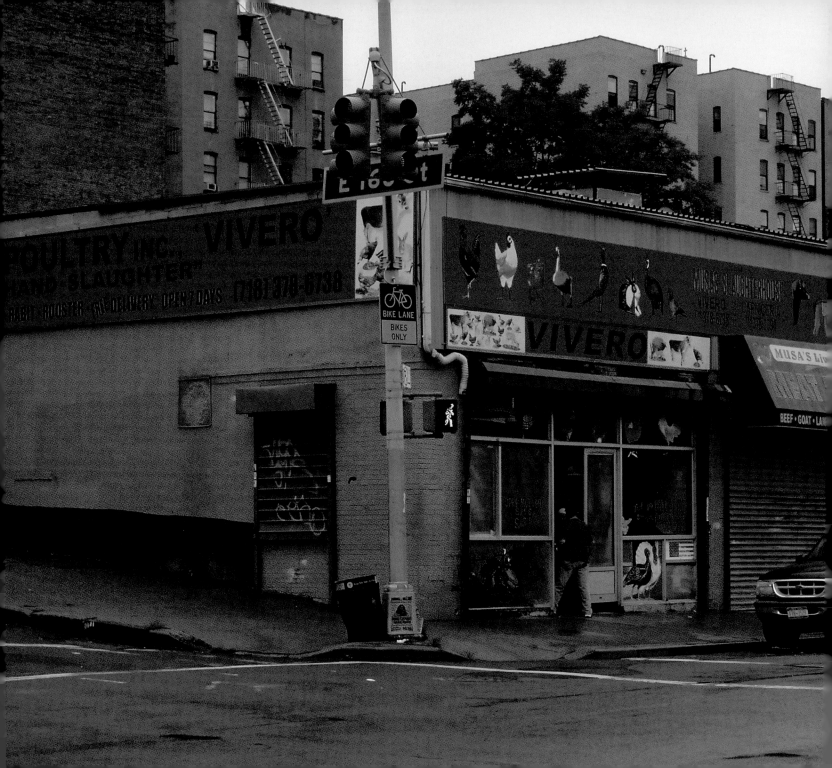

apartments looked inward—basically, every direction but east; those apartments that had an eastern exposure were practically windowless on that side. Luckily for Tudor City residents, those slaughterhouses were cleared in the early 1950s to make room for the United Nations, which now sits on their former site. Those apartments with an eastern exposure are still nearly windowless, but this is New York, home to the "air-shaft view," so what else is new.

Now with the rebirth of ethnically driven slaughterhouses, albeit small and for individual customer sales only, the tensions between them and the neighbors still rage. In 2008, prompted by a fight in St. Albans, Queens to block the opening of a new slaughterhouse, the New York State Legislature passed a law banning all new slaughterhouses within a 1,500-foot radius of a residential dwelling for a period of four years, which for all intents and purposes effectively bans any new slaughterhouse for the immediate future. This law is effective until August 2012.

The reality is these live-animal markets exist under the radar of most New Yorkers. Except when an animal or two escapes and shows up on some busy city thoroughfare.

In the spring of 2009, a 500-pound cow named Molly ran loose on the streets of Jamaica, Queens, for over an hour before she was caught and subdued by a dozen cops. Later that year, two goats wandered around the Bronx for two days before being caught. And the previous fall, a flock of thirteen chickens and one turkey were captured on the streets of Harlem. In all instances, the animals came from live-animal markets in those respective neighborhoods. And in all instances, the animals escaped what had previously seemed like their preordained slaughter. All the animals, once caught, were sent to animal sanctuaries rather than back to the slaughterhouse.

No double jeopardy in the Big Apple. Despite all its bluster and attitude, it can be a forgiving city.

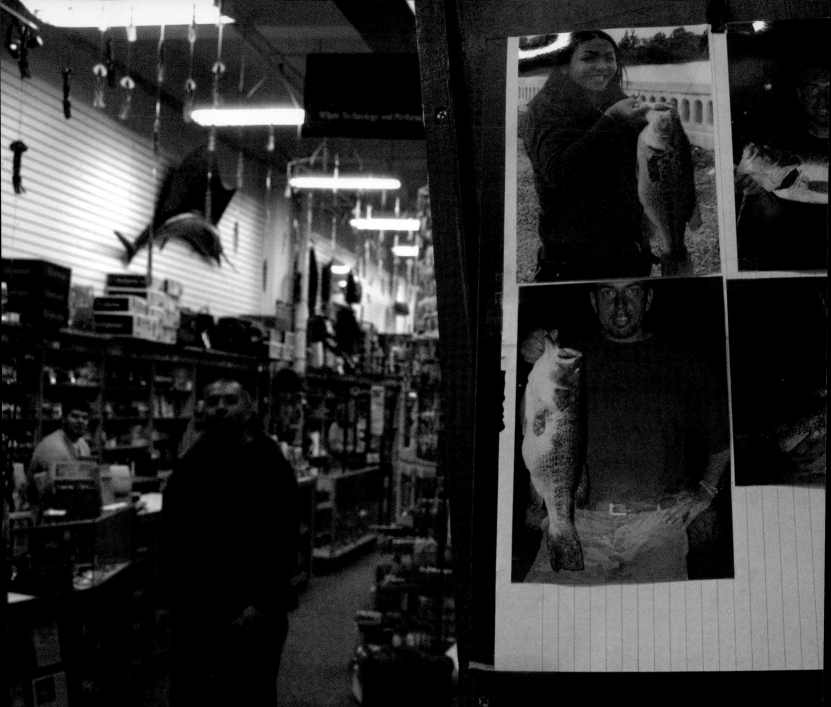

fishing tackle

Capitol Fishing Tackle Company has been a Manhattan fixture since 1897. During its hundred-plus-year lifespan, it has operated out of four different Manhattan locations: 34th Street and Third Avenue (1897 to 1942); Seventh Avenue between 22nd and 23rd Streets (1942 to 1964); West 23rd Street below the Chelsea Hotel (from 1964 to 2006); and West 36th Street between Seventh Avenue and Broadway (from 2006 to present).

The location beneath the Chelsea Hotel—simultaneously famous and infamous for the colorful artists, writers, musicians, and eccentrics one and all who were the hotel's residents and customers—was probably the most unlikely place one would expect to find a bait and tackle shop, although its present location in the heart of the Garment District runs a close second.

While it was still located at the Chelsea Hotel, *Field & Stream* magazine published an article about Capitol Fishing with the headline, "The Weirdest Tackle Shop in America." The article read in part,

> At any given time... a dominatrix might strut in to purchase some nautical rope for a bondage session, a downtown barmaid might bounce in for some monofilament to thread through the hole of her belly button piercing, a theatrical monster makeup artist might borrow tackle boxes for something in which to keep his brushes, and an Upper East Side matron might brusquely demand a spool of 6-pound-test FireLine—and nothing else, thank you—for use in her latest beading project.

"Andy Warhol came in all the time to buy fish line," adds Richie Collins, Capitol's owner since 1974. "I guess he used it to hang pictures." But so did the likes of Lew Glucksman, a Wall Street powerhouse who at one time headed Lehman Brothers, the now-defunct investment bank. Richie Collins recalls how Glucksman would arrive around lunchtime in a limousine—with sandwiches for himself and staff—and while the limo was parked outside, Glucksman would talk about boats and fishing, sometimes well into the afternoon. (Lehman Brothers' demise was well after Lew Glucksman died, so he can't be blamed for not minding the ship; in any case, his mind was on a different kind of ship.)

No matter the location—the Chelsea Hotel, the Garment District, or anywhere else in Manhattan—the store has always been the destination of hardcore fisherman. "If you're a fisherman, you'll find us," is how Richie Collins sums it up. But he worries now about the ability of any fish and tackle store to survive in Manhattan. "There were 24 fishing tackle stores in Manhattan in 1974," he says. "Capitol is the only one left." There are two high-end freshwater fly-fishing places in Manhattan—Orvis and Urban Angler—but only Capitol is a full-service store.

Of course, the outer boroughs each have several tackle shops, as one would expect, for, after all, there are 500 miles of shoreline in New York City, with many fishing opportunities—and thus, a fishing culture—which New Yorkers who are not fishermen sometimes forget. Seeing someone carrying a fishing rod on the subway, for instance, is still as incongruous seeming as someone carrying golf clubs.

The biggest obstacle for a fishing tackle store in Manhattan—as is the case with almost anything in Manhattan—is the rent. Capitol had to leave its Chelsea Hotel location, where it had been for over 40 years, when its rent was raised to $41,000 per month (yes, per month) from the $9,000 a month it had been paying. And although the rent at its present location isn't

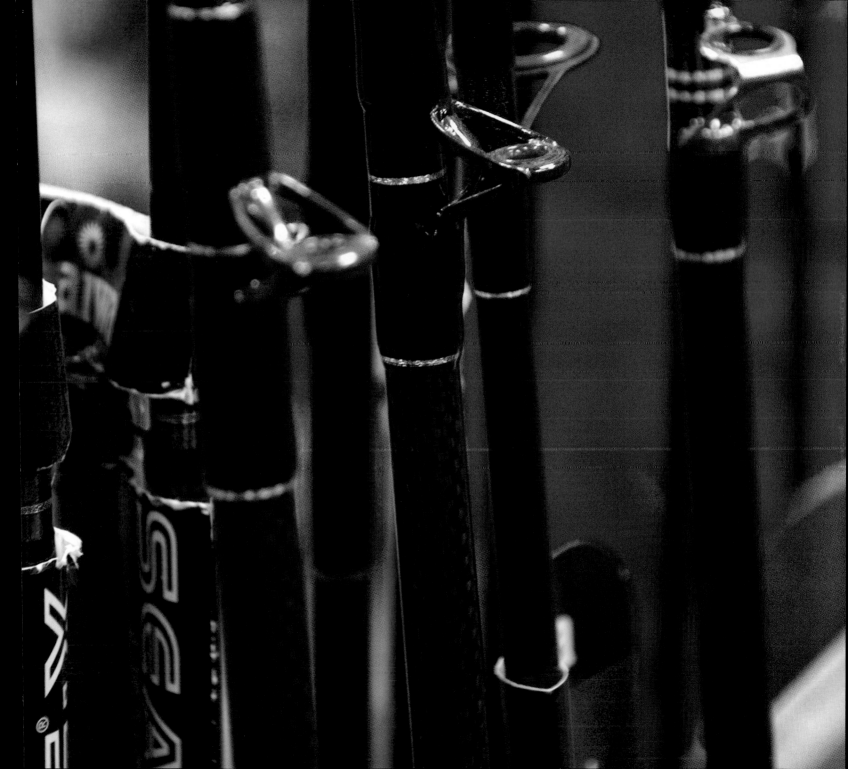

anywhere near what the owners of the Chelsea Hotel wanted, rent in the Garment District, in an eleven-story midtown office building, can't be cheap.

The additional obstacles (not counting the recession that rages as of this writing) that threaten not only the Manhattan fishing tackle business, but outer borough stores as well, include the competition from the internet—online suppliers have proliferated—and, more significantly, the tighter restrictions in recent years on saltwater fishing in terms of length of season, minimum size, and daily catch limits. It is the catch limit—the number of fish one can keep in a day—that impacts the most on the demand for fishing tackle, because for a lot of fishermen, if one can't fish to eat, what's the point of fishing at all?

It is argued by many New York fishermen that these restrictions are greater in New York than in the neighboring states of New Jersey and Connecticut. (These regulations are established by the federal government, through the National Marine Fisheries Service, on a state-by-state basis.) New York, for example, has stricter catch limits on summer flounder (commonly known as fluke) than New Jersey. New Jersey fishermen can keep six flukes per day, while New York fishermen can keep only two. Plus the minimum size in New Jersey is lower than New York: 18 inches versus 20.5. In June 2008, the attorney general of New York sued the feds, arguing that, in the case of the flukes, it was no fluke, but rather, an unfair application of the regulations that resulted in New Yorkers being discriminated against. The outcome of the suit is not yet known.

As if the saltwater fish restrictions were not bad enough, freshwater restrictions are worse. Although every borough has ponds and lakes within their parks that are stocked with fish, all fishing within the city's parks are on a catch-and-release basis only. As the state's Department of Environmental Conservations website says, somewhat tauntingly, "Make sure to bring a camera to capture the memory!"

Having been around for over a hundred years, Capitol Fishing Tackle Company obviously has some staying power, so one would assume, despite all of the above, that it will continue to operate for decades to come. And if you do check out the shop, make sure to pay special attention to the signage above the storefront. It is the original neon sign created for Capitol in 1941, dismantled and reinstalled multiple times, from one incarnation to the next. The neon lights are set within handcrafted stainless steel letters, and the background of the sign is made of porcelain. In the lower right corner it says "Cutlery." Don't be confused. Capitol hasn't sold cutlery since about 1976. But it does make for a nifty-looking sign.

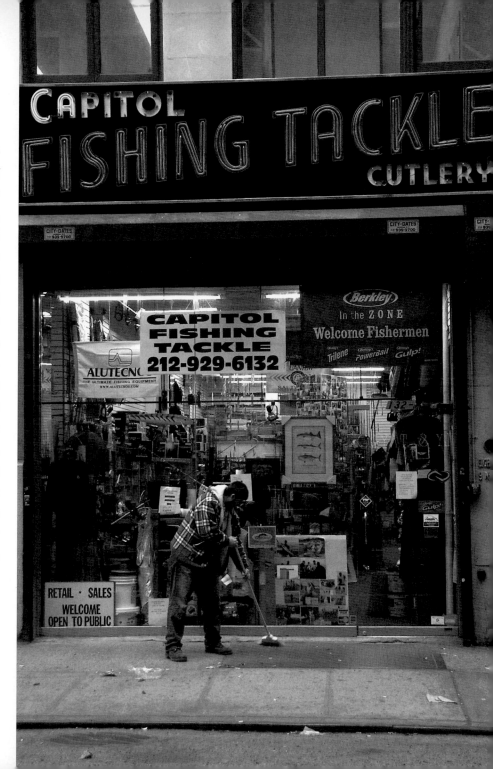

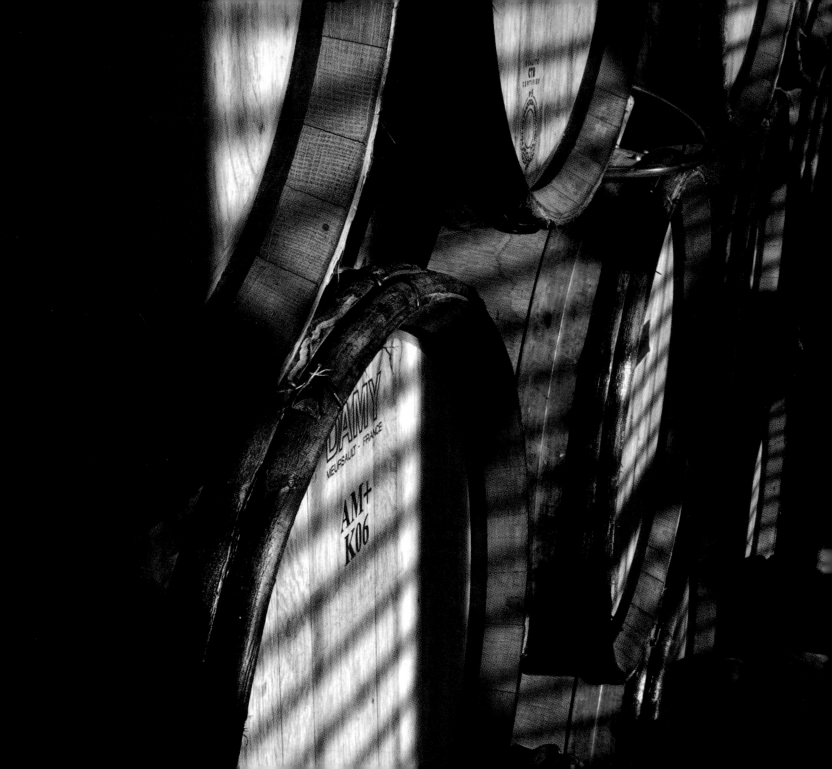

winery

the setting for the Red Hook Winery could not be less bucolic. Set on an industrial block in Red Hook, Brooklyn, where razor wire rather than grape vines is the neighborhood motif, its creation as well as its location is, nevertheless, a true New York love story. Love of wine, music, friendship, and neighborhood. It goes something like this.

Many years ago, in the outer reaches of a New York borough, a young boy named Mark lives with his parents in a blue-collar neighborhood of mostly policemen and firemen. His parents are neither. Mr. and Mrs. Snyder do have a passion for good wine, however. In a time when New York City is still very much a city of merchants, a personal relationship develops between Mark's parents and Peter Morrell of the Morrell Wine Company. He becomes their wine purveyor, family friend, and sometimes dinner guest. The world of wine is very much an integral part of the Snyder household, and Mark's parents share their love of wine with their young son, letting him, at age five or six, take sips of world-class wine. It's as though Mark is growing up in a family in Paris, France rather than Gerritsen Beach, Brooklyn.

Mark's childhood is an exceedingly happy one, but like so many other native New Yorkers, he thinks pastures are greener elsewhere, and he yearns to leave New York. Mark is a clever child and a quick study, and he parlays his multiple talents to become a highly sought-after sound technician, building guitar rigs for big name musicians and their bands—Peter Frampton, John Mellencamp, Billy Joel, and Ringo Starr among them. He is called a "guitar tech wizard" and "guitar technician extraordinaire."

He travels the world. He is in Berlin when the wall comes down in 1989, and he has a piece

of the wall to prove it. In his spare time, he visits wineries all over the world, for the love of wine instilled in him by his parents at an early age just won't go away. Whenever he is in the San Francisco Bay area, as he often is, he visits the wineries of Napa and Sonoma.

Once, while touring with Ringo Starr, Mark visits the Farrari-Carano Winery in the Sonoma Valley. Its winemaker, George Bursick, is a drummer and an avid Beatles fan. They talk music and wine. Hoping Mark will reciprocate, George gives Mark the "backstage tour" of the winery, the first person to ever give him this kind of insider access. Later, he introduces Mark to Bob Foley, another winemaker (Robert Foley Vineyards) and musician (the Bob Foley Band). They, too, talk music and wine. Bob shares the holy grail of winemaking with Mark. Mark shares the holy grail of technical music gear with Bob. Their mutual love of wine and music leads to their becoming fast friends.

After sixteen years of touring eleven months a year, Mark is beginning to weary of life on the road. Also, after almost two decades of travel, he concludes that New York, the city he was once eager to escape, is in fact the greatest city in the world. He loves New York. He wants to come home. He decides to start a wine distribution company, based in New York. It will distribute the wines of Bob Foley, Abe Schoener, and other high quality, limited production winemakers.

After a time of working out of his living room, Mark decides his company, Angel's Shares Wines, needs a real office. Years earlier, Mark had needed packing supplies to ship products for Framptone, the company he'd formed with Peter Frampton to produce a line of performance accessories and guitar gadgets, such as guitar talk boxes. In other words, he'd needed boxes for their boxes. Mark had visited Cornell Paper & Box in Red Hook. Wandering around the waterfront warehouse, all of a sudden Mark looked up and lo and behold, there was Lady Liberty! The Statue of Liberty was so close, he felt he could have shaken hands with her. Mark

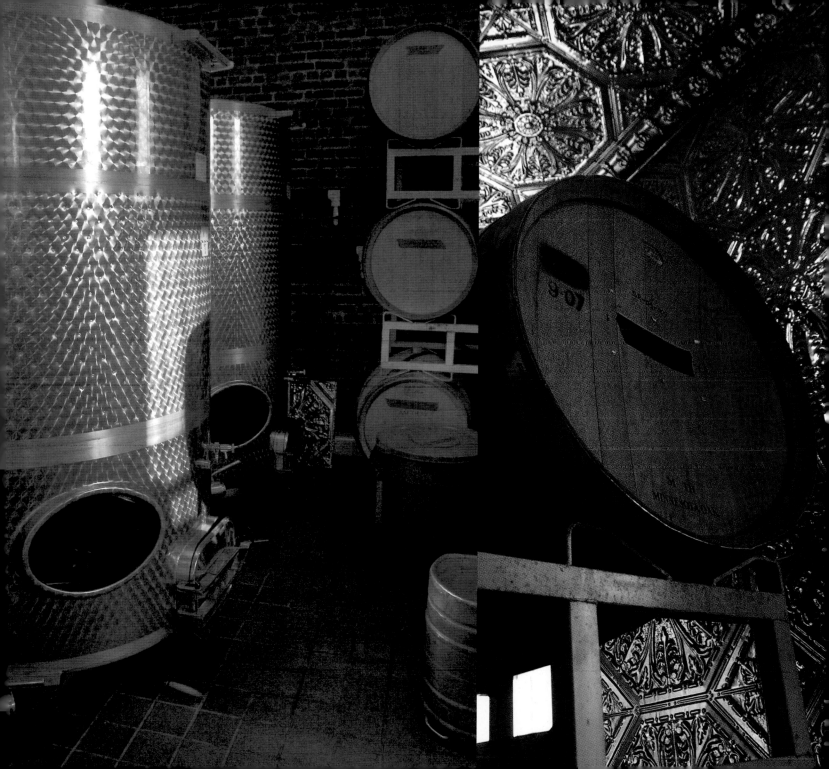

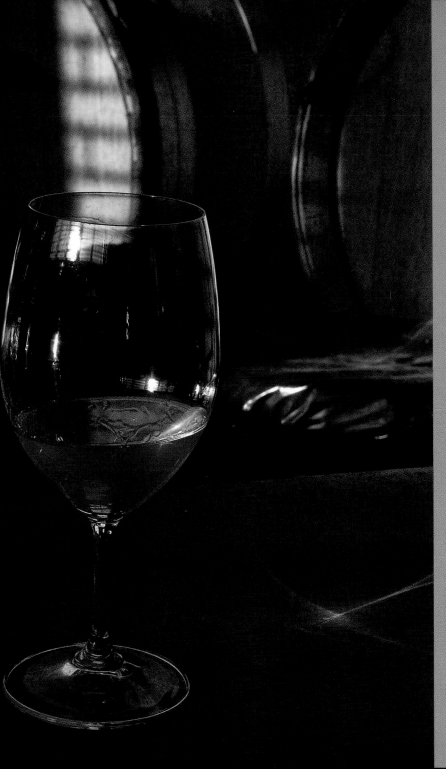

was smitten. He could not get the neighborhood and its proximity to the statue out of his mind, so years later, it is in Red Hook that Mark rents the office space he needs for his wine distribution company.

Bob Foley and Abe Schoener come often to Red Hook on business. They too fall in love with the isolated waterfront neighborhood of warehouses, manufacturers, docks, artists, urban pioneers, empty lots, community gardens, and all manner of creative activities commercial and otherwise. "How can we spend more time here?" one of the threesome asks. "Let's start a winery!" the other two reply jokingly. But no one is laughing.

Starting a winery based in Red Hook, they decide, is the perfect way to bring together their

passions as well as the friendship itself. They will use grapes from the North Fork of Long Island to produce their fine wines, and in that way help eradicate the disconnect between the New York wine market and New York wines, hoping that someday, New York restaurants, like their California counterparts, whose wine lists are three-quarters filled with California wines, will also offer a preponderance of local wines. At the same time, they will buy supplies from local merchants and thereby support those in their chosen neighborhood.

Greg O'Connell, "the mayor of Red Hook," rents them space in an old building that was once the destination of seamen—the front a bar and restaurant, the upstairs a bordello (talk about one-stop shopping). The back of the building was once a munitions factory where cannonballs were manufactured. The dividing wall now removed, the whole space is used for the winery. A great space with a magical history for a winery that will produce magical wines. The location is perfect. There's synergy with the Six Point Ale Brewery across the street, and they can order hand-blown "wine thieves" for extracting wine from Pier Glass just down the block, and neighbors will poke their noses in to see what is going on, and then offer their help, as many actually do during the first grape crushing season. The gods all seem to be on their side.

They hire Christopher Nicolson, a sometime Alaskan fisherman, as their on-site winemaker, and in the fall of 2008 harvest their first supply of grapes. Red Hook Winery bottles its first whites in Spring 2009. The first reds in 2010.

Therein the true story of how a winery grows in Brooklyn.

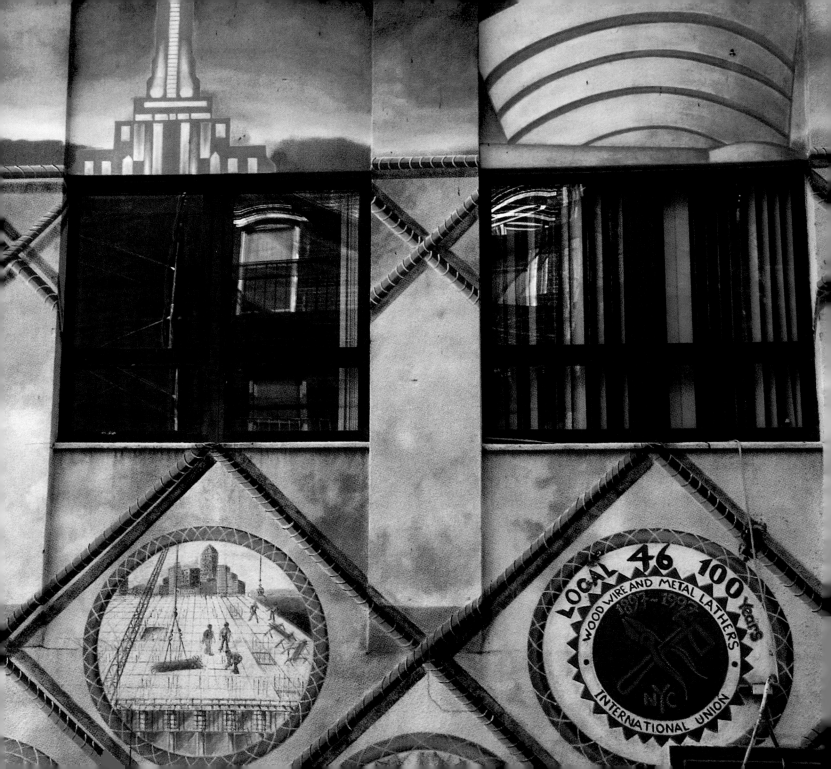

metallic lathers

Why a union headquarters and hiring hall would be located in the midst of the decidedly non-working class corridors of Manhattan's Upper East Side—along one of the city's most expensive boutique/shopping and dining strips—is a very good question. Why, in a word, would a union, whose membership neither lives nor works in a neighborhood, plunk itself down in enemy territory, so to speak, in a neighborhood more defined by blue blood than blue collars?

A 2003 article in the *New York Times* captured the incongruity well. Describing a long line of men camped out on the sidewalk in front of the Metallic Lathers Union (these are the guys who lay the steel rods that reinforce concrete) waiting to get an application to join the union and a chance at the then $38 an hour job ($62 an hour with benefits), the article homed in on the incompatibility of the union and the neighborhood.

> Yesterday on the Upper East Side, the usual sidewalk queues formed for Sunday brunch, museum exhibits and Rollerblade rentals. But one line, beginning at Third Avenue and 76th Street and encircling most of a city block, was made up of burly men with bleary eyes lolling about in portable lounge chairs. The line began to form Friday morning under a sign for Local 46, the Metallic Lathers Union of New York and Vicinity. Since then, people from all over the Northeast began flocking here to the local's headquarters for a chance to apply for union membership, an opportunity that comes every two years.
>
> The union is handing out applications to the first 200 people in line this morning. Most have slept on the sidewalk since Friday—some directly on the pavement, others in tents with air mattresses.

[A] woman in a blue bonnet approached and asked… if these were homeless men waiting on a food line, "because they look like they've been here so long."

"These men are waiting to join our union… These are the men who are going to be putting up the buildings in this city."

The article ended with this final observation, "The rear of the line ran next to the sidewalk cafe of Orsay on Lexington Avenue, where well-dressed diners eating goat cheese salads and salmon souffles tried to ignore the would-be construction workers cheering on the Mets."

That more or less captures class warfare, Upper East Side style. The vignette of these would-be construction workers camping out on the sidewalks of a chic Manhattan neighborhood may not be as off-putting, perhaps, as the placement of a giant inflatable rat in front of a construction site in some upscale neighborhood, as one commonly sees throughout the city to signal the hiring of non-union laborers, but… well, you get the picture.

It's not that New York is not a union town, for the city is, and always has been, one of the most pervasively unionized cities in the country, despite the fact people don't necessarily think of it that way. To many, New York is thought of as a center of financial clout rather than union might… until, that is, there is a transit workers' strike, or a doormen's walkout, or an elevator operator's work stoppage, any one of which pretty much closes the city down.

In point of fact, the city's labor history is long and rich; from the fiery pro-labor, anti-capitalist demonstrations and speeches centered in and around Union Square in the early part of the 1900s to the hordes of workers who then lived and worked on the Lower East Side in its tenements and factories. And lest anyone doubt New York's place in the history of the American labor movement, the very first Labor Day celebration—September 5, 1892—was held in New York City, with ten thousand workers marching from City Hall to Union Square.

Indeed, what has distinguished New York from most every other city is the fact that as unionization nationwide has decreased dramatically—as the country changed from heavy manufacturing to service industries, high finance, and high tech—New York has proved to be resistant to this decline, maintaining a high percentage of union workers despite the national trend. In the 1950s, approximately 35 percent of workers in America were members of unions. By 1983 that percentage had dropped to 20 percent, or 17.7 million workers, and by the end of 2008, to 12.4 percent, or 16.1 million workers (which actually was not only an increase from the previous year but also the biggest rise in a quarter of a century).

New York City, however, had a union membership at the end of 2008 of about 1.3 million members, or more than 26 percent of all workers—over twice the national average. New York State—primarily because of the city, which claims more than 60 percent of the state's 2.1 million union members—has the highest percentage of union membership in the country. North Carolina has the lowest at 3.5 percent.

Of course, the composition of the city's union movement has changed, even while its numbers have been maintained. Whereas manufacturing unions once formed both the bulk and heft of New York City's union membership, particularly from the early 1950s through the mid-1970s (the period of unions' greatest influence and power), in the last several decades, the city's union membership has shifted and now is comprised mostly of government/municipal workers, transit employees, utilities workers, construction workers, and, most recently, service employees, particularly minorities (including recent immigrants, many of whom are non-citizens) in the fields of health-care, home care, and childcare.

New York being New York, the city claims a groundbreaking Freelancers Union, representing the thousands and thousands of freelancers who define a huge part of the city's

workforce, particularly in creative fields. Even the city's comedians have seen the benefit of unionization. For a brief period in 2004, 300 of the city's comedians coalesced to form the New York Comedians Coalition, pressuring comedy clubs to raise their pay: from $60 to $120 on weekends for a ten- to twenty-minute set, as well as a small increase from the average of $15 to $25 a set on weekdays.

Finally, the fact that New York has always been a large union town might help explain why it's also always been a heavily Democratic one. For instance, District Council 37, of the Municipal Employees Union, has 121,000 members, and in 2008, 90,000 were registered Democrats. Republican candidates don't have a chance here. Mayor Michael Bloomberg ran as a Republican only to avoid the Democratic mayoral primary. In truth, he was a Democrat in Republican clothing.

All of this having been said, the initial question remains: Why, indeed, are the Metallic Lathers located here? Maybe they have learned the basic lesson of New York City, which is that much of the life of the city revolves around real estate. One can only imagine the rent the union receives from its retail tenants on the street level of their two-story building, which is in one of the highest priced parts of the city. With the upscale gourmet food store Citarella directly across the street and other establishments of that ilk in the neighborhood, the rents the union commands from its tenants—a Chinese restaurant, a nail salon, a women's shoe store, a women's accessories boutique, and a women's handbag shop—must fall into line. Pre-recession, that is, as of spring 2008, the average asking rent per square foot for retail space on the East Side was $164, the highest in the city. (This, compared to Manhattan's average asking price of $111 per square foot.) And it would be surprising if the union hadn't received something from the

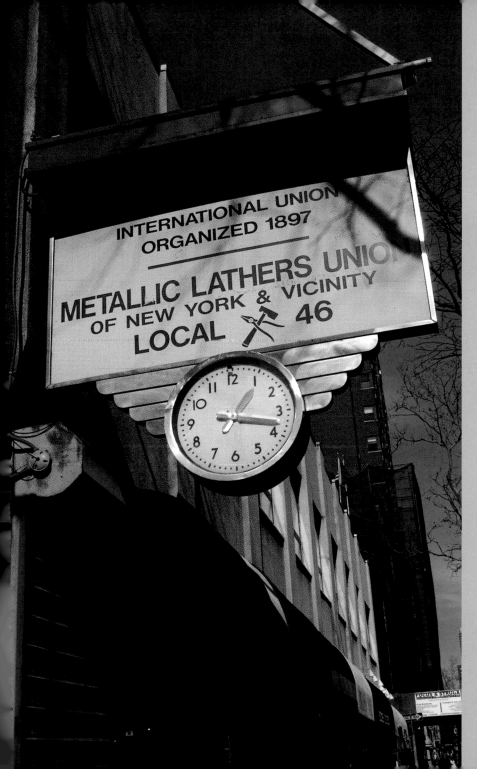

developers of the luxury 31-story apartment building that looms above it right next door. Though the building's developers apparently bought air rights from the St. Jean Baptiste Roman Catholic Church (which, between the church itself and the adjoining office and parish house, owns nearly the entire block), the union's air rights must have been worth something to the developers, if for no other reason than to preclude its sale to someone else.

In any case, for the Metallic Lathers Union, it's a very valuable piece of prime Manhattan real estate indeed. A shrewd, profitable, steady cash-flow-producing investment.

Location, location, location.

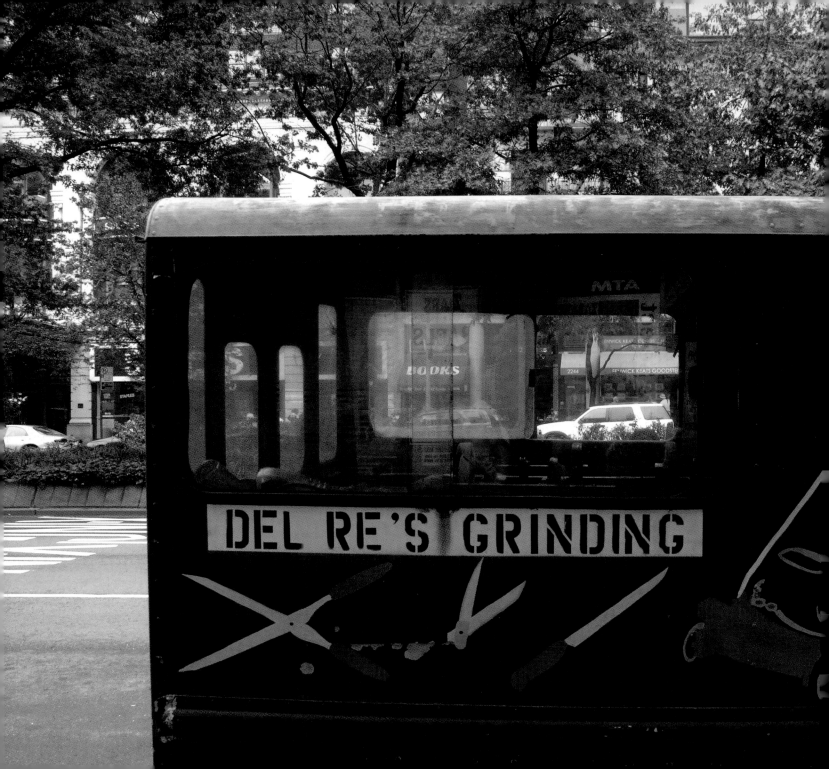

mobile knife-sharpening

the days when the city's goods and services were delivered to one's doorstep are long gone—Chinese takeout and pizza being the obvious exceptions. It's been generations, certainly, since the iceman cometh, but, decades, too, since the city's residential streets were teeming with fruit and vegetable peddlers (initially in horse-drawn carts and later in small trucks), milkmen, junkmen, ragmen, laundrymen, seltzer men and, yes, knife sharpeners.

Most all of these trades and tradesmen went the way of the trolley car. A handful survive, more out of a sense of nostalgia and inertia than economic efficacy. Sure there is Mister Softee, ubiquitous during the warm weather months, but at one time there were numerous ice-cream truck companies vying for the sweet tooth of the city's children: Good Humor, Bungalow Bar, Howard Johnson's, and all manner of independent operators. As for seltzer deliverers, while there are probably no more than a half dozen who now ply that trade, up through the 1950s there were literally hundreds and hundreds of seltzer men in New York City; several hundred in Brooklyn alone.

And the fate of the mobile knife or cutlery sharpener? In the 1920s and 1930s, hundreds of grinders combed the city's streets. They were mostly newly arrived immigrants, primarily from northern Italy or southern Germany, who first carried a grinding wheel on their backs as they went from block to block. Later, they modernized to a horse-drawn carriage and then to a truck. By 1930, there were enough of these grinders to form the New York Grinders Association (which actually still exists, though their location is now inexplicably in New Jersey and their members are for the most part not mobile). In present day New York, there remain no more than a handful of these itinerant cutlery sharpeners, or "gypsy grinders" as they are referred to, somewhat disdain-fully, by more sedentary (that is, more established and successful) sharpeners. There is the guy in the red truck, the guy in the green truck, the other guy in the other green truck, the guy in the gray truck, and... well, that's about it. They roam a certain few neighborhoods—mostly downtown Brooklyn, the Village, and the Upper West Side of Manhattan—hewing to no predictable nor discernible route, no regular schedule and no contact information.

Though the devolution from hundreds to a handful seems cataclysmic (most of the original grinding businesses changed

from cutlery grinding to cutlery rental), the fact that any of the mobile grinders remain seems miraculous. After all, for a business that depends upon sharpening such items as lawn mowers, hedge cutters, saws, and ice-skates (in addition to the main business of cutlery), New York can't be the best place in the world to operate.

But more an obstacle than anything else is the simple fact that New Yorkers are a hard crowd to please, especially those finicky or perfectionist New Yorkers who worry about their knives and scissors being sharpened on a regular basis. The following quotes from one New York City blog illustrate the problem.

Blogger No. 1: "Don't use the [color left unidentified to protect the innocent] truck guy unless you know for certain that you want your knives reground. He does not sharpen/hone your knives; he grinds the blade. From my experience, he does not really understand the correct angles needed on professional quality knives—he just grinds the heck out of them. Are they sharp? Sure. Are they sharpened correctly? No."

Blogger No. 2: "I had knives sharpened several times by the guy in the [same color as above] truck. He has always done a wonderful job, and I would recommend going to him."

Be aware that these itinerant sharpeners don't have water in their trucks. There are certain knife sharpening mavens who insist that proper sharpening can only be done on a low speed wheel with a water bath, since the water prevents the steel from overheating and thereby weakening. On the other hand, these mobile trucks are typically cheaper than other sharpening services.

If in doubt about whether or not to entrust your kitchenware to one of these itinerant grinders, take the advice of one New Yorker: "Those guys that drive around in those old fashioned vans? Don't know about the quality, but definitely score some points for the experience."

key lime pies

as if it weren't impressive enough to make the best Key lime pies in New York City, Steve's Authentic Key Lime Pies, based in Red Hook, Brooklyn, turns out what many think may be the best Key lime pies anywhere in the country. No less an authority than Amanda Hesser, former food editor of the *New York Times Magazine* and food writer par excellence, says of them, "The best Key lime pie. Mason-Dixon or no." Which may explain why Wolfgang's Steakhouse orders Steve's Key lime pies not only for its Manhattan location, but for its Los Angeles and Honolulu locations as well. (The pies get trucked, along with beef, from Hunts Point in the Bronx to Los Angeles, and then shipped by plane to Hawaii.)

How does someone born and raised in Miami come to make a living in Brooklyn, New York, making Key lime pie? It would be the equivalent of someone in Ogden, Utah making a living selling knishes.

Well, perhaps no one ever told Steve Tarpin, the founder and owner, that he no longer lives in Miami. He still lives near the water, has his shop on the waterfront, and still fishes year round, often tuning into a Florida Keys radio station for fishermen on his bakery's radio. He refers to the waters between Brooklyn Heights, Governor's Island, and the southern tip of Manhattan as the "Golden Triangle," for yielding him many catches, including, recently, a 42-inch striped bass. "When I lived in Florida, I fished more than I worked. I guess," he admits, "you could say the same about me now."

Having brought his South Florida lifestyle to Brooklyn, it seems only natural that he make a living selling Key lime pies. What started as something he did just for his own pleasure and

consumption has grown into a full-fledged business. It started in 1995 after a Manhattan restaurant owner tasted one of Steve's pies at a barbeque event and began ordering them for his restaurant. The business first operated out of Steve's Brooklyn studio apartment, moved to a small shared commercial kitchen in 1999, and finally in 2001, relocated to its present location in a pre-Civil War era warehouse building on Brooklyn's waterfront.

The secret to Steve's Key lime pies? Well, Key limes! It turns out that most Key lime pies in this country are not made with fresh Key limes. Key limes, which are smallish—about the size of walnuts—yellowish and more acidic than the greener and larger Persian limes that one finds in supermarkets everywhere, are no longer grown for commercial production in this country. There are small growers—backyard growers—in South Florida and, to a lesser degree, in Texas and California, but ever since a 1926 hurricane decimated Florida's Key lime groves, their large-scale production in this country has disappeared, and concomitantly, so has their appearance in food markets. Key limes are now mostly grown in Central America—Mexico and Guatemala mainly—and the West Indies. If you do find them for sale here, they'll likely be in upscale markets, and they'll be expensive. The upshot of this loss of a domestic source of Key limes is the use of Persian limes in their stead, or worse, concentrated Key lime juice, which, of course, yields an ersatz Key lime pie as opposed to the real thing. On Steve's website, it recommends the concentrated juice "if you're stripping paint or removing rust, but not in a food product."

Steve's Key limes come from Mexico—around Veracruz or Colima—via a Texas shipper who delivers a pallet of Key limes at a time. A box of Key limes weighs about 40 pounds and contains 300 to 350 Key limes (a 40-pound box of Persian limes, by contrast, would contain maybe 80 limes), and Steve's goes through about twelve boxes a week, or about 4,000 Key limes.

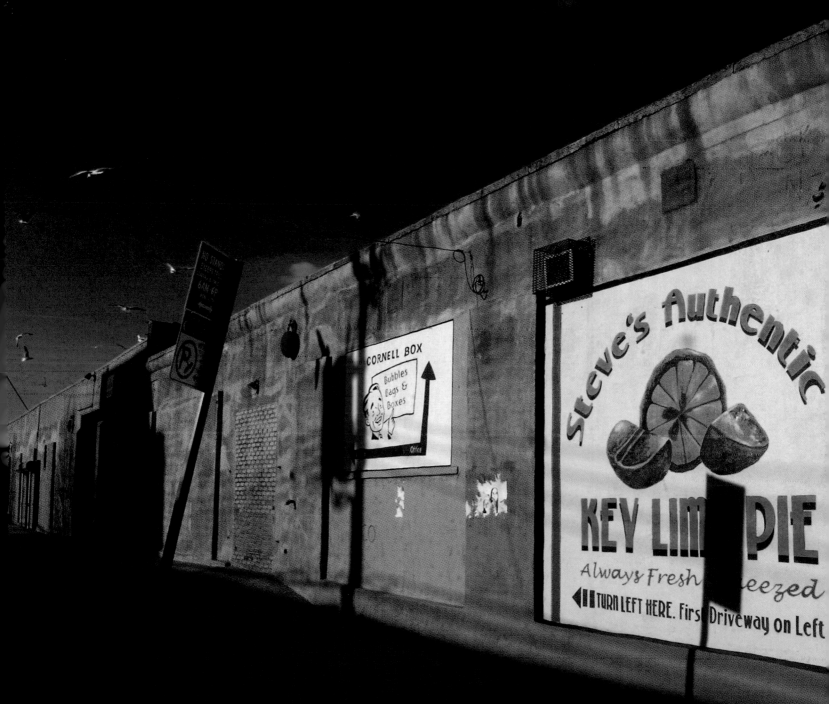

They are now squeezed in a commercial Zumex Juicer, although in the early years, it was done by a hand juicer which is still brought into action when the Zumex is down. It takes about twelve Key limes to produce a half a cup of lime juice.

In addition to the fresh lime juice, his pies (4 inch, 8 inch, or 10 inch) have only four other ingredients: eggs yolks, concentrated milk, graham cracker crumbs, and butter (the latter two

mixed for the crust). "We keep it simple," he says. "If it required six ingredients instead of just five, I think I'd be out of business."

His goal is to get closer and more involved in the growing and processing of the Key limes, perhaps developing a relationship with or buying an interest in some Mexican grove. In the meantime, he has four or five Key lime trees growing in huge pots outside his bakery (and taken inside during the cold weather months by his garden center neighbor). When reminded that Eli Zabar grows tomatoes, strawberries, and other produce in greenhouses atop his Vinegar Factory on the Upper East Side of Manhattan (see page 183), one could see the wheels start to turn inside Steve Tarpin's head. The seeds—undoubtedly Key lime—of an idea may have been planted.

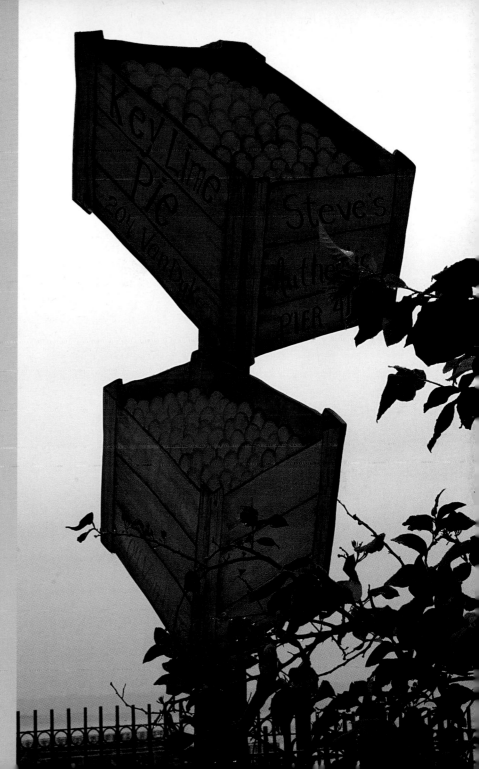

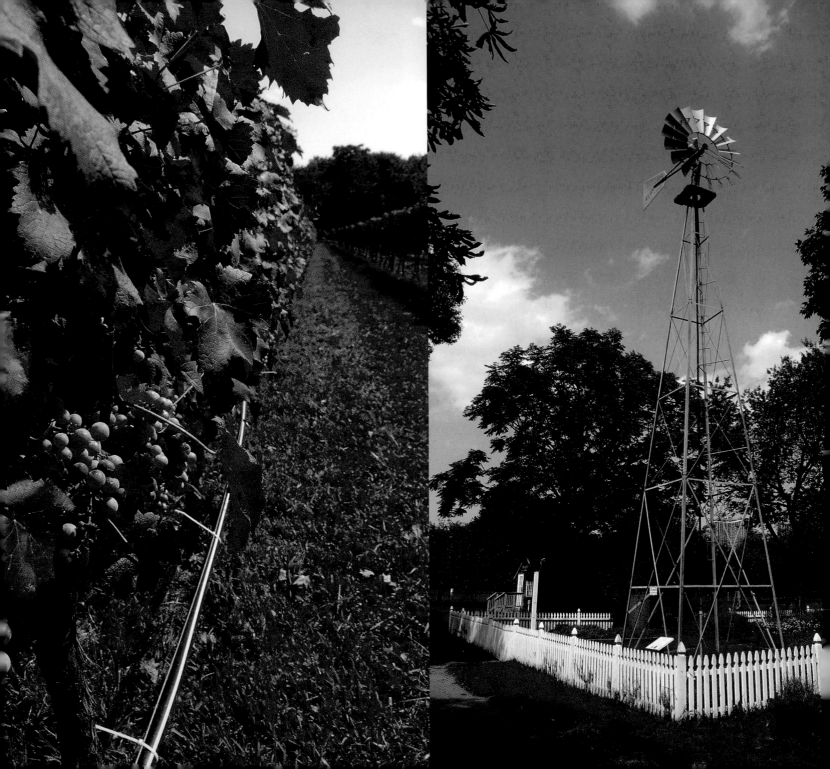

farming

the largest remaining parcel of farmland in New York City—47 acres worth—lies in the Floral Park/Bellerose neighborhood of Queens, close to the Nassau County line. Originally part of a tract consisting of 101 acres (in 1900, it was the second largest farm in Queens), the plot has been farmed continuously for over 300 years, since the turn of the 17th century, through the Revolutionary War, the Civil War, and the world wars.

Sold to the State of New York in 1926, the farm provided produce for nearby Creedmoor Psychiatric Center until 1975, when it became what it remains today: the Queens County Farm Museum. (Though in 1982, it was sold to the city, and became part of the Department of Parks and Recreation.)

Though it is a museum, it continues to be a working farm as well, and recently expanded its cultivated acreage and range of crops. To the typical slate of city vegetables—tomatoes, eggplants, cucumbers, zucchini—it has added such items as cauliflower, brussels sprouts, beets, fennel, and radicchio, which it sells on-site and at farmers' markets. In 2004, it planted a one-acre vineyard—the only commercial vineyard in New York City—consisting of more than 1,000 individual plants of four varieties of grapes: Chardonnay, Merlot, Cabernet Sauvignon, and Cabernet Franc. And in 2009, the farm began raising livestock: sheep, goats, and pigs, for wool, milk, and pork, respectively. According to the museum's director, it is the only farm in the city that raises livestock for, as he puts it, "productive purposes."

Before there was any talk of a back to the land movement, long before Alice Waters and her mantra "grow local," the city's farms fed the city's people. There were fresh, locally grown

fruits and vegetables as well as locally raised livestock as close to most city residents as their local subway stop would eventually be. In the 1890s there were close to 3,000 farms in New York City. By the early 1900s, the city was still home to hundreds and hundreds of farms. In 1921, just prior to the population and building booms that would eventually eat up almost all the remaining farmland for housing and commercial development, there were, according to a May 1921 article in the *New York Times*, 800 farms in New York City. A mere five in Manhattan, but 55 in the Bronx and 54 in Brooklyn. Staten Island claimed 121. Queens, then and now "the banner agricultural section of the city," was home to 565 farms! (For comparison's sake, in 1921, there were 935 farms in Nassau County, 2,470 in Suffolk, and 1,538 farms in Westchester.)

By 1950, just over 300 farms were left. The very last remaining privately owned farm, also located in Queens (Fresh Meadows), was sold in late 2003. As recently as 2001, it was selling its vegetables from a stand on its property at the corner of 73rd Avenue and 194th Street.

The handful of remaining farms are all publicly or institutionally owned and run. In addition to the Queens County Farm Museum there is the 15-acre Decker Farm on Staten Island owned by the Staten Island Historical Society and part of Historic Richmond Town; the Gericke Farm, also on Staten Island, which is part of Cornell University's Co-operative Extension Program; the 4-acre farm used by John Bowne High School in Flushing, Queens for their on-site specialized agriculture program; the 2.75-acre farm in Red Hook, Brooklyn, a project of the non-profit group, Added Value; and the recently opened 3-acre farm on Governor's Island, a joint project of Added Value and the corporation that runs Governor's Island.

The non-profit group Just Food encourages urban agriculture, and under its "City Farms" program supports 30 or more "farms" all over New York City, though truth be told, these

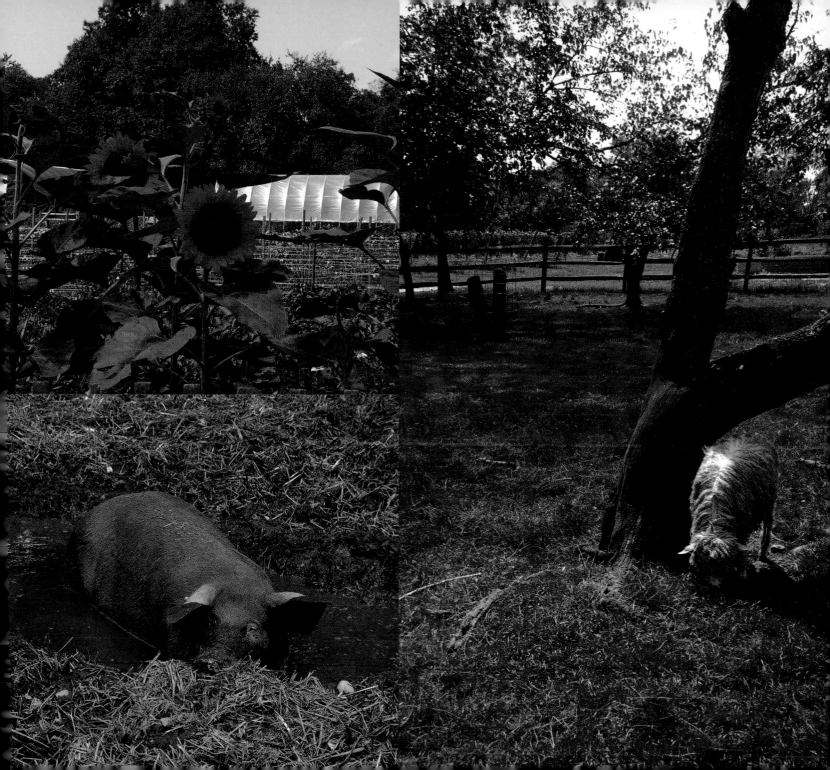

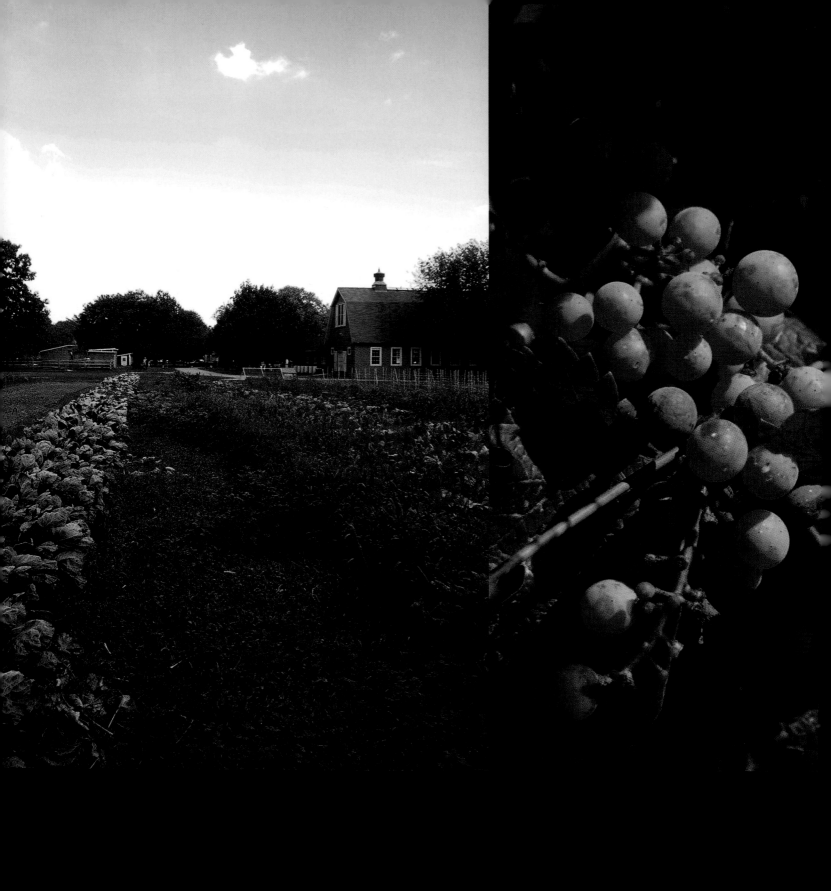

"farms" are more garden than farm. And, of course, New Yorkers grow herbs, fruits, and vegetables on rooftops, fire escapes, terraces, and patios and in their front and backyards. A couple in Brooklyn has even transformed an old Dodge pick-up truck into a mobile "farm," called the Truck Farm.

Land being at a premium in New York, and most arable land having long since been built upon, one idea for the future posits the notion of creating vertical farms. A Columbia University public health/microbiology professor has promoted this idea of building multistory buildings devoted to the growing of food crops. Since it is predicted that by the year 2050, nearly 80 percent of the world's population will reside in urban centers, why not bring the food source directly to the cities? And what better place to start than New York?

In the meantime, for those still interested in the horizontal farm experience, the 47-acre Queens Farm Museum is a wonderful place to visit. After spending some time there, imbibing the ambience—the tractors and other large farm equipment, the working windmill, the 1772 vintage farmhouse, the smells, the animals, the green fields, the orchards, the vineyard—you might begin to believe you're on some Midwestern farm. But before this feeling becomes too convincing, turn to the northeast. The 34-story North Shore Towers looming in the distance will quickly disabuse you of your fantasies.

No, Toto, you are definitely not in Kansas!

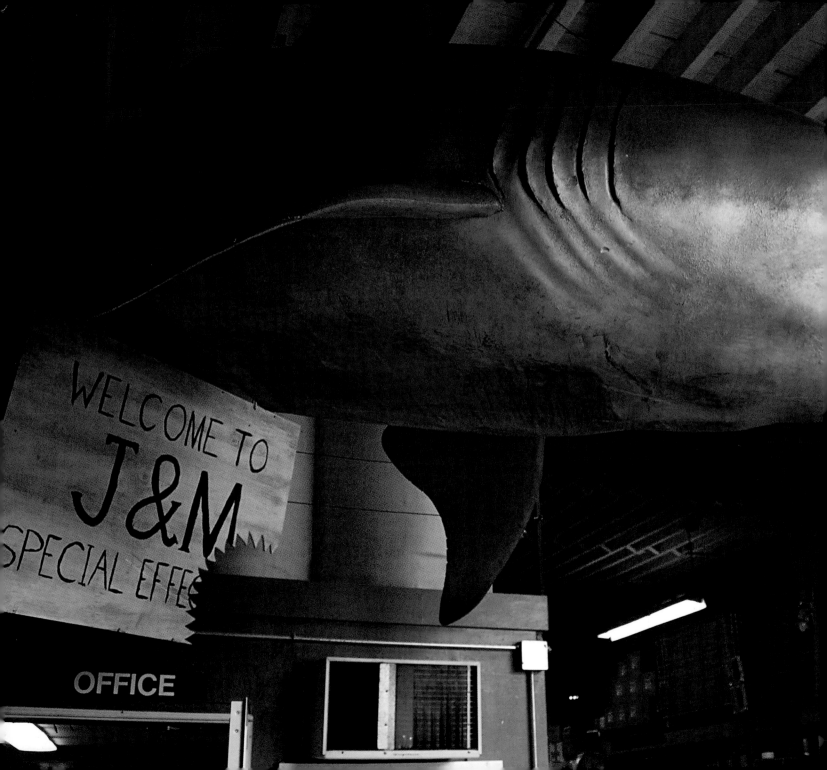

special effects

J & M Special Effects, situated on the "shores" of the Gowanus Canal in Brooklyn, is not your garden-variety special effects company. It is, according to one of its design associates, "Where you go when you need something completely absurd or off the wall that no one else knows how to do."

Sure, with all the theater, television, and film production that goes on in New York City, it is no surprise that there are multiple companies that provide props and other materials for the sets of these various productions. What is surprising is that a company like J & M—which besides providing rain, snow, fog, wind, smoke, and lightening—specializes in pyrotechnics, explosions, and theatrical weaponry, the storage and the testing of which does not exactly make for a perfect fit in the densely populated, space challenged confines of New York. (In point of fact, the largest concentration of such pyrotechnic oriented special effects companies—and where the demand for them is the greatest in the country—is in Las Vegas.)

Once described in the *Daily News* as a company that stores "explosives, flammables and other toxins in a custom-built facility," it appeared as if George Bush's Weapons of Mass Destruction might have finally been discovered—in Brooklyn, New York! But the *Daily News*'s characterization was not exactly accurate (the *Daily News* not accurate!?). In fact, there are no toxins (not counting the Gowanus Canal itself), if by toxins one thinks of poisonous gases or potentially lethal biological organisms that could be

released and spread to deadly effect. What is stored inside a cement bunker within J & M's 11,000-square-foot warehouse is a supply of various pyrotechnic products (flame projectors, titanium flakes, aluminum flakes, zirconium, electric matches, and myriad fireworks, which include gerbs, squibs, mines, comets, stars, and air bursts, to name a few) and explosives (detonators, ignitors, high and low explosives, including gun-powder and blanks).

The ability to store and demo explosives and flammables, which it does in its parking lot as well as inside its warehouse, is what distinguishes J & M from most other of the city's non-digital special effects companies. Most of the others are in the business of supplying special effects machinery (fog and wind machines, for example), but J & M has a full-time staff of over a dozen people to design, create, and test special effects, as well as sell and rent the standard and non-standard types of products. "Think of us as a storefront special effects business with a staff on-site," urges one of its employees. "Not just a warehouse."

J & M's ability to be this kind of business depends upon being in a neighborhood zoned for manufacturing, which fewer and fewer neighborhoods are, as the city's manufacturing areas increasingly get rezoned and transition more and more from manufacturing to residential or mixed use. Prior to moving to its present location in 2006, J & M was located for nearly 20 years in DUMBO (Down Under the Manhattan Bridge Overpass), until that neighborhood was pervasively rezoned for non-manufacturing, and J & M was forced to relocate.

Upon landing in Gowanus, rezoning almost bit J & M in the butt again. Much of the area was being rezoned for mixed use to allow for residential development, and initially the dividing line between the old manufacturing zone and the new mixed use one ran through J & M's parking lot! After making its case before the zoning powers that be, that line was moved a block away, allowing J & M to continue to blow up things to its heart's content.

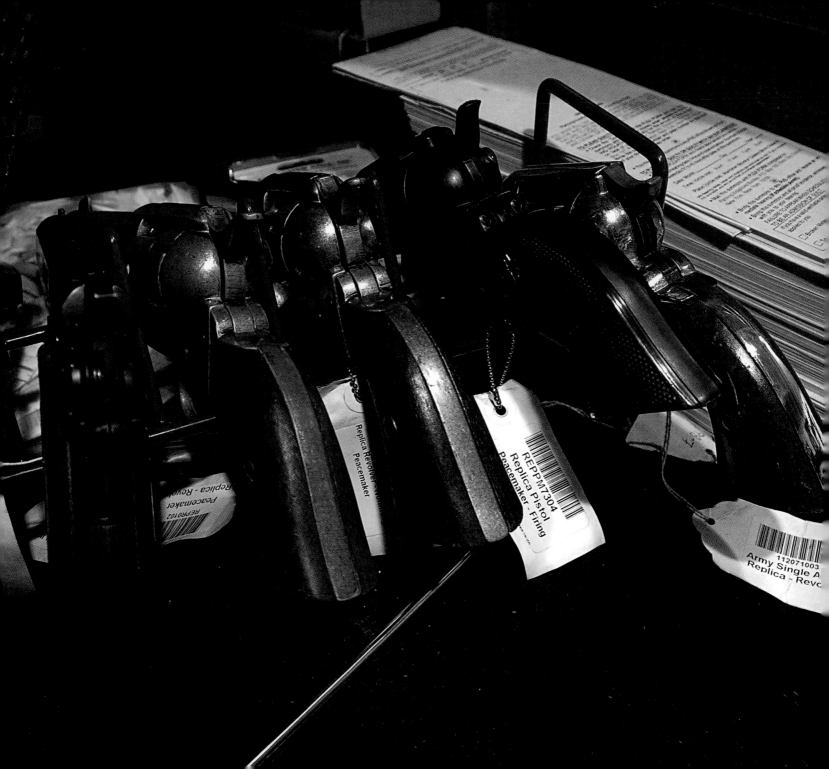

Sometimes J & M does blow up things just for the fun of it, staff admit. While the rest of New York is ratcheting things down by observing "casual Fridays," at J & M they're amping things up and having what they refer to as "crazy Fridays," when employees literally blow off steam. "Let's say one of the computers was giving us a hard time during the week," says a staff person. "Well, come that Friday, we just might blow it up. We blew up a snowman around Christmas one year," he continues. "Also a reindeer display. And, oh yeah, once we blew up a cherry pie."

But, obviously, most of the explosions are for legitimate business purposes, as when the monthly "pyro" maintenance is done by exploding leftover and past "use-by-date" pyrotechnic products, or, as is more often the case, test explosions for some stage or film production (blowing up a guitar for a video introducing The Who, for example), though neighbors don't always react kindly to these blasts. Some say, "I wish I knew you were going to do that, because I would have come to watch." But others exclaim, "I wish I knew you were going to do that, because I almost had a damn heart attack."

"Now we post notices, usually 24 hours in advance of any explosion or pyrotechnic display," says one employee. "And we even have an e-mail list of neighbors who want to know."

Anyway, should you hear an explosion some Friday afternoon, take heart in knowing that it's simply "crazy Friday again at J & M's." And should you hear gunshots, take solace in knowing that they're only blanks. Bottom line is that New York needs its manufacturing zones left intact—or better yet, expanded—so consider an explosion now and then a small price to pay for the manufacturing health of the city.

play

cricket

althoughough the game of cricket is not likely to supplant basketball as "the City Game" anytime soon, in 2008 the Brooklyn Parks Commissioner did pronounce it the fastest growing sport in Brooklyn. Home to large numbers of recent immigrant groups from the cricket-playing countries of the world (India, Pakistan, Jamaica, Trinidad, Guyana, and other nations once under British rule), New York City—particularly the outer boroughs—was destined to reach a critical mass of cricket enthusiasts.

There are now six different adult cricket leagues in the city, with some 700 participants. In 2006, New York City hosted the cricket national championships. And in the spring of 2008, the Department of Education launched the NYC High School Cricket League—the only one in the country—with 14 schools participating and playing a 12-game season; in a year the league expanded to 23 schools. There is even an elementary school in Ozone Park, Queens that has a cricket team, the first and only elementary school in the city to have one. For the time being, those children are destined to play among themselves.

And whereas in most of the United States the Police Athletic Leagues sponsor baseball, basketball, football, and maybe soccer leagues for teenagers, in 2008 the New York Police Department started a summer teenage cricket league; six teams the first year and ten teams the next. Singh's Sporting Goods, with locations in Queens and the Bronx (and on the web), is probably the largest cricket equipment store in the United States.

There are now cricket fields in city parks in all five boroughs. Van Cortlandt Park in the Bronx has thirteen. Spring Creek Park in the Marine Park section of Brooklyn is the only cricket field built specifically for that purpose, and it was built in lieu of an initially proposed

Little League baseball field! The oldest of the city's fields is in Walker Park, home to the Staten Island Cricket Club, which was founded in 1872 and has played cricket every summer since, even through world wars and the Great Depression.

In his 2008 novel of displacement, disorientation, assimilation, and dissimilation in post-9/11 New York, *Netherland*, Joseph O'Neill writes at length about New York City cricket and of the Staten Island Cricket Club in particular, where he is a member and for whom he plays. (Though he is an Irishman by birth, he was raised in Holland.) Of New York City cricket venues, and Walker Park specifically, O'Neill writes:

> Walker Park was a very poor place for cricket. The playing area was... half the size of a regulation cricket field. The outfield is uneven and always overgrown, even when cut... and whereas proper cricket, as some might call it, is played on a grass wicket, the pitch at Walker Park is made of clay, not turf, and must be covered with coconut matting; moreover the clay is pale sandy baseball clay, not red cricket clay, and its bounce cannot be counted on to stay true for long...
>
> There is another problem. Large trees... clutter the fringes of Walker Park. Any part of these trees, even the smallest hanging leaf, must be treated as part of the boundary, and this brings randomness into the game. Often a ball will roll between the tree trunks, and the fielder running after it will partially disappear, so that when he reappears, ball in hand, a shouting match will start up about exactly what happened.
>
> By local standards, however, Walker Park is an attractive venue... no other New York cricket club enjoys such amenities or such a glorious history: Donald Bradman and Garry Sobers, the greatest cricketers of all time, have played at Walker Park. The old ground is also fortunate in its tranquility. Other cricketing venues, places such as Idlewild Park and Marine Park and Monroe Cohen Ballfield, lie directly beneath the skyways to JFK. Elsewhere, for

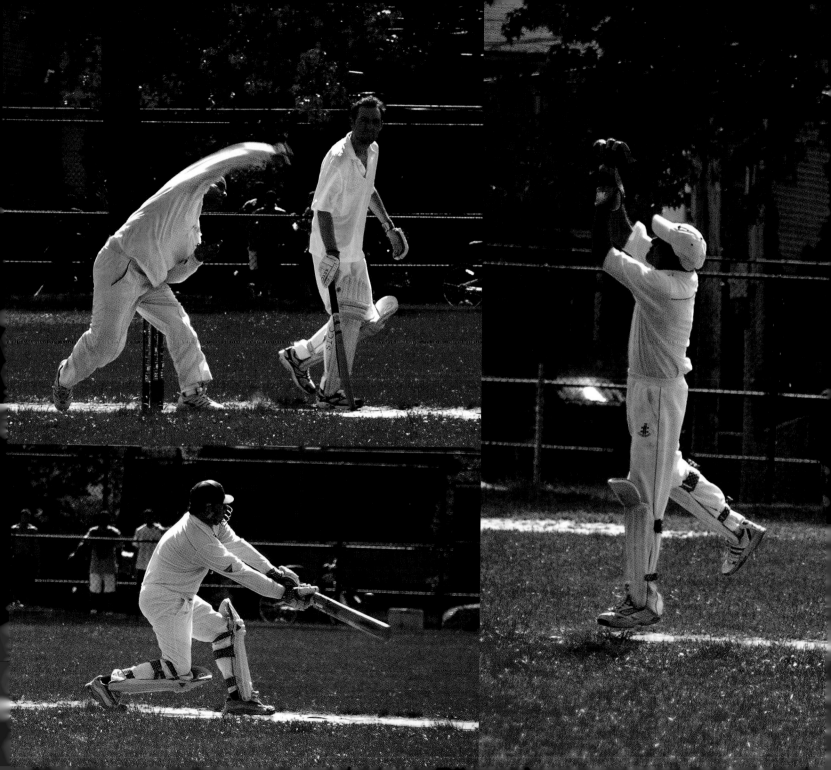

example Seaview Park (which of course has no view of the sea), in Canarsie, the setting is marred not only by screeching aircraft but also by the inexhaustible roar of the Belt Parkway, the loop of asphalt that separates much of south Brooklyn from salt water.

O'Neill goes on to describe the inimitable style of cricket that has evolved in New York by virtue of the parameters—call them limitations—of the city's various cricket fields.

What all these recreational areas have in common is a rank outfield that largely undermines the art of batting, which is directed at hitting the ball along the ground with that elegant variety of strokes a skillful batsman will have spent years trying to master and preserve: the glance, the hook, the cut, the sweep, the cover drive, the pull, and all those other offspring of technique conceived to send the cricket ball rolling and rolling, as if by magic, to the far-off edge of the playing field. Play such orthodox shots in New York and the ball will more than likely halt in the tangled, weedy ground cover.

Not only is the brand of cricket—like most other things in the city—particular to New York, but so too is the demographic of its participants. O'Neill points out that whereas in other parts of the cricket-playing world, cricket tends to be a sport closely identified with the upper class, in New York City it is a sport primarily for working-class immigrants.

Chuck Ramkisson, the character in *Netherland* who first introduces the narrator to the world of New York City cricket and then serves as his guru and guide to this subculture, makes poignant observations about being an immigrant in the city as well as a person of color and someone who plays cricket.

In this country, we're nowhere. We're a joke. ... Every summer the parks of this city are taken over by hundreds of cricketers but somehow nobody notices. It's like we're invisible. Now that's

nothing new, for those of us who are black or brown... I sometimes tell people, You want a taste of how it feels to be a black man in this country? Put on the white clothes of the cricketer. Put on white to feel black.

Proving that truth is sometimes stranger than fiction, a spectator at a recent summer afternoon match at Walker Field observed the following.

Amid the normal chatter and sounds of an afternoon match well in progress, between the Staten Island Cricket Club and the British Schools and Universities Club, all of a sudden came the loud pealing of bells from an ice-cream truck. This got the attention of a tall, dark-haired woman spectator, who was overhead saying to her male companion, "I'd love an Italian ice."

For reasons of his own—maybe he was intent on the match, or perhaps he just lacked chivalry—her companion balked.

"I'll go. I'll get you one," declared a cricketer from the outfield, obviously taken by the striking woman.

"That's ridiculous, you're in the middle of a game," responded her incredulous companion.

"It's all right—I'll get a sub," replied the fielder.

He did. He absolutely did! He left the field, purchased the ice, presented it with a flourish, accepted her thanks, ignored the rolling of the eyes of her companion, and steadfastly refused any reimbursement from the grateful woman.

And blithely resumed his position on the field.

One tried to imagine something like this happening at, say, Lord's Cricket Ground in London. Not a chance. Which only goes to show that New York's most venerable cricket venue and London's most venerable cricket venue are not exactly equals.

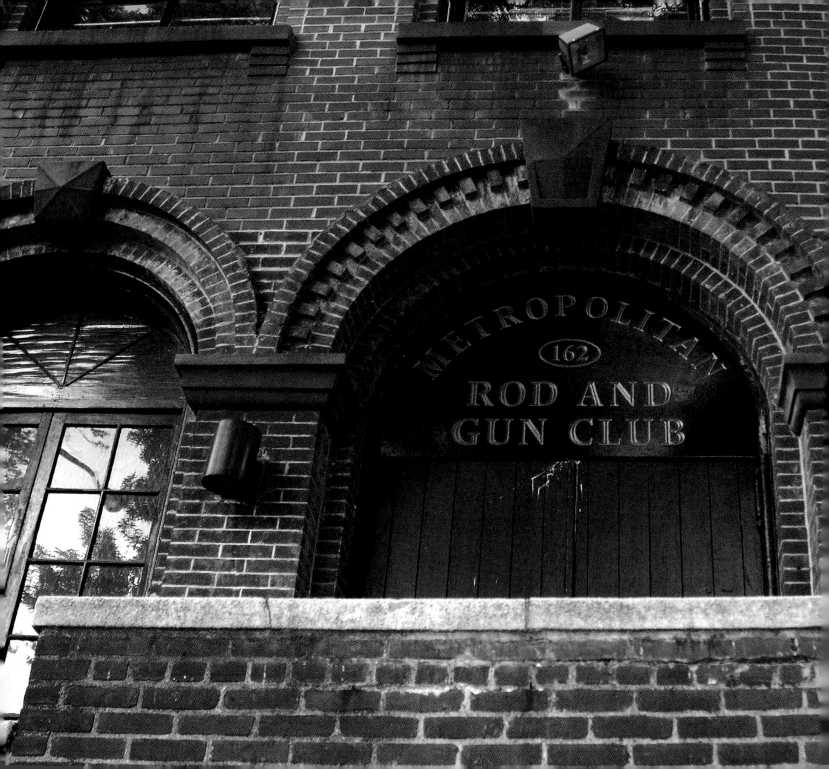

pistol shooting

The Metropolitan Rod and Gun Club, at the corner of Pacific and Henry Streets, in a beautiful Romanesque Revival row house in the heart of the historic Cobble Hill section of Brooklyn, has been in existence since the early 1930s (and in this building since 1940). Inside are meeting rooms, a kitchen, a six-position 55-foot rifle and pistol range in the basement, and an archery range on the second floor. Presently, it claims over 250 members.

A gun culture (at least, a non-criminal one) is probably not the first thing one thinks of when one conjures up quintessential New York City images. Yet each of the five boroughs claims at least two or three gun clubs or ranges. Not surprisingly, given its more rural/suburban setting and mindset, Staten Island, with a half dozen or more such clubs, has more of them than any of the other boroughs.

It's a wonder there are any. Aside from space being at a premium, New York City has just about the most restrictive gun laws in the country; more restrictive, in fact, than the rest of the state. Elsewhere in New York State a permit is not required for rifles and shotguns. And while licenses are required everywhere in the state for handguns, those issued

outside New York City are valid everywhere in the state except the city. Getting a handgun license in the city will take between four and six months and will cost in excess of $300. And it has to be renewed every three years! Obviously, there are guns galore in New York, despite the restrictive firearms laws; enough so that shootings are news items virtually every day of the week, and multiple times on weekends. In the 1990s, before crimes of all types dropped precipitously, there may have been as many as two million illegal guns in circulation in the city, with maybe 90 percent of them purchased in another state.

Manhattan, of course, brings its own peculiar sensibility to the gun culture, as it does to most things. *Meet Market Adventures*, a social networking/meeting club for singles, recently ran the following ad: SINGLES NIGHT AT THE FIRING RANGE: West Side Pistol Range, 20 West 20th Street. "Join Meet Market Adventures and other adventurous singles for a fun interactive night as you experience the rush of firing a .22 caliber rifle."

Only in New York.

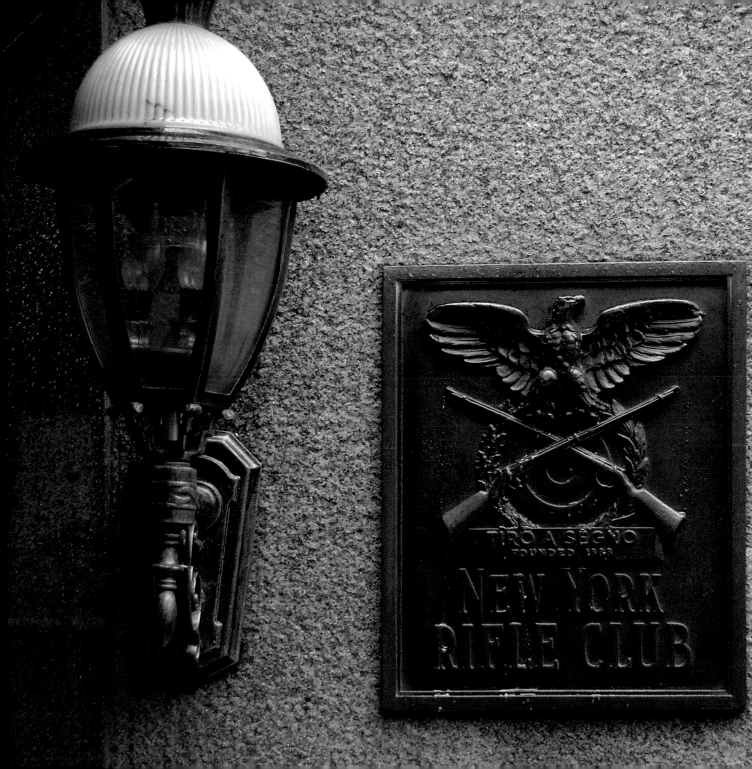

trapeze school

to be driving down the West Side of Manhattan parallel to Hudson River Park and to look over to the old Pier 40 Building, home to the Holland-America Lines when New York was still a major port city, and see trapeze fliers atop it is to see something truly surreal.

What you would be seeing is the site of Trapeze School New York. Started in 2002 (at a location also in Hudson River Park but further south, just below Canal Street), this spot at Pier 40, overlooking the Hudson, the Statue of Liberty, and Ellis Island, is the school's warm-weather (April to October) home. Its permanent, year-round indoor headquarters—inside a tent on an industrial block of West 30th Street, between 10th and 11th Avenues—is no less surprising. The canvas tent looks like it could be one of the structures used by the Sanitation Department for storing salt for winter snow and ice removal. The several, long vertical windows, and the glimpses they provide of trapeze rigging and aerialists flying by, tell you that it's not.

While to the casual observer, New York may seem an unlikely location for a school devoted to the teaching of trapeze skills (there are not exactly a lot of job opportunities for plying this skill here), for its founders, Anne and Dave Brown and Jonathan Conant, New York City was the only place they ever really considered. (Though they've

since opened branches of the school in Boston, Baltimore, and Los Angeles, and the hope is to open one in London.) "Visibility was our number one motivation," Dave Brown recounts, "but we never expected the success that we've had. It just went ballistic after the *Sex and the City* episode." (In a 2003 episode, Sarah Jessica Parker's character, Carrie Bradshaw, visits the Trapeze School.)

"What's unexpected to our students," he continues, "is not our location. What's unexpected to them is that we can teach them a knee hang and that they will be caught by a catcher by the end of their first class. They're thinking, 'You must be smoking something.' They're astonished that they can go from knowing nothing to doing a trick and being caught. Surprised by how much they can do."

"What's also unexpected," Anne Brown adds, "is that women seem to be better at flying trapeze than men. At least initially. Remember, this is not a muscle sport. It's a timing and flexibility sport. Men try to muscle their way through the first class. Women are more willing to go with the flow. Also, listening has a lot to do with it. Women are better listeners. And, too, women are more willing to do something they're not perfect at the first time. Men want to look good at it. Women can appear foolish at the beginning. Women dominate the sport. One of the few they do. Maybe it's the spandex. Guys are afraid of the spandex."

And while on the subject of gender, the demographic of classes at the Trapeze School mirrors that of the city as a whole. That is, women far outnumber men. In any ten-member class (the class size limit), there are typically eight women and two men. "It's the best ratio men will ever find anywhere," Dave offers.

As surprising as it might be to discover the Trapeze School perched on top of an old pier building, equally unexpected is the discovery of the complex of fields within the pier complex,

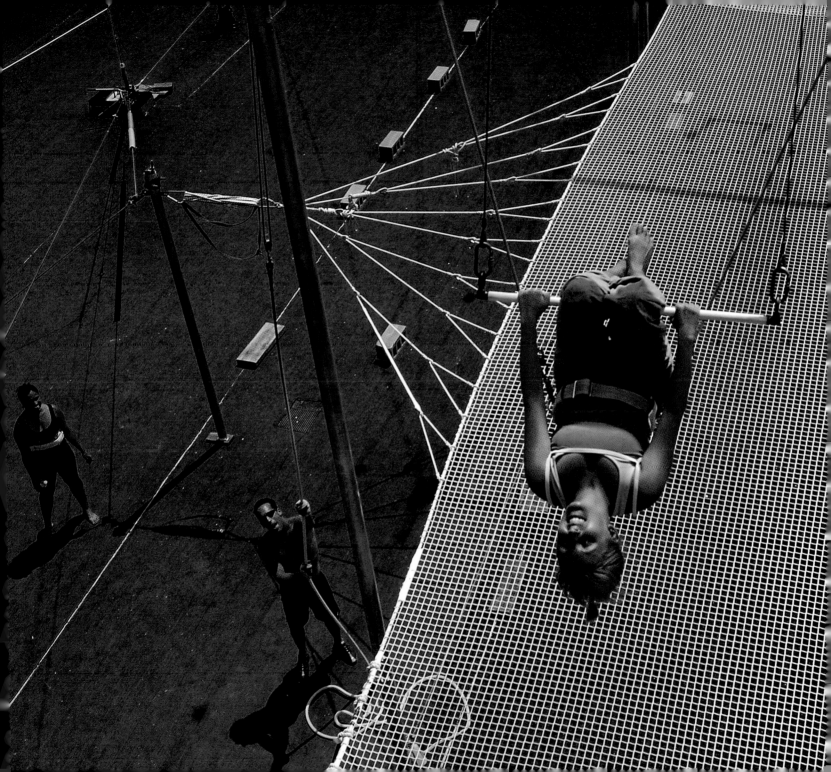

both within the courtyard and on the roof. A soccer field (somewhat smaller than regulation size) has been constructed on the roof, and two regulation-sized soccer fields have been built within the three-acre courtyard. An artificial turf area on the roof offers opportunities for sunbathing and other non-active recreations.

The fields have lights, so one can view soccer games or practices here in the late hours of the evening. Until 1 a.m.! This is, after all, the city that never sleeps.

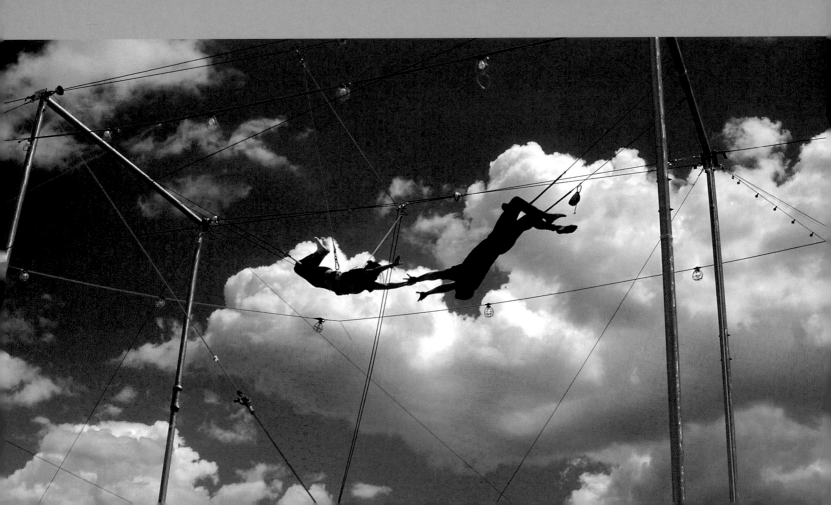

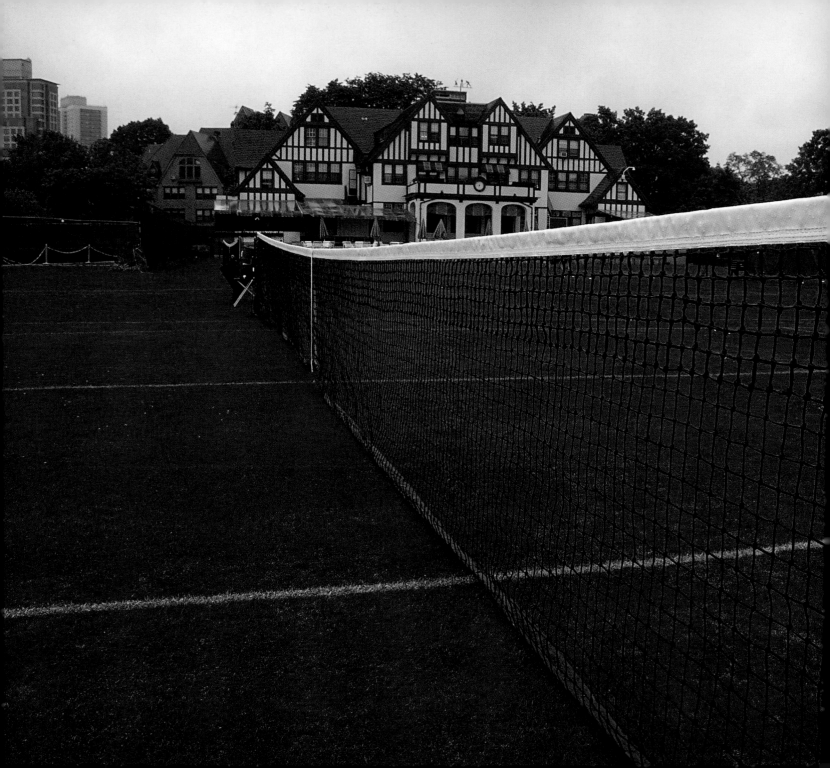

grass tennis courts

Only one percent of all tennis courts in the United States are said to be grass (and that's probably a high-ball estimate). Eight of them—the only ones in New York City—are located at the West Side Tennis Club at Forest Hills. In the words of one observer, the club is a "great old jewel out there in the middle of Queens."

The name West Side derives from its original location on the Upper West Side of Manhattan. Founded in 1892 on Central Park West, between 88th and 89th Streets, it remained there for a decade, before the property became too valuable to be maintained as tennis courts. The club moved to 117th Street and Amsterdam Avenue for six years, then relocated again, this time to Broadway and 238th Street. In 1911, when the club hosted its first Davis Cup matches, it became immediately apparent that this location was way too small to accommodate the crowds. In 1912, the 10.5 acres that is today the West Side Tennis Club at Forest Hills was purchased for a $2,000 down payment and a $75,000 mortgage. The initial grass courts were made from grass transported from the Broadway location.

In 1915 the National Men's Singles Championship, heretofore played in Newport, moved to Forest Hills (followed by the Women's Championship in 1921), and it was played there continuously for the next fifty years, and from 1969 to 1977 as the US Open. (In 1978, when the Tennis Center

at Flushing Meadows was completed, the US Open moved there, where it remains.) At the last US Open held on clay courts at Forest Hills in 1977, Guillermo Vilas of Argentina beat Jimmy Connors of the United States in four sets for the men's title, and in the women's final, the American, Chris Evert, beat Wendy Turnbull of Australia in straight sets.

Today Forest Hills operates as a private membership tennis club (with 38 courts that include all four surfaces—hard, har-tru, red clay, and grass) while hosting the occasional lower-level professional event.

Given the fact that the first grass court ever set up in the United States was at the Staten Island Cricket and Baseball Club (lawn tennis was introduced in this country in 1874 by Mary Outerbridge, a Staten Island resident, who had seen the game being played by British Army officers in Bermuda), it might not seem that big of a stretch to fathom grass courts in Queens as well. In the decades immediately following Outerbridge's introduction of lawn tennis to America, grass courts were ubiquitous. After all, the United States Tennis Association was originally called the United States *Lawn* Tennis Association. Nowadays grass courts are about as common as wooden rackets or white tennis balls.

Until 1974, three of the four tennis Grand Slam tournaments were played on grass. The only exception was the French Open, played, then as now, on clay. Now only Wimbledon is played on grass, the US Open and the Australian Open having changed from grass to hard court. The passing of grass courts in the United States and elsewhere (there apparently are no grass courts in all of Spain) can be attributed to several things. One factor certainly has been the advancement in tennis racket technology and the advent of high-tech, oversized, composite rackets that generate great power, compared to the smaller, less lively wooden rackets of yore. With these new-age rackets comes a different style of play. Essentially it is a baseline game

characterized by longer, harder-hitting rallies from or behind the end line; a game that is more suited to slower courts than the serve-and-volley game most effective on grass, the fastest of all tennis surfaces.

The ball on grass stays low, and it moves fast. Bounces are unpredictable, if indeed the ball bounces at all. Speaking to this tendency of the ball to stay low on grass, a tennis commentator observed, "It just lies there like an obedient dog." Given this unpredictability, the strategy on grass, therefore, is to let the ball hit the court as little as possible, and hence the volley part of the serve-and-volley game (a volley is when one hits the ball, typically right at the net, in the air before it bounces).

The other, perhaps bigger reason for the demise of grass tennis courts, has been the increased popularity of tennis. Formerly a country club sport, tennis has been embraced by the masses, and although grass courts are the easiest and cheapest courts to install, they're the hardest to maintain. They simply cannot withstand use by the hordes who now play the game.

The few grass courts that remain today are predictably located at hoity-doity private clubs—places often going back a century or more that began as cricket, croquet, or polo clubs—in wealthy, and, yes, WASPy neighborhoods; places where Lacoste and L.L. Bean clothing are *de rigueur*: Newport (Rhode Island), Merion and Germantown (Pennsylvania), Chestnut Hill (Massachusetts), Fisher Island (Florida), or Rancho Mirage (California). The West Side Tennis Club is a private club but no more exclusive than your basic Manhattan gym, and while Forest Hills was created as a private community of Tudor architecture, today it is just your typical middle-class, ethnically mixed New York neighborhood of American-born Jews, Russian Jews, Israelis, Asians, and South Asians.

That Queens, New York, is counted among these rare and rarefied grass court venues is a testament to a certain kind of tenacity. Grass courts are high maintenance, even without the issue of wear and tear. They require rolling and mowing, sometimes several times a week, fertilizing, "fungiciding," and, of course, watering, and watering, and more watering. And, then, when it rains, it takes forever and a day to dry. Plus, every time the court is mowed, new lines have to be laid out.

Imagine their being used as public courts! Fortitude and a sense of preserving history can only account for the keepers of those grass courts that survive and are maintained. And hats off in particular to Forest Hills, for like so many things that are harder to do in New York City than anywhere else, so too maintaining grass courts. Unlike those grass courts in more idyllic settings—and particularly those in warmer climes—the courts in Queens get murdered by the cold weather and by the city's pollution. The former longtime groundskeeper at Forest Hills once said, "The soot and oil that comes out of there"—he pointed to the nearby high-rise apartment buildings—"is very damaging to the grass."

Is there a more unlikely setting than Queens, New York, anywhere in the United States? Perhaps only one. And that would have to be Baker City, Oregon, a high desert town of about 10,000 people in the eastern part of the state, two hours drive from the nearest big city, where the summers are hot and arid and the winters wet and cold. Nonetheless, since 1996, four beautiful grass courts sit—somewhat forlornly and certainly surprisingly—in the otherwise sparsely populated, moon-like landscape.

Unlike those at Forest Hills, these grass courts suffer neither from heavy use nor urban pollution.

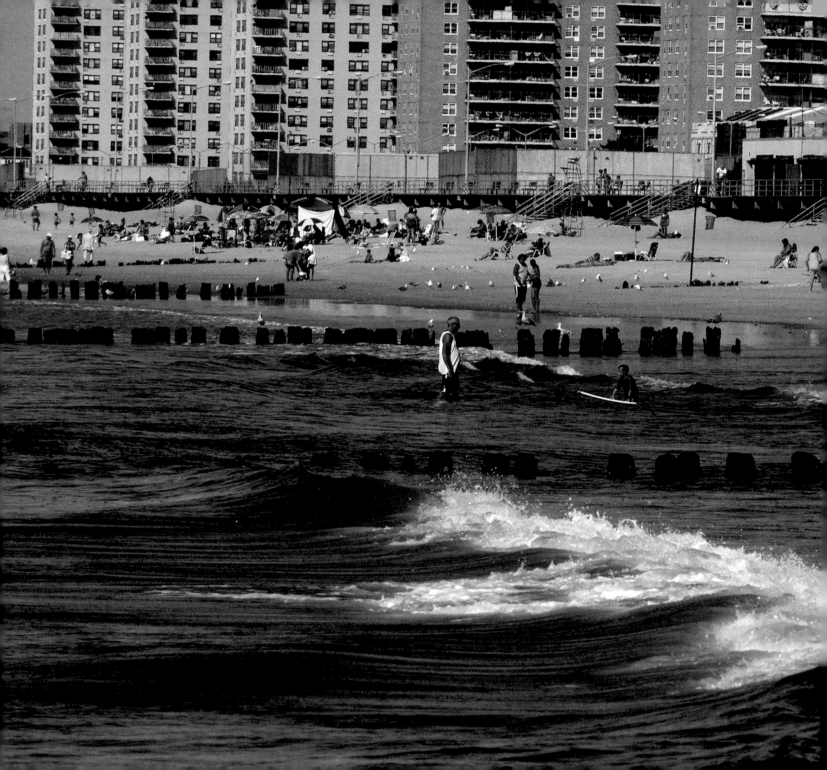

surfboarding

Spot someone carrying a surfboard on the A Train, and it's a good bet they're coming to or from the Rockaways, where New York City's lone surfing-only beach is located. Actually, two of the Rockaway beaches are now designated for surfing only: Beach 90th Street (really 87–92 Street), the city's first surf beach, designated as such in 2005, and Beach 67th Street (67–69 Street), the second surf beach, established in 2007 due to overflow demand. New York is likely the only place in the world where surfing is accessible by subway!

Of the city's 14 miles of beaches, just over half of them are in the Rockaways. (Of the city's roughly 1,000 lifeguards who work at its 7 beaches and 52 pools each summer, over half are employed on the Rockaway beaches.) And of all the beaches in New York City, only Rockaway Beach has what would be considered sizable waves. For that reason, the Rockaways, and specifically the area around Beach 90th Street, is where surfers have congregated for decades. In fact, legend—or, perhaps, more appropriately, rumor—has it that the great Hawaiian surfer, Duke Kahanamoku, came to the Rockaways in 1912 to give a surfing demonstration. Others maintain he came here only to swim, and did that not around what is now the surfing beach, but much further east, in Far Rockaway.

87

Be that as it may, surfers have ridden the waves here for fifty or more years, though not in great numbers until recently. Before 2005, surfers were often cited for being in violation of New York City's Health Code provisions that made "bathing" when lifeguards were not on duty a summonable offense. Paving the way for the designation of a surfing beach, the city first legalized surfing by amending the archaic Health Code provision, which was said to have dated from the 1850s, by exempting "surfing" from the definition of "bathing." Now, on a hot summer day, when the surf's up, 200 to 300 surfers might be in the waters of Beach 90th Street, with additional surfers at Beach 67th Street as well. The best waves are said to be around the rock jetty (on the left looking out to the water), which not only is the most dangerous area, but the most crowded as well.

Surfing is permitted year round—many say the best surfing is after November—and, in fact, wetsuit clad surfers can be observed even on the coldest winter days. Surf reports are available at www.surfline.com, which even includes a real-time webcast of the surf at Beach 90th Street.

Rockaway will never be confused with Southern California, Hawaii, Australia, or other world-class surfing destinations, though its proponents claim its waves break every bit as well as those in New Jersey or the Hamptons. Nonetheless, there is an identifiable year-round surfer presence here, albeit dark-haired rather than blond, and the neighborhood immediately around Beach 90th Street does have the feel of a laid-back beach community, though likely grittier than most. A 2009 article in *the New York Times* cited a post on a surfing website that said of Rockaway, "By far the ugliest place I've ever surfed [imagine East Berlin circa '79]. All this place is missing are the guard towers and rolls of razor wire in the sand." Two surf shops, where boards can be rented and also stored, contribute to a beach town ambiance. Massive public housing projects that loom nearby contribute to a contradictory "un-beach" town atmosphere.

Since 2005 the Annual Richie Allen Surf Classic has been held in early September in the area of Beach 90th Street. The event honors the former Rockaway resident, lifeguard, and surfer who became a fireman and was killed in the World Trade Center on 9/11. A part of the boardwalk at Beach 91st Street is named in his memory, though the original plan was to name it after the aforementioned Duke Kahanamoku, who never did live here, or anywhere near here for that matter, but who did one day nearly a hundred years ago allegedly pass through, with or without his wooden surfboard. Pressure from Richie Allen's family and friends overrode those rooting for the Duke, who likely has many streets named after him elsewhere.

In Hawaii, for instance?

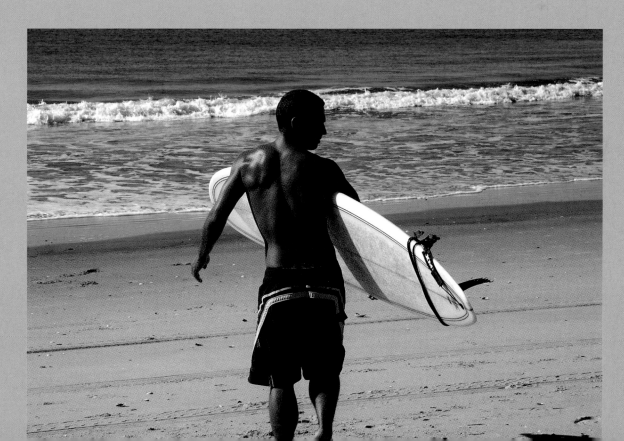

biking

What looks like something that should be in Amsterdam or some other bike-centric city—Paris, or Copenhagen, or Beijing, or even Portland, Oregon—is actually the bike storage room off the lobby of an East Village high-rise. With its literally scores of bikes (it can accommodate 104 bikes on four two-level structures), from tricycles to high performance custom-mades, this room hints at the nascent cycling culture here.

Theoretically New York City should be the ideal place for bike riding—compact, flat, and paved throughout—but, of course, it isn't. The city has a way of laying waste to most theories, and cycling its thoroughfares is no exception. To the usual New York City obstacles of sheer numbers and sheer density, add that of sheer attitude.

Cyclists—okay, bike messengers at any rate—say pedestrians be damned. Pedestrians say to cyclists, you get what you deserve. Cyclists say to cabs, watch where and when you open your goddamned doors. Cabbies say to cyclists, stay in the damn bike lanes. Cyclists say to double-parked trucks, move the f— out of the bike lanes. Truckers tell cyclists to go to hell. Throw in buses, delivery vans, limos, pushcarts, mobile food vendors, strollers, dog walkers, and jaywalkers and you begin to see the problem. And, of course, this doesn't even begin to encompass such additional hindrances such as the condition of city streets (potholes galore), transporting bikes on public transportation (not permitted on buses and permitted on subways but difficult to accomplish, particularly around rush hour), or theft.

The obstacles are seemingly insurmountable, yet those stalwart New Yorkers (the upside of having attitude) intent on cycling around the city have not only kept up the fight for more bike lanes, more respect, and more participants, they have actually won many victories and have in

recent years even accelerated the process toward making the city much more bike-friendly.

Transportation Alternatives, a bicycle advocacy group, estimates that on any given day, as many as 130,000 New Yorkers ride their bikes. (They estimated only 90,000 a day in 1998.) In terms of the number of cyclists who use their bikes to commute to work, the NYC Department of Transportation estimated that their numbers increased 35 percent in just one year, between 2007 and 2008, and 45 percent overall since 2006. Still, it's only about 1 percent of the city's population that commutes to work by bike, compared to, say, in Portland, Oregon, where that number is estimated to be about 6 percent, or compared to Beijing or Copenhagen where the percentage of commuters is more than 30 percent of the population.

This increase in bicycle use in New York City in general, and commuting in particular, is largely due to the city's major commitment to increase its number of bike lanes. Since 2006, the city has added 200 miles of bike lanes (a number equal to the total number of miles added in the previous 20 years!) to the already existing 220 miles, bringing the total miles of bike lanes here to 420. The announced goal is to have 1,800 bike-lane miles by year 2030. (There are, by comparison, over 6,000 miles of streets throughout the city's five boroughs.) On top of this, the city has created three miles of off-road bike trails in Highbridge Park in Upper Manhattan (including a dirt jump area) as well as trails in Cunningham Park in Queens and Wolfe's Pond Park in Staten Island.

Also, as of the end of 2009, there were over 6,000 bike racks installed around the city, including the newly designed, award-winning one that looks like a circle bisected by a line (it looks a lot like the "don't smoke," "don't turn," "don't whatever" signs that have become ubiquitous). And although to many this accelerated pace of adding bike lanes, bike paths, bike racks (bike shelters too) might seem late in coming, one should not forget the fact that the bike path that runs the

length of Ocean Parkway in Brooklyn—from Flatbush all the way out to the ocean—was the first bike path ever built in the United States. In the 1890s!

For a time, it appeared that New York City might even try to import the successful bike-sharing system that operates in Paris, where there are over 20,000 bicycles spaced throughout the city available for spontaneous pick-up and drop-off. The mayor and other city officials visited Paris to check out the program, but what works in Paris or elsewhere—Washington, DC, has a bike-sharing program, albeit with only about a hundred bikes, as does Tulsa, with even fewer—does not necessarily work here. (The city did try a scaled down bike-sharing plan in a small area of Manhattan for a few weeks in the summer of 2009.) The fact that New York City is *sui generis*—that it cannot, or will not, easily take or copy things from other places—is both the city's strength (certain kinds of intolerances—racial, ethnic, gender, cultural, or otherwise—that might be tolerated in other cities probably won't be in New York) and its weakness (well, like a bike-sharing program).

New York has a long way to go before it rivals Amsterdam or Paris, but the recent uptick in bike use and the city's receptivity to it has been unmistakable. The League of American Bicyclists has recognized New York City as a "Bicycle Friendly Community," the only east coast big city to be so named. And *Bicycling* magazine did name it "one of the most improved cities for cycling in the nation."

Now, of course, added to all the previous obstacles cyclists once faced—motor vehicles and pedestrians chief among them—is the problem of navigating with and against the thousands of new cyclists spawned by the new bike-friendlier culture.

In other words, be careful what you wish for.

KISSENA
PARK
VELODROME

velodrome

The Kissena Velodrome is a 400-meter, banked, oval asphalt track used for fixed-gear bicycle racing. That New York City is home to one of the few velodromes in the entire country will probably surprise most people, including most New Yorkers. (The United States, by the way, has at most 20 velodromes, while Europe has about 400—more than 120 in France alone.) Even more surprising is the fact that cycling was once the most popular and highest paying professional sport in this country, and New York City was at its vortex.

The heyday of cycling was from the 1890s to the 1920s. By the turn of the century, more than 300 factories churned out over a million bicycles a year. Bicycle racing was a major professional sport then, fueled partly by great interest in the six-day race, which began in England and eventually made its way to the United States. This race, which takes place in a velodrome, had a racer riding for six days, 24 hours a day, in an attempt to ride the most number of miles (the original seven-day races were reduced to six to preserve Sunday as the day of rest).

The first six-day race in America was held in 1891 at Madison Square Garden. (The original Garden, built in 1879, was actually constructed for the purpose of housing a velodrome.) The winner of that first race, rode just over 1,466 miles in six days. In 1896, Marshall Taylor, the first great African-American cyclist, won the six-day race at Madison Square Garden before 15,000 fans. Appearance money for the top riders was as high as $1,000 a day, and this was on top of their split of the total purse, which could be as much as $50,000!

These six-day races proved to be more than just grueling. Reminiscent of the dance marathons of the time, as portrayed in the movie *They Shoot Horses, Don't They?*, the six-days

were outright dangerous, taking extraordinary tolls on racers' bodies (spectacular and bloody spills) and minds (exhaustion and hallucinations).

Not surprisingly, therefore, in 1898, concluding that these races were "inhuman spectacles," New York passed the Collins Law, which prohibited any rider from riding more than twelve hours a day. But, ingeniously, the promoters at Madison Square Garden got around this law by introducing two-man teams to the six-day event. One team member rode—for two-hour stints—while the other rested, and in this way, the races were able to go on for 24 hours each day without any one racer riding more than the allowable twelve hours. For originating this event, Madison Square Garden was immortalized when the race came to be called the "Madison." The winner of the last one-man six-day race staged at Madison Square Garden in 1898 logged 2,007 miles. By comparison, the world record for the two-man six-day, set in 1924, the last year that racers rode 24 hours a day, was 2,824 miles.

The last six-day race of any kind held at Madison Square Garden (and in the United States) was in 1961, the popularity of cycle racing having by then waned from its heights in the 1920s. The advent of the automobile and the arrival of the Great Depression together had placed a huge damper on the craze. But the six-day race and the "Madison" (referred to by the French as *l'americaine*) continues in Europe to this day, but racers ride for only four or five hours an evening, and winners are determined under some byzantine scoring system based on points for every twenty laps completed.

Perhaps, because of New York City's rich racing legacy, it is not so anomalous that of the handful of America's velodromes, one be located here. (Other, more likely venues—places that are more obvious population centers for rugged, outdoorsy types—include such places as Colorado Springs, CO; Trexlertown, PA; Portland, OR; San Diego and Carson, CA; Blaine,

MN; Frisco, TX; and Kenosha, WI, which, at over fifty years old, is America's oldest velodrome.)

Robert Moses built the Kissena Velodrome in 1963, and its dedication in 1964 coincided with the opening of the World's Fair in Flushing Meadows. That year the Kissena Velodrome was the site for the 1964 Olympic cycling time trials, and significantly, five of the eight qualifiers for that year's team rode for the Kissena Cycling Club, for whom the Kissena Velodrome, then and now, is home.

Although the Kissena Velodrome has been eclipsed as a primary training ground for turning out cycling champions (Colorado Springs, Carson, and Trexlertown are considered the *crème de la crème* of velodromes and training centers for America's elite cyclists), it still manages to nurture a champion or two: Nelson Vails, of Harlem, an Olympic cyclist; George Hincapie, from Queens, another Olympian and an eleven-time veteran of the Tour de France; and Kirk Whiteman, of Brooklyn, a national track bike champion and one of five African-Americans to ever hold that title.

The Kissena Velodrome was once referred to on the track bike racing circuit as the "Big Bumpy," an affectionate but not so flattering reference to the cracks, holes, and bumps that came to characterize its track's surface. In 2002, though, it shut down for two years to undergo a half-million dollar resurfacing and renovation. This was at a time when New York City was bidding to get the 2012 Olympics, and one has to assume that part of the strategy was to show the International Olympic Committee that this was a city that took its sports—and its sports facilities—seriously. Well, New York didn't get the Olympics, but the Kissena Velodrome got a new asphalt pavement coated with an acrylic sealer, new landscaping, bleachers, a fence, regulation racing lines, and improved drainage.

Races are held there continually from April to October. Every Wednesday night during the summer sees races for men, women, and kids. In addition, the Kissena Cycling Club sponsors road races at Floyd Bennett Field and in Prospect Park, both in Brooklyn.

Despite cycling's center having moved from New York—mostly to points south and west—many still argue that New York City is the ideal place to train: miles and miles of flat terrain; miles of loops and hills in both Central Park and Prospect Park, where roads are closed to vehicle traffic; the ability to bike to and from work, and, of course, if one gets really serious about it, the prospect of a day job as a bike messenger, combining work and play.

In fact, bike messengers have in large numbers adopted the fixed-gear, no-brake track bike as both the most challenging—and therefore hippest—way to cycle around the city. It is a badge of honor to be able to whip around the streets of the city, dodging both vehicles and pedestrians, on a no-brake track bike. Rather than "Look Ma, no hands," it's "Look Ma, no brakes." (One slows down, or stops, by reversing the pedals or by sliding.) Bike messengers even once formed their own top competitive track racing team, Team Puma.

Although the website America's Best & Top Ten, does not include the Kissena Velodrome among the top ten in the country, it does get honorable mention, and that ain't bad.

And, finally, the Kissena Velodrome, smack in the middle of the city and close to where cyclists either live or are staying, holds the claim to fame that it, alone among all velodromes in this country, is the only one to which racers actually ride their bikes.

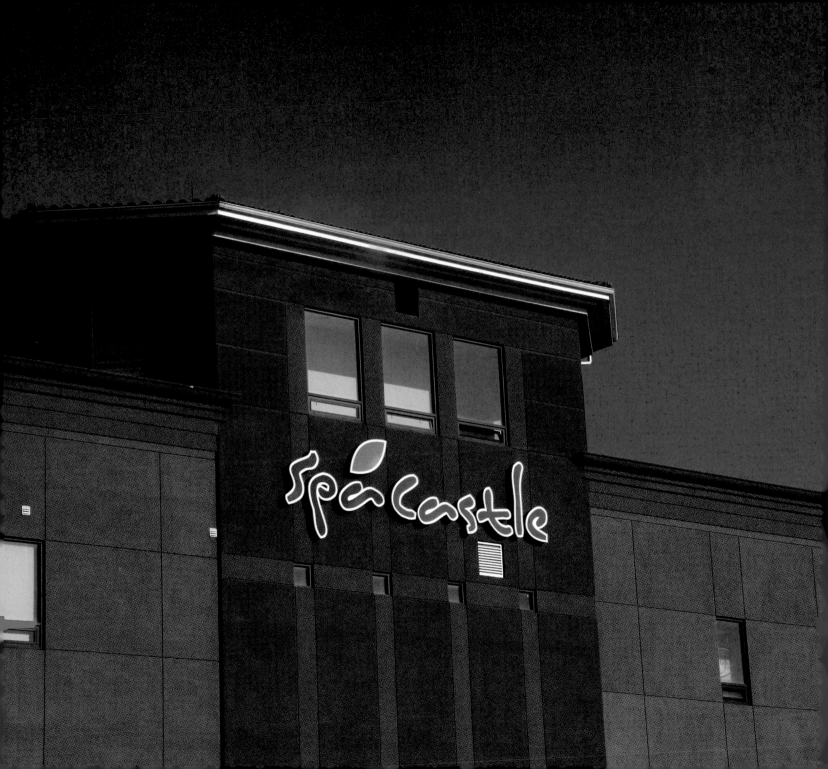

korean bathhouse

Spa Castle, "a perfect combination of traditional Asian saunas and luxurious European spas," according to its website, is modeled on the Korean *jjimjilbang* (a word that gives "spellcheck" palpitations, but, my god, think of its value as a triple word score in Scrabble!). *Jjimjilbangs*, 24-hour public bathhouses, are found throughout Korea, where there are said to be in excess of 13,000 of them, including more than 2,500 in Seoul alone.

Although just a handful of these family-friendly spas exist in the United States, it makes sense that one of them—perhaps the largest—be located in Queens, given its large Korean-American residential population. Queens, the most ethnically diverse of the city's five boroughs, has a population that is nearly half foreign-born, and it is where some 140 different languages are spoken. About 70 percent (more than 45,000 people) of New York City's Korean-American population resides in Queens, and as a whole, the Korean-American community in the city is second

in number only to that of Los Angeles. (Koreans comprise the city's third largest Asian population, after Chinese and Indians. Next most populous after Koreans? Filipinos.)

What doesn't make sense is that this Korean-oriented establishment, opened in 2007, be located in College Point. True, Flushing, with the borough's largest residential Korean population, borders College Point, just to the south, but College Point itself is a working-class neighborhood of low buildings whose ethnic past was mostly German, Italian, and Irish. A beer garden, rather than a Korean spa, would have been more in keeping with the neighborhood's history and sensibility.

Two of College Point's most pressing contemporary concerns are traffic and parking, so it was not surprising that the announcement of the planned construction of this three-story, 60,000-square-foot spa on a residential block was met with public resistance, though, ultimately to no avail. Apparently the size of the building lot and its being zoned for light manufacturing (which allows for other commercial uses), made it an irresistible site for its Korean developers/owners, who tried to assuage community concerns by pointing to the planned on-site parking garage (though the garage fits only 106 cars and Spa Castle can accommodate over a thousand patrons at a time).

With multiple heated indoor mineral pools; a cold bath pool; outdoor bade pools (warm bath pools with aqua-jets); "themed" sauna rooms constructed of different materials such as gold (96 percent pure!), salt (mined in the Himalayas), jade, sienna, infrared rays, etc.; relaxation rooms with personal television sets; a fitness center; exfoliation/scrubbing and massage services; a sushi bar, salad bar, and a "sky" restaurant offering authentic Korean fare, Spa Castle is way more than an ordinary spa.

Which, one guesses, is part of its allure, at least for those who come out of curiosity and, of course, to those repeat customers who return time and time again. Not so for its residential neighbors, nor the dog walkers and other users of the quiet city park directly across the street.

If anyone is to blame for allowing this large-scale, over-the-top establishment, which would look more at home off the Strip in Las Vegas than here in an otherwise quiet neighborhood of private homes and apartments, blame the city's Board of Standards and Appeals, the ultimate decision-making power to allow or disallow the use of the property for the purposes of a spa.

Alternatively... well, just calm down. Take a nice hot mineral bath, a sauna, maybe a body scrub and then a massage, a pedicure and facial, watch some TV, have some sushi, take another hot dip, then a cold dip, and, then, maybe have some nice Korean food.

Relax! We know just the place.

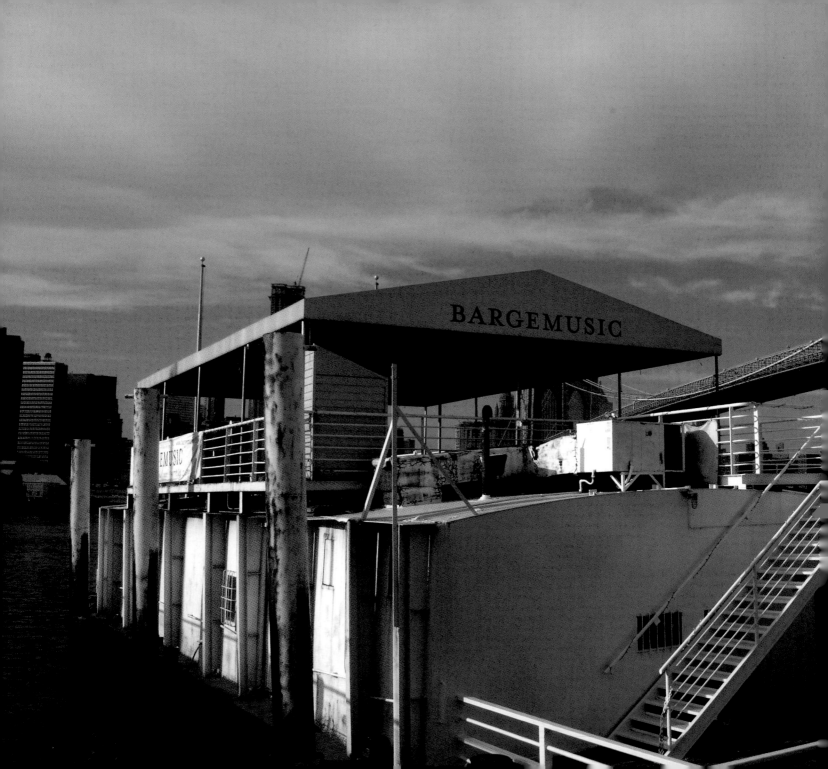

bargemusic

In a city with more world-class classical music venues than one could count on six hands—Carnegie Hall, the Metropolitan Opera, Alice Tully Hall, Avery Fisher Hall, Merkin Hall, the Brooklyn Academy of Music, and Town Hall among them—a chamber music venue on a 102-foot, 100-plus-year-old converted coffee barge might seem a mere postscript, a minor league player. It is not. Rather, Bargemusic, which has been offering chamber music concerts since 1977, is by the standards of almost any serious chamber music person—performer or listener—one of the city's most outstanding venues.

The *New Yorker* music critic Alex Ross has said of Bargemusic, "If there is a chamber music space in New York more enthralling than Bargemusic, I do not know it. Docked just to the south of the Brooklyn Bridge on the Brooklyn side, this floating concert hall has a certain unquantifiable magic; the room is small and the acoustics warm, with the audience right in the thick of the sound. Yachts silently glide past the windows, and the skyscrapers at the south end of Manhattan seem to sway gently as the barge rocks back and forth."

Olga Bloom, the 91-year-old founder and guiding force behind Bargemusic (and a violinist herself, who debuted at

Carnegie Hall in 1960, playing pieces by Haydn, Brahms, Bartók, and Bach), originally intended her barge to be a place for student musicians to perform, but that idea was scrapped in favor of serving as a performance space for highly accomplished professional musicians. Over the years, the likes of such renowned musicians as Peter Serkin, Fred Sherry, Richard Stolztman, Ida Kavafian, and Peter Schickele, have performed there. With four performances (Thursday through Sunday), every week of the year, Bloom is able to say without an ounce of hyperbole, "We give more concerts than any other concert hall in the world."

Also, without exaggeration, one could say Bargemusic is not only the city's only floating classical music venue, but perhaps the world's as well, although there is some historical precedent for chamber music being performed on a barge. In 1717, fifty musicians aboard a moving barge on the Thames played—appropriately enough—Handel's *Water Music,* which had been commissioned by King George I, and for whom it was performed. The musicians played on one barge as it followed the royal barge on which the King and party traveled. George apparently had the musicians play the piece three times, but basically, the floating music barge was a one shot deal. Bargemusic, on the other hand, has been presenting chamber music every week for over thirty years.

More improbable than the venue itself are the excellent acoustics that Bargemusic offers. After all, the starting point was not particularly promising: a steel boat, a narrow space, and a low, 10-foot ceiling. And yet, critic after critic over the years has commented on just how good the acoustics are. The cherry wood paneling taken off an old Staten Island ferry and painstakingly applied within the interior helps, but mostly one has to believe that the space has been blessed by the music gods. And these gods are fickle ones at best. Take the example of Alice Tully Hall, the major chamber music venue at Lincoln Center.

From its inception in 1969, critics have characterized Alice Tully's sound as arid. Only after a multi-million dollar, two-year-long renovation that began in 2007 did the hall achieve better acoustical results. Part of that enhancement entailed the elimination of what is referred to as "unwanted visual noise," which the acoustic design firm that worked on the Alice Tully renovation defined as "distracting elements like acoustic panels and hardware, railings, exposed equipment, exposed light fixtures, and so forth." In the case of Alice Tully Hall, the visual noise was eliminated or muted by, among other things, covering the unwanted visual elements with a thin veneer of African moabi wood.

Of course, the issue of "visual noise" raises the question of how the stunning views one observes through the windows behind the musicians at Bargemusic affects one's listening. As magical as the cityscape and river traffic are—not to mention the changing night sky as it goes from dusk to darkness—is it a distraction?

Once again, the music critic Alex Ross weighs in. "The spectacular view of the lower-Manhattan skyline and the rocking motion of the barge ought to be distractions, but somehow one listens all the more closely in these disorienting surroundings. Music suddenly seems precarious, rather than placid; musicians are dramatic figures in a landscape, rather than robots going through the usual motions. It also helps that the space is so intimate, the musicians so close. Many so-called chamber venues in Manhattan are essentially too big for the music."

No matter what improvements are made to the acoustics at Alice Tully Hall (or any of the city's other large music halls), it will always remain a large hall—with a capacity of about 1,000—which is antithetical to the original notion of chamber music, which is to be performed in intimate spaces—i.e., in chambers. Rooms. Bargemusic, with a capacity of only 130, puts the chamber back in chamber music.

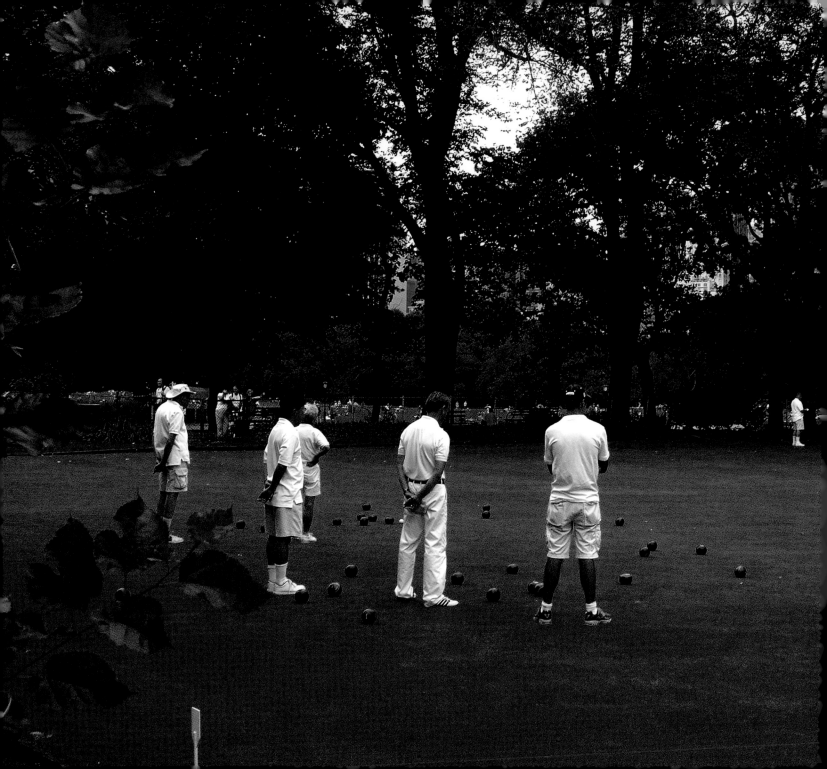

lawn bowling

Characterized by civility and gentility and played oh so quietly on swaths of green by players wearing white, lawn bowling can hardly be called the quintessential New York City game. Yet, 15,000 square feet of Central Park—just north of the Sheep Meadow near West 69th Street—is devoted to it, and since 1926 has been the home of the New York Lawn Bowling Club.

In fact, lawn bowling was first played here over 350 years ago, way before basketball, "the City Game," was ever given a thought. The Dutch are said to have played a version of the game in the early 1660s on a market square in Lower Manhattan, and the British, who popularized the sport, built the first lawn bowling green nearby, where the US Customs House now stands, in 1664. In 1733, the British designated a park in that neighborhood as an official site for lawn bowling. That park? Bowling Green!! Duh! Which, incidentally, was not only the city's first public park, but also the first public park in North America.

Bowling Green Park still stands, but no longer as a venue for lawn bowling. The "bowl" has been replaced by "bull"—*Charging Bull*, the statue that stands in Bowling Green Park in front of the New York Stock Exchange, signifying, maybe, the bull markets that will flourish. And lawn bowling has moved uptown.

Before the Revolutionary War, lawn bowling was the most popular sport in America, but apparently went into a period of decline during and after the war (not surprisingly, given the rampant anti-British sentiment). It became popular again at the end of the 19th, beginning of the 20th, century. In 1926, when the bowling green in Central Park was created, there were eight lawn bowling clubs in and around the city, forming the Metropolitan District Lawn Bowling Association. (Another 15,000-square-foot lawn was established in Central Park in 1934 next to the existing one, but since the 1970s, it has been devoted to croquet rather than lawn bowling. But more about that later.)

The other major lawn bowling venue in New York City was in Brooklyn. The Brooklyn Lawn Bowling Club, located in a corner of the Parade Grounds in Prospect Park, actually predated Central Park's bowling greens and club, and is said to have been the oldest lawn bowling club in America. But, alas, no longer. By the 1970s, its membership had dwindled to a handful, its clubhouse graffiti-covered by neighborhood vandals, and its manicured lawn burned. Truly! In 1973, someone burned a bag of garbage in the middle of the green, destroying a good patch of the grass in the act. By the 1980s, the Brooklyn Lawn Bowling Club was no more; its 1933 clubhouse now the home of the Prospect Park Youth Resource Center.

As a matter of interest, it should be noted that the oldest lawn bowling club in the world today is the one in Southampton, England, established in 1299 and still active. And too, Glasgow, Scotland presently has 200 public bowling greens, which is probably far more than we have in the entire United States.

In any case, Central Park's New York Lawn Bowling Club seems to be going strong. Its membership hovers between 80 and 90—the age range is from the 20s to 80s and is evenly split between males and females—which apparently is a robust enough number, although the number

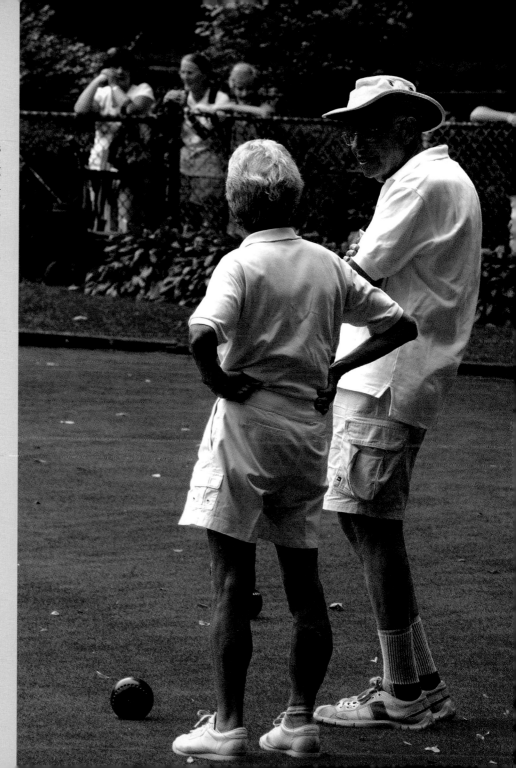

of interested spectators it attracts is uniformly large. Walking through the Park and coming upon a game in progress, it's nearly impossible not to stop and watch, so compelling a sight it is in its unexpectedness.

The game itself looks arcane, though upon closer observation it reveals its similarity to bocce, *Boules*, *Petanque*, shuffleboard, or any number of other games whose basic objective is to get a ball, disk, or other object closest to a target, fixed or otherwise. Lawn bowling is played on a strip called a *rink*, which is 120 feet long by 15 feet wide. (The bowling green can accommodate eight rinks, and multiple games are played simultaneously.) The object of the game is to roll a ball (called the *bowl*) close to a small

white ball (the jack). The catch is that the bowl, which weighs about three pounds, is not round but rather asymmetrical and therefore curves as it is rolled (there is something like six feet of curve for every 100 feet of distance). Teams of one, two, three, or four players compete, alternating turns just as one does in, say, shuffleboard.

Watching the nature of play, with its slowness of pace, gentleness of tenor, and close attention to the rules of etiquette (there is, for example, no trash talking), it is hard to imagine that lawn bowling was banned in England—at least for commoners—for three centuries! Various kings, from the 14th century through the 16th continued the ban, believing it was a diversion from more serious tasks at hand. Not kidding. Time spent lawn bowling was time not spent plying one's trade.

Watching the super well-behaved lawn bowlers in Central Park, it is hard to imagine them neglecting their jobs, family, or anything else in pursuit of the game. In short, they do not seem a particularly profligate or dissolute bunch. *Au contraire*.

In 1972, the second of the lawn bowling greens—the one established in 1934—was given over to the game of croquet. The New York Croquet Club, established in 1967, had built a croquet course in the Ramble within Central Park (mid-park between 73rd and 79th Streets), but fell victim to a dispute over the fence that surrounded the facility. The Parks Commissioner required a fence if the course were to be located in the Ramble, but reacted negatively to the chain-link fence that was first erected. That chain-link fence was replaced by a wooden one, but it too was rejected as too heavy looking, giving the place the appearance of a stockade. At that point, the Croquet Club petitioned for, and was granted, the second bowling green.

It seems the New York Lawn Bowling Club has never gotten over this expropriation of one half their territory for the home of the New York Croquet Club; according to an article in the

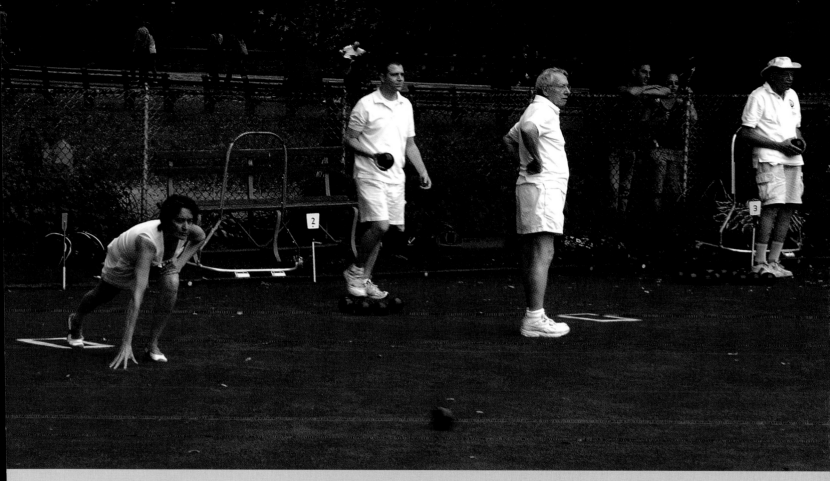

New York Times about the two clubs, there is no love lost between them. They coexist, and one supposes peacefully enough (everyone, after all, looks pretty benign in their whites), but there is not a lot of fraternizing between the respective club members, despite the fact that they are practically in each other's yard, playing on adjoining greens.

The lawn bowlers refer to the croquet players as "Crokes," which at least sounds derogatory, if in fact it isn't. What the croquet players call the lawn bowlers is anyone's guess. "The Bowls?"

home

japanese house

japanese House, as it is called, modeled on a Japanese pagoda, is not what one expects to find in the middle of Flatbush. But in the context of other homes in this area of Brooklyn called Prospect Park South, Japanese House is no more out of place than many of its immediate neighbors. They include Colonial Revival, Classical Revival, French Revival, English Tudor, Queen Anne, Spanish Mission, and a Swiss chalet, to name just some of the myriad styles that look more indigenous to, say, Palo Alto than Brooklyn.

The Japanese house (at 131 Buckingham Road) and the other stately, albeit sometimes over the top, homes clustered on Buckingham, Argyle, Albemarle, and Rugby roads just south of Church Avenue were built at the turn of the 20th century and given these British-sounding names to elevate their status by Dean Alvord, a developer who purchased 50 acres of land to create a community that would "illustrate how much rural beauty can be incorporated within the rectangular limits of the conventional city block." Or, in other words, "to create the country in the city." Intended for "people of culture with means equal to some of the luxuries as well as the necessities of life," he modeled this development on ones he had seen in Bronxville and St. Louis. In that intent, at least, he seems to have hit the bull's-eye.

Japanese House reflects the Japanese style both inside and out. Japanese decorative art graces the fireplace and dragon motifs are incorporated into the stained glass windows. Outside was a Japanese garden. Alvord boasted at the time that the house was "a faithful reflection of the dainty Japanese art from which America is learning so much." Although completed in 1903 and offered for sale for $26,500, it was not sold until 1906, and then, apparently, only at a loss.

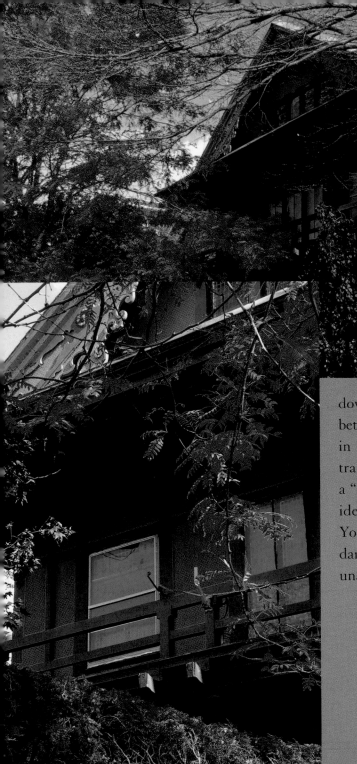

A couple of blocks from Japanese House, at 101 Rugby Road, is the Queen Anne house that was used as the setting for "the pink house" in the movie *Sophie's Choice*. A few blocks away at 114 East 118th Street are the scaled-down remnants of the Knickerbocker Field Club, tucked in between buildings and totally not visible from the street. Built in 1893 as an exclusive private club—reachable by passenger train—it was once the domain of the rich and famous, and as a "city country club," it was the perfect example of Alvord's ideal of Greenwich, Connecticut come to Brooklyn, New York. The original clapboard clubhouse was severely damaged by fire in 1988, and the financially strapped club was unable to rebuild it. Instead, it was demolished.

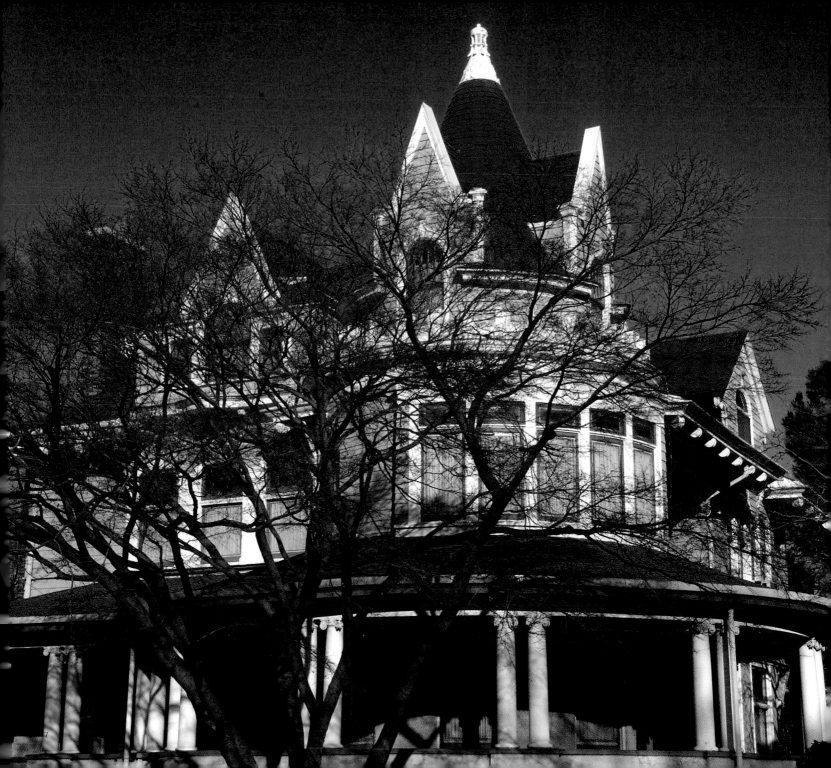

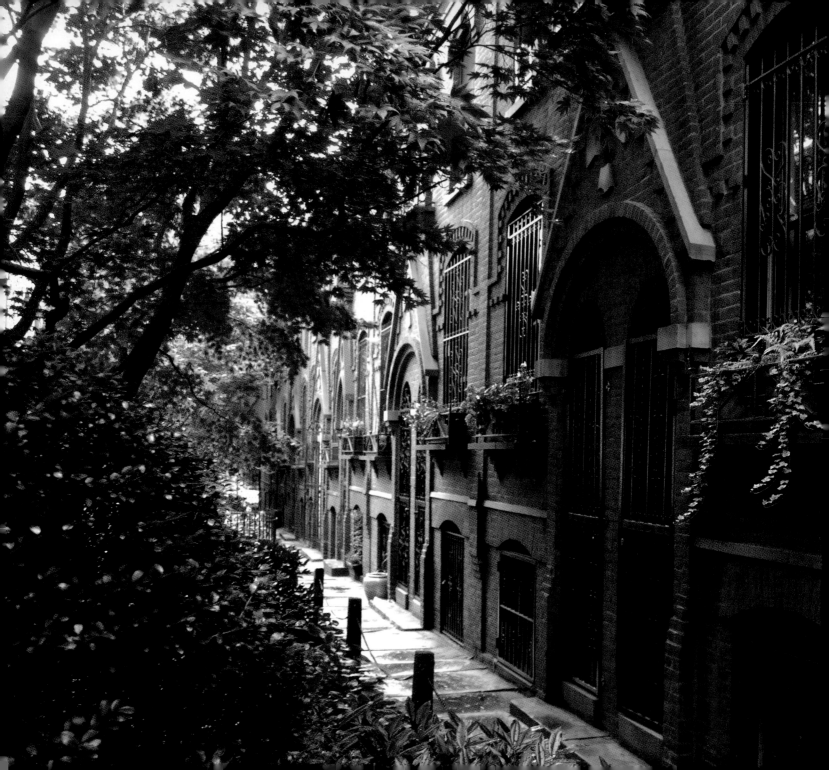

workingmen's cottages

If it's possible for something in New York to look more English than the English original on which it is modeled, then the Workingmen's Cottages in Cobble Hill, Brooklyn—two facing rows of Romanesque Revival-style townhouses with a very English-like garden in between—accomplishes this, and then some. It's a little like Hollywood creating a Western set in which the recreated Western town looks more "Old West" than any actual town possibly could have. True even of some Hollywood sets depicting New York City neighborhoods, for that matter. And true too of this decidedly British-like mews bounded by elegant, intricately designed, and expertly crafted iron gates at either end (the gate on the north side of the mews is always open and can be entered by non-residents).

These exquisite little townhouses—11.5 feet wide and 32 feet deep with two rooms on each of its three floors—are today privately owned and worth nearly a million dollars each (one sold for

$925,000 in 2008). But when they were built in 1878 by philanthropist/businessman Alfred Tredway White, they—along with the Home apartment buildings a block away and the adjacent Tower apartments, which together with the cottages form a quadrangle—were intended to provide working-class dwellers an alternative to the tenements then pervasive in 19th-century New York.

Among the earliest advocates of the tenement house reform movement in New York was none other than Walt Whitman, the people's poet, who in 1857 implored builders "to mingle a little philanthropy with their money-making and to construct tenement houses with a view to the comfort of the inmates as well as the maximum of rent." White apparently took such urgings to heart, and after visiting London where he observed progressive housing projects for working people, he launched his own projects to create model tenements, or, as he described them at the time, "improved dwellings for the laboring classes."

One of the things that sets White's housing apart from other developments was his use of only half the building site for construction, leaving room for gardens and recreation areas, as witnessed by the open spaces between the cottages as well as in their backyards and also the courtyards within the Home and Tower apartment buildings.

Both the cottages and the apartment building units had their own toilet facilities, which was also unique to poor people's housing at the time. And one of the great innovations employed in the apartment buildings—all of them six-stories high—was an outer central stairway, made of iron, which replaced the inner stairwell common to tenements. The outer stairway allowed for more air and light to get into the apartments, and since it served as the means of getting to and from all apartments, tenants were always meeting on the stairs and the terraces leading to them, making living there less private—and friendlier. Lastly, and significantly, Alfred T.

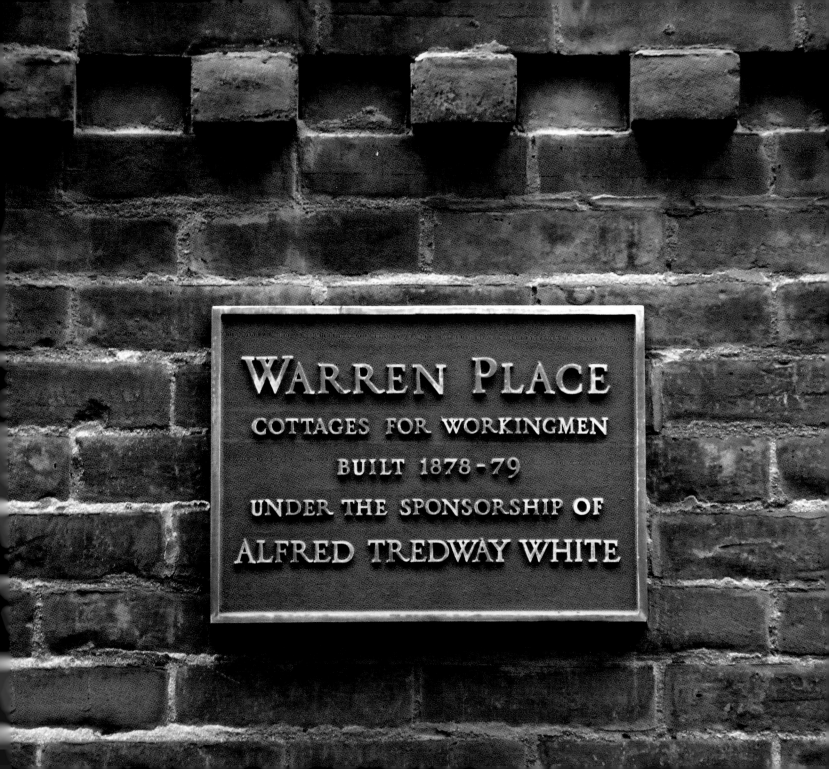

White's buildings—cottages and apartment buildings alike—all were constructed of brick, making them fireproof, which the majority of tenements at the time definitely were not. On the contrary, poor and working-class tenements were typically firetraps.

When construction began, White said that his apartments "were intended to meet the wants of clerks, artisans, mechanics and all workmen and women who desire to live in private, pleasant homes but can afford to pay only moderate rents." (Try to imagine present-day New York City real estate developers mouthing these words. Are you listening Donald Trump, Bruce Ratner, Harry Macklowe, *et alia?*) And true to his word, upon completion, White charged $18 a month rent for the Workingmen's Cottages and in the Home and Tower buildings, $6 a month for a three-room apartment, and $7.95 a month for a four-room.

White's housing (26 small Workingmen's Cottages, plus 8 larger ones at right angles to them, nearly 300 apartments in the Home and Tower buildings and the later Riverside buildings in Brooklyn Heights) was not only "Brooklyn's first venture in thoughtful urban planning and development" but also the first low-rent housing projects built in the entire United States. (New York City can also claim the first low-income public housing project to be built in the United States: First Houses, a low-rise, garden apartment-like project built in 1935 on the Lower East Side/East Village, where they still stand and remain in excellent condition.)

Tenants who lived in the Workingmen's Cottages apparently loved being there. At the time of their first major modernization in 1935 (which entailed installing more modern heating units and tiled bathrooms), there was one family who had occupied the same cottage for 45 years and two other families who had been in their cottages for 33 years.

The cottages as well as the other White holdings were sold by his heirs in 1947 (he had died in 1921). By 1949, the new owner, claiming hardship, announced that he intended to raise rents,

and, of course, he did. The die was cast. It was wishful thinking to expect the new owner to bring the same sensibility to real estate ownership as did Alfred White. And somewhere along the way, as the city turned from a city of renters to a city of owners, and Cobble Hill became more and more gentrified along with the rest of this part of Brooklyn, the Workingmen's Cottages gradually became privately owned. And, as stated above, despite their size (just over 1,000 square feet and with absolutely no opportunity for add-ons), these little jewels command big bucks—when, in fact, they come on the market, which they rarely do.

Perhaps some solace can be taken in the fact that the fate of the nearby and adjoining apartment buildings (now called the Cobble Hill Towers) is not so dramatically removed from White's original purpose. In 1975 the apartment buildings were sold to an owner who did major renovations to the buildings, then in disrepair and under-occupied, and he has continued to rent them to mostly middle and moderate income tenants at reasonable rents. They are probably the neighborhood's biggest and most desirable bargain. If Alfred T. White were to convert the Tower's 19th-century rents into 21st-century dollars and adjust for inflation, although he might be amazed to see the level to which both the dollar and rents had risen, at least he wouldn't be turning over in his grave. His legacy survives, albeit not wholly intact. It could be worse.

charlotte gardens

Charlotte Gardens, a fifteen-acre tract of 89 three-bedroom, one-and-a-half bath, single family pre-fabricated ranch homes, might be considered fairly nondescript if it was located in some random middle-class or working-class suburb. But smack in the middle of the South Bronx, in the Crotona Park East neighborhood, these unremarkable looking, 1,500-square-foot houses have gained a measure of fame and notoriety beyond what their modest circa 1980s appearance would otherwise suggest.

Begun in the early 1980s and completed in 1987, more presidents, and presidential wannabes, have visited Charlotte Street and its environs than perhaps any other neighborhood in the city: first to declare the area a symbol of urban blight, and then to praise it as a metaphor for urban renaissance and renewal.

Jimmy Carter started the presidential parade, when he visited Charlotte Street, then an abandoned, rubbish-strewn empty lot, on October 5, 1977 and declared the South Bronx to be the country's worst slum and promised his administration would do something about it. Ronald Reagan followed in 1980, and as a presidential candidate used the example of the still abandoned site on Charlotte Street—saying it looked like World War II London during the blitz—as another instance of Democrats not keeping their promises. Jesse Jackson came to the South Bronx in 1984 (and slept the night there) when campaigning for the Democratic presidential nomination, to highlight the problem of poverty in America.

In 1997, to commemorate the tenth anniversary of its completion, President Clinton visited Charlotte Gardens, and pointed to it as an example of what government can accomplish, even though, in fact, Charlotte Gardens was completed with difficulty—the first houses were

finished in 1983 but the last, a full four years later, in 1987—and with precious little help from the federal government. Most of the money came from the city.

Visitors today tend to be tour groups who come to see an authentic New York City "poor," mainly black and Hispanic, neighborhood, once written off as dead but now literally risen from the ashes. In 1977, at the time of Carter's visit, it was estimated that the South Bronx had lost 100,000 apartments to fires. Of course there were other causes for the decay that came to define the Bronx of the 1970s. Two frequently cited culprits are Co-op City in the northeast Bronx, for siphoning off middle-income families, and Robert Moses, whose several expressways through the Bronx intersected and cut off otherwise viable neighborhoods. But fires (from arson) were certainly pervasive and, to be sure, a major reason for the loss of housing.

Since the resurrection of Charlotte Street and nearby areas, more than $2 billion dollars has been spent on new and renovated housing (approximately 30,000 units) in the South Bronx, and evidence of this new construction—single family homes, garden apartments, high-rise apartment complexes—is everywhere. But like most complicated things, the revival, despite its obvious successes, has a downside as well. As certain critics have noticed lately, all this new housing has led to a steep increase in the cost of housing all over the South Bronx, for both renters and buyers. The Charlotte Gardens houses, which cost around $50,000 in 1987, were selling for almost $200,000 ten years later in 1997 (original buyers had to agree not to sell for ten years, as a way to establish and maintain stability in the development). Presently, even after the real estate downturn, the houses, when they come on the market (which they rarely do), are valued at over $400,000. They, and much of the other housing in the South Bronx, is now too expensive for most of its residents! Despite all of its gains, the 16th Congressional District, which includes the South Bronx, is not only still among the poorest districts in New York City, but in the entire country as well.

In any event, presidents have stopped visiting. Tour buses still do.

palazzo chupi

it has been variously described as hot pink, bold pink, reddish-pink, rose pink, or just simply "pink", as well as soft red, Pompeii red, candy-colored, or "somewhat salmon." Further, it has been characterized as Neo-Mediterranean, or simply Mediterranean, Florentine, Venetian, Moorish, and Turkish.

No matter the difference of opinion over the question of color or style, most everyone would agree that the artist and film director Julian Schnabel's Palazzo Chupi (apparently "Chupi" is some word of endearment that he uses for his Spanish wife), on West 11th between Washington and West Streets, is way too tall and way too colorful for this quiet, and mostly low built, far West Village block.

When construction began in 2005, among the many protesters was the Greenwich Village Society for Historic Preservation, whose mission it is to protect "the sense of place and human scale that define the Village's unique community." And it is precisely that sense of place and scale that the building snubs its nose at.

As to the issue of height, the Society argued that Palazzo Chupi, at 167 feet, violated the newly enacted zoning regulations for the area that limit building height to 75 feet, although it lost that argument when it was decided that the palazzo's foundation work was already

in place by the time the law went into effect, and thus work could be completed as planned. Though much of Greenwich Village has been designated an Historic Landmark District, this part of the West Village, west of Washington Street, has mostly not been.

As for the matter of style, neighbors more than likely will have concluded that the building is better suited to Florence, Venice, Spain, or Turkey than the far West Village of Manhattan. And the fact that Schnabel boasted that he had sketched the general design for the exterior of the building in about fifteen minutes flat probably does not win him their admiration nor endear him to them. He has also boasted that he painted a copy of a Picasso, which hangs in the building's triplex apartment, in just one day! Just to see if he could.

If neighbors, preservationists, architectural critics—and just about anyone else who has ever walked this block and looked up—have not been kind to Julian Schnabel's homage to home, neither has the real estate market. The building contains five apartments—a triplex, two duplexes, and two single-floor apartments—atop the original three-story commercial structure, which now houses the artist's studio, gallery space, and the building's swimming pool and garage. Only two of the five apartments sold early on. (One duplex was sold to a banker, one of the floor-throughs to the actor Richard Gere—who never moved in and almost immediately put it up for sale himself—and the other single-floor apartment is occupied by the Schnabels.) The unsold triplex, originally listed at $32 million was reduced to $24, and the unsold duplex, originally $27 million was reduced to $23. And this was before the real estate market's collapse! After that, the triplex was reduced again to $22 million and the duplex to $19. Finally, in the fall of 2009 the triplex was sold for $10.5 million to the same banker who owns the duplex, paying less for the triplex in 2009 than he paid for the lower and smaller duplex in 2007! The other unsold duplex was sold in of the fall of 2009, and apparently Richard

Gere found a buyer for his never-lived-in apartment as well, selling it in late 2009 for a million less than he paid for it.

Let it be said to all future buyers, no matter what the deal, *caveat emptor*, for any owner will have to suffer the barbs of neighbors and passersby alike. This building is not universally beloved, to say the least. And this is despite the fact that it is an absolutely compelling sight; to the point that one ventures to say, nary a soul with a camera has ever walked by who has not photographed it. Though in this instance, seeing might still not be believing.

What prompted Schnabel to build this over-the-top creation that rankles those who love the quiet character of the West Village the most? Only his therapist will know for sure, but a March 2008 article in *Vanity Fair*, referencing Schnabel's modest, working-class Flatbush, Brooklyn roots, suggests, "one could view the building itself as a sort of architectural autobiography. The grandness and craftsmanship betray the memory of a little boy who was nuts about his parents but felt debilitated by the small scale and lackluster materials in their Brooklyn home."

It goes on to say, "Then there's the epiphany he had as a young artist walking through a huge wooden door into a courtyard in Mexico City and being wowed by the sense of privacy that people could have in the middle of a teeming urban world."

If this is an explanation—even a partial one—it doesn't seem all that plausible, since all of the above-stated ends could have just as easily been achieved with a building more in keeping with the streetscape. Grandeur and bigness are not synonymous. Also, a quiet interior did not require the loudness of the exterior.

All of which is to suggest, that contrary to conventional wisdom, one *can* take the boy out of Flatbush *and* take Flatbush out of the boy. Which is too bad, for Brooklyn connotes down to earth, and Palazzo Chupi could have benefited greatly by being closer to it.

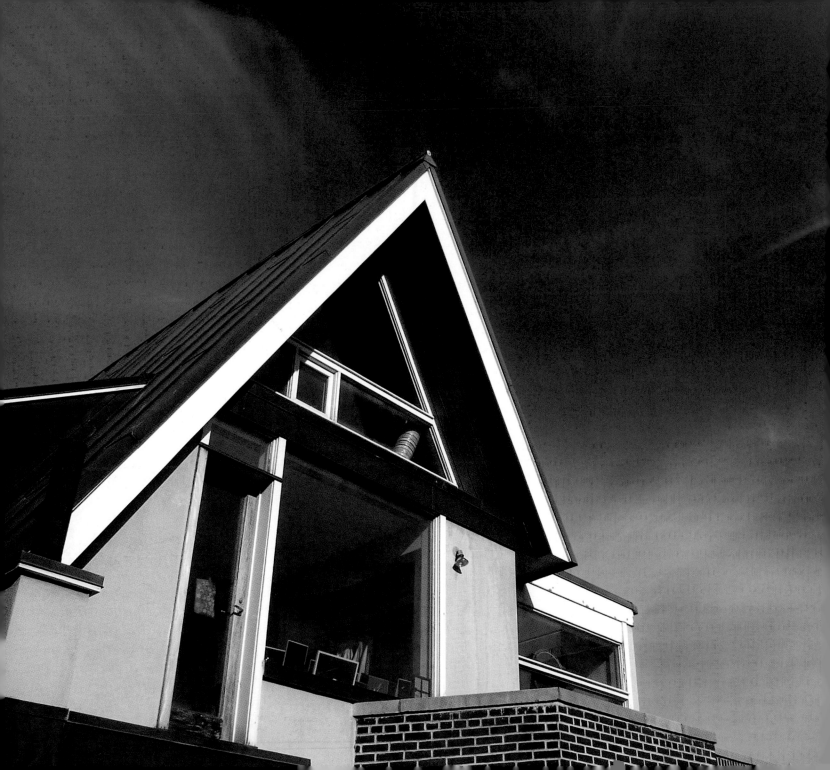

a-frame

It is possible to walk past the nine-story apartment building on West 78th Street (between Broadway and Amsterdam) a thousand times and never notice the penthouse on its roof. But if you happened to be in, say, the children's playground on Amsterdam at 77th Street and you looked up, you'd be struck by the A-frame—something that looks like a ski chalet—sitting atop the building. The ski chalet in the sky is surprise enough; its juxtaposition with the underlying 1920s Tudor structure is, well, almost surreal.

If most people have tales of six degrees of separation, the story behind this A-frame is one of sixty degrees of separation.

In 1990, the architect and owner (and ultimately designer and occupant) bought the then one-room, one-story, 400-square-foot penthouse apartment with the intention of expanding by building up and out, enlarging the apartment and adding a second floor. He ran his plans by the New York City Department of Buildings and got tentative approval. But by the time he was ready to execute five years later, he was informed that his plans violated code, specifically, the provision that mandates that buildings have 30-foot backyards; this despite the fact that the building, with its 15-foot backyard, was built in 1926 when no such rule was in force.

The Department of Buildings was adamant. If the back wall of the second-floor addition to the existing penthouse went to the back edge of the building's roof, or even within 15 feet of it, the penthouse would be extending into the 30-foot "backyard," albeit ten stories above it! It made no sense. But, logic be damned.

Believing logic, good sense, and the gods were on his side, the owner decided to argue his case and jump through however many hoops the Department of Buildings placed in front of him. From the beginning, his design, in his words, was "an attempt to be in keeping with the rest of the building. To be an asset, and not something that just landed on the roof. For the sake of neighbors if not for anyone else."

Who could argue with that? Who could not see the purity of intent? The New York City Department of Buildings, that's who!

Over a period of six to eight months, the owner did battle with the department. The scenario went as follows, with multiple trips to the Buildings Department and multiple tweaking of his plans along the way:

1. File plans with Buildings Department for examiner review (objection)

2. Appeal to Chief Examiner (denied)

3. Appeal to Borough of Manhattan Commissioner of Buildings (denied)

4. Appeal to Monthly Technical Meeting of all five Borough Commissioners (denied)

5. Appeal to Deputy Commissioner of New York City Department of Buildings (denied)

6. Meeting with New York City Commissioner of Buildings by virtue of serendipitous circumstance of owner's father, of Italian descent, knowing a New York City Civil Court judge of Italian descent, who knew the then Commissioner of Buildings, also of Italian descent (sent back to Deputy Commissioner with instruction to "work it out")

7. Second meeting with Deputy Commissioner who informs owner that a roof (as opposed to a wall) can overhang into a rear yard

8. A roof is defined as having an angle of sixty degrees or less (*more* than that constitutes a wall and not a roof)

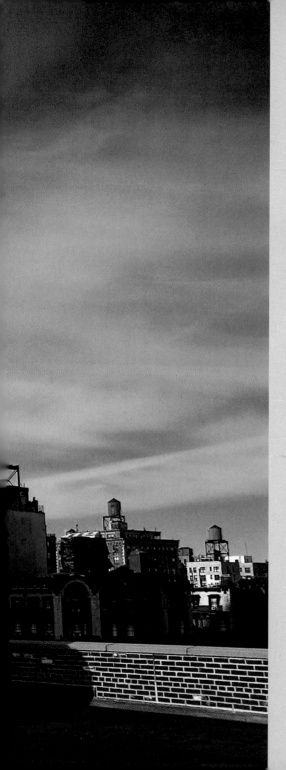

9. Owner submits revised plans with second and third floor additions capped by a roof sloped at sixty degrees (approved!)

And a sixty-degree, sharply angled roof doth an A-frame make.

When one considers the obstacles the Department of Buildings created by its strict and somewhat dubious interpretation of the building code, compared to its laxness in the case of Julian Schnabel's Palazzo Chupi, one has to wonder what they were thinking. In this instance, the department thwarted two-story plans that would have been more in keeping with the Tudor building than the building-code-induced three-story A-frame that resulted. In the case of the Palazzo, a stricter enforcement of zoning regulations would have prevented a structure that was totally and obviously out of keeping with the neighborhood from the get-go.

But that's what real estate development in New York City is like. It entails wrangling with the Department of Buildings, whose interpretation and application of rules and regulations is predictably unpredictable and too often inconsistent. Which, one has to conclude, makes for some pretty unique, though often rather puzzling, construction. The 170-foot-high bubblegum pink Moorish behemoth Palazzo Chupi, for one. An A-framed ski chalet ten stories in the air, for another.

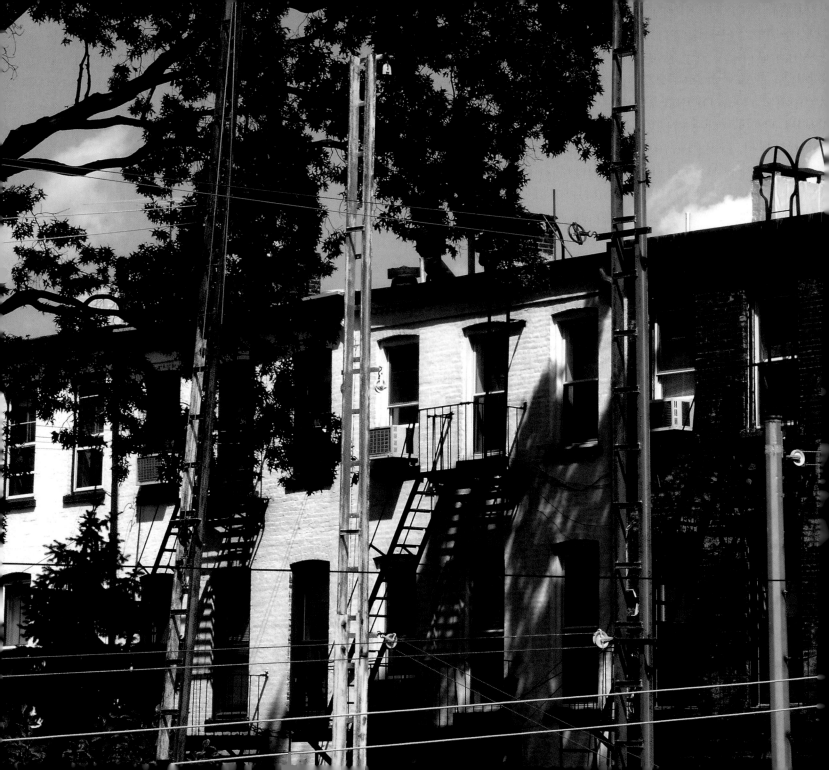

clotheslines

At the turn of the last century, in the early 1900s, clothes hung from clotheslines throughout the city. Clotheslines were to early 20th-century New York—particularly tenement New York—what satellite dishes and cell-phone towers atop buildings are to the city today.

By the end of the 1900s, clothes hanging out to dry were certainly no longer a pervasive New York City motif, but nor were they completely obscure. In the outer boroughs, in neighborhoods of privately owned, freestanding homes, backyard clotheslines could still be found. And even in high-rise apartment dwelling parts of the city, particularly in neighborhoods of the poor, the working-class, and the newly arrived, the practice of drying clothes outdoors—on lines strung from fire escapes, terraces, and backyard towers—continued to hang on. (Pun absolutely intended.)

Now, well into the new millennium, some would say that clotheslines might even be making a comeback. New immigrant groups continue to hang their clothes out to dry as they did in their country of origin. The rest of the world is not as obsessed with—nor can they necessarily afford—clothes dryers. While over 80 percent of Americans "deem dryers a necessity," and almost all use them, whether their own or a laundromat's, according to a Pew Research Center poll, in Europe, for example, the ownership of dryers is less a necessity and less desired. In the Netherlands, said to have the largest percentage of household dryers, that number is just over 60 percent. Italy, among highly developed countries, is, hands down, the leader among nations still committed to hanging clothes out to dry. Only about 5 percent of Italians own a dryer!

But the more recent reasons for the spike in the use of clotheslines may be attributed to the twin impulses of saving money and energy. The recession following the housing industry bust in 2008 made the use of clotheslines more desirable as a cost saving mechanism. Dryers account for

about 6 percent of the typical American household's electricity costs, second only to refrigerators as the most costly home appliance. It is estimated that the average American household spends between $80 and $100 a year for the use of their dryer; 30 to 40 cents per load for an electric dryer and 15 to 25 cents per load for a gas dryer. Drying clothes outdoors on a line is, by contrast, free.

As for the growing awareness and concern with global warming and environmental issues, many have been moved to hang their clothes out to dry "as their small contribution toward saving the planet." The use of dryers, collectively, is estimated to use up the energy equivalent of 30 million tons of coal a year.

Additionally, according to Project Laundry List, a not-for-profit organization established to "make air-drying laundry acceptable and desirable as a simple and effective way to save energy," the reasons for eschewing electric or gas dryers in favor of hanging clothes on lines—besides saving money and energy—include the following: it reduces greenhouse gas emissions, it makes clothes smell better, it makes clothes last longer, and it exposes clothing to sunlight, which acts as a disinfectant. And, if you're still not convinced, how's this for an incentive: hanging clothes out provides a twenty-minute workout!

In certain parts of the country there are laws restricting, or even banning, the use of outdoor clotheslines, mostly for esthetic reasons. Indeed, one of the major aims of Project Laundry List is to promote "right-to-dry" legislation (you read that correctly: "right-to-dry" not "right-to-die") in localities where the right to hang clothes has been limited. New York City, however, as far as anyone can tell, has no such restrictions, though there are plenty of apartment complexes, co-ops, and condos where clotheslines are not provided, or they're removed, or their use is simply not encouraged. (The oldest, strongest, and most explicit right-to-dry law in the United States is in Florida, not surprisingly—it is, after all, *the* Sunshine State.)

Perhaps no other New York City neighborhood has as rich and proud a clothesline culture as Carroll Gardens in South Brooklyn. Long home to Italian immigrants who settled there in the early and mid-1900s, since it was close to the then-thriving Brooklyn waterfront, where so many of the men worked, it soon sprouted clothesline galore—four-story-high metal towers that populated the backyards. Remember, Italians have a love affair with their outdoor clotheslines. And although many of the original Italian residents of South Brooklyn have died—and their children and grandchildren have gone to Staten Island or Long Island—there is still an Italian presence and a preference for the outdoor line.

More significantly, these sturdy, metal clothesline towers have been bequeathed to the newer generation of non-Italian gentry who now reside in Carroll Gardens. And, just as in the case of the mountain that is climbed simply because it is there, these otherwise antiquated towers are used. To say nothing of the additional impetuses of money and energy savings.

April 19 is National Hanging Out Day (really!), to celebrate and encourage the use of clotheslines. Although New York is a lot more clothesline-friendly than other places, don't expect the suspension of the city's alternate side of the street parking regulations on April 19 anytime soon. Though one can dream.

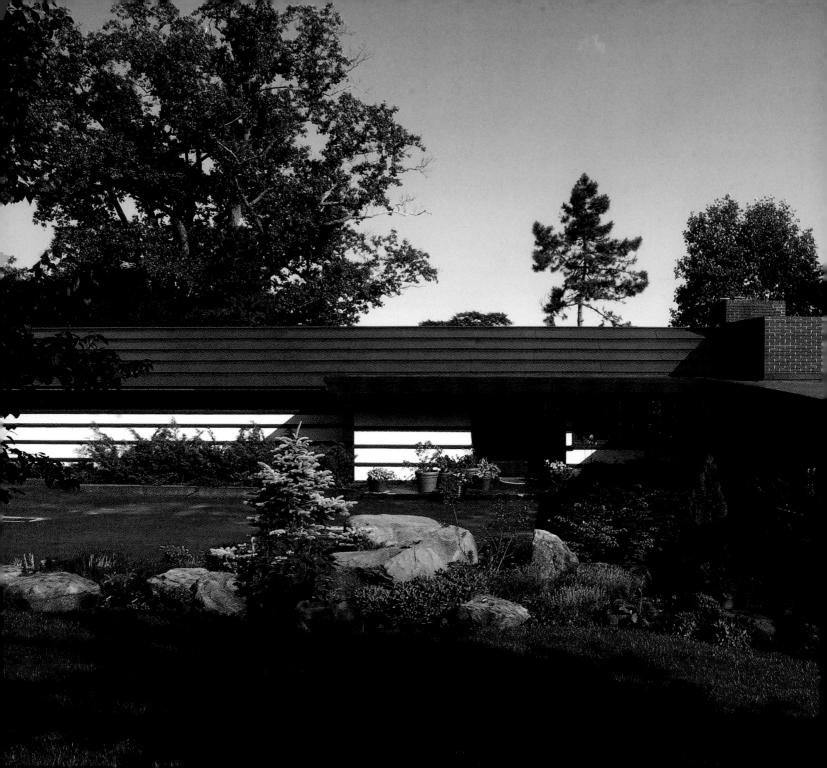

frank lloyd wright house

Who'da thunk it? No, really, who would have thought the only Frank Lloyd Wright house in all of New York City would be located smack dab in the middle of Staten Island? It's true, there are two other Wright buildings in the city—the Guggenheim Museum, which most everyone knows about, and the interior of the Mercedes Benz showroom on Park Avenue at 56th Street, which very few people know about—but this is his only house. (The living room of the Francis W. Little house of Wayzata, Minnesota, installed in the Metropolitan Museum of Art, doesn't really count.) At first blush, a Frank Lloyd Wright house on Staten Island seems as improbable as a Trump Tower in downtown Des Moines. Or maybe not. Read on.

In 1957, the Casses of Corona, Queens were watching a television interview between Mike Wallace and the then 90-year-old Wright. Wright was talking about the need to create affordable housing, and toward that end, had designed prefabricated homes. Mr. Cass, who had never before heard of Frank Lloyd Wright, was intrigued. He persuaded Mrs. Cass, who had heard of Wright, to write a letter expressing their interest in purchasing one of these prefabs, to be erected on a three-quarter-acre lot they owned on Staten Island. Wright agreed. A contract was signed, and Marshall Erdman, a builder based in Madison, Wisconsin, manufactured the parts of the house and shipped the pieces to Staten Island, where they

were installed on a hillside in the Lighthouse Hill neighborhood, overlooking the neighborhood of Richmondtown—including the historic Richmond Town village and museum—and New York harbor.

Only two of Wright's prefab designs—Prefab No. 1 and Prefab No. 2—were ever executed, and less than a dozen homes got built (apparently, what was meant to be affordable housing was not so affordable). The Staten Island house—one of two Prefab No. 1s that were built—was christened "Crimson Beech" by the Casses because of a large, several-hundred-year-old copper beech tree that was on the property at the time. The four-bedroom, three-bath, low-slung, L-shaped house, with its exterior of cream-colored masonite punctuated with horizontal strips of mahogany, red brick, and a red-painted metal roof, begun in 1958 and finished in 1959, took only about five days to erect, though it required an additional four months to complete all the other work (installing electricity and plumbing, putting in appliances, and so forth). The cost of the house, plus shipping, was $20,000. The contractor and various sub-contractors in New York were paid an additional $35,000. The total cost by move-in day was about $100,000. (Mrs. Cass, then a widow, sold it in 1999 for $800,000, and it was sold six years later, again for about $800,000.) Wright died a few months before the Cass house was completed, and therefore he never got to see it (nor the completed Guggenheim) nor to meet the Casses, although Erdman, its builder, attended Crimson Beech's opening, as did the governor of Wisconsin! In 1990, the house was granted historic landmark status by the city.

That this pre-fabricated house resides on Staten Island, upon reflection, may not be so odd. It was well known that Wright was no lover of New York City. For instance, from the website of the Guggenheim, the following appears: "Wright made no secret of his disenchantment with Guggenheim's choice of New York for his museum: 'I can think of several more desirable

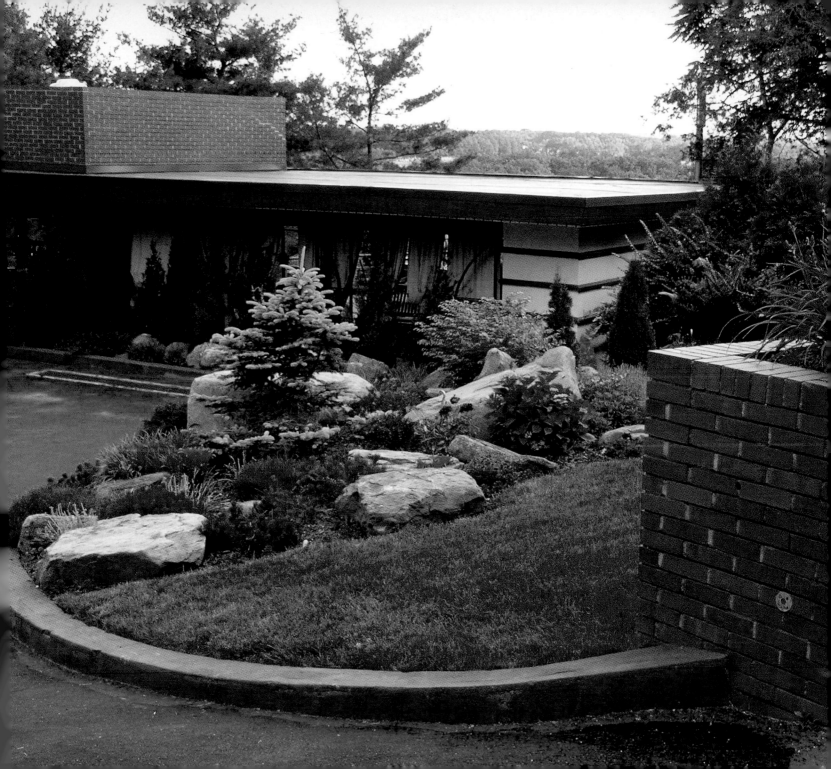

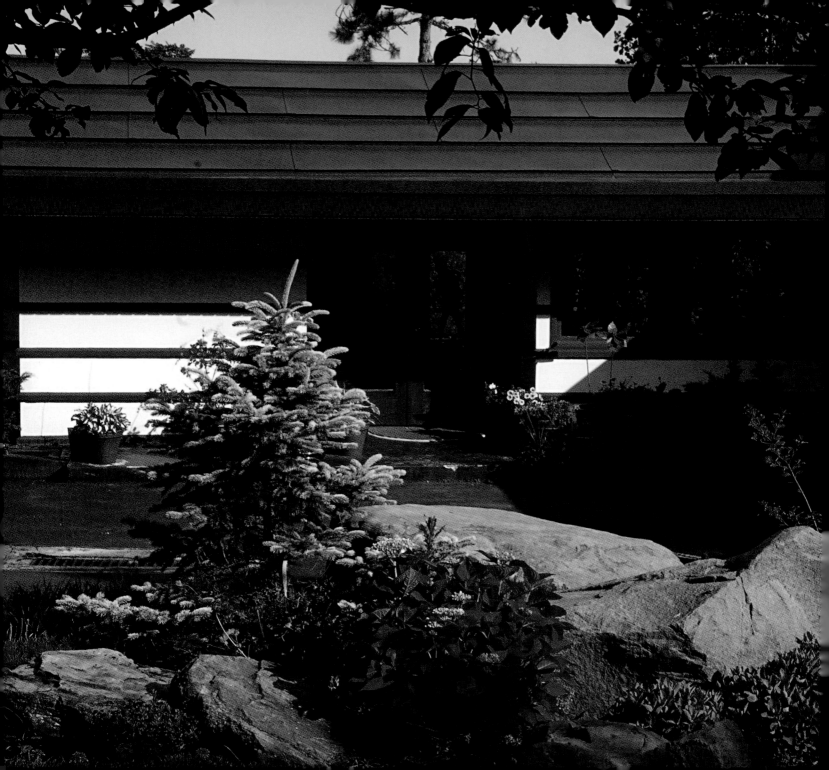

places in the world to build this great museum,' Wright wrote in 1949 to Arthur Holden, 'but we will have to try New York.' To Wright, the city was overbuilt, overpopulated, and lacked architectural merit." Some suggest that Wright's circular design for the Guggenheim was his attempt to break up the city's grid pattern and the linear buildings that it spawned. An article about Crimson Beech in the *New York Times* went so far as to quote Wright as referring to New York City as "a pig pile" and "a fibrous tumor."

In short, Wright was a man of the Midwest, and it is the Midwest that is the locus of most of his creations. Not surprisingly, of the 400 or so houses designed by Wright, four are in New Jersey, compared to the lonely one in New York City. But, in reality, Staten Island—physically and psychically—bears more similarities to New Jersey or even some Midwestern suburbs, than it does to the rest of New York City. Plus, it can't be accused of having a grid pattern for its streets nor the linear architecture that comes with it. So, in a real sense, Staten Island allowed Wright to have one of his houses *in* the city but, thankfully—for Wright's sake—not *of* it.

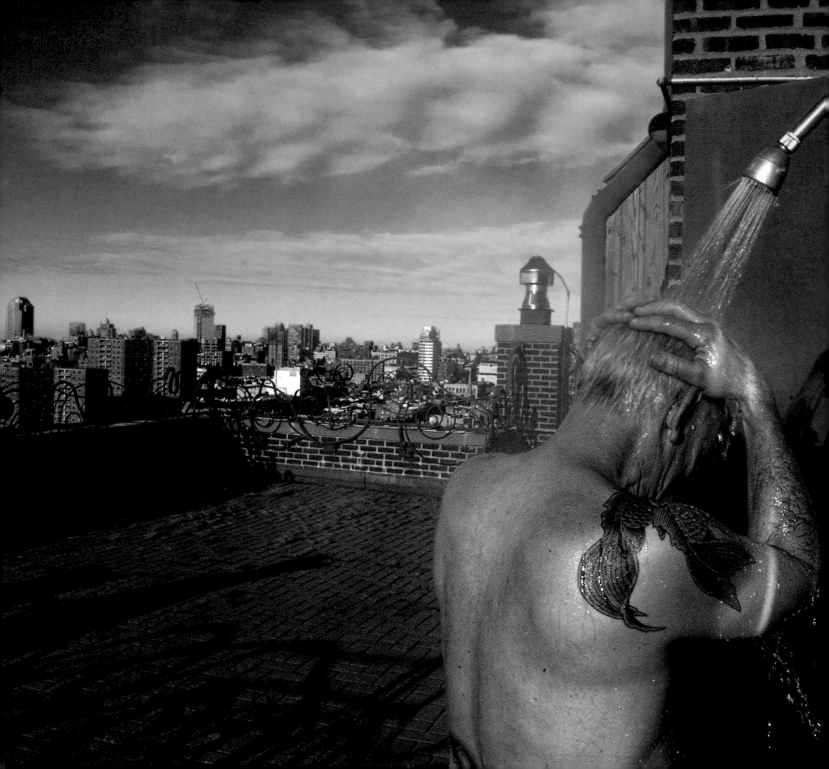

outdoor showers

early on a cold mid-November morning (cold enough to see one's own breath), high atop an East Village penthouse apartment (seventeen stories up), a middle-aged man enters his outdoor terrace (overlooking Tompkins Square Park and with a 360-degree view of a good portion of the rest of the city, including the East River) and proceeds to take a hot shower. "I'm probably the only guy in Manhattan who showers outdoors every morning," he declares, as he vigorously soaps his body and then shampoos his hair, unseeable and unknowable to anyone around with the possible exception of passing helicopters. On this particular morning, there are none.

"I grew up in Vermont, so I'm used to doing things outdoors," he offers as an explanation. "Plus, I love the idea of doing this very private thing in public, yet not really. To be totally exposed and yet not exposed at all. I don't know—I just love it."

In point of fact, he does not shower every morning (that is, year-round), and this mid-November one is likely to be one of the last until the spring. (He shuts the water off before the winter freeze sets in.) Nor is he the only New York City dweller with an outdoor shower. Indeed, an August 2007 article in the now defunct *New York Sun,* "Outdoor Showers Are New Trend for Refreshing Living in the City," proclaimed "outdoor showers springing up on apartment rooftops and hotel terraces… the sexiest new amenity to take Manhattan," which was probably a gross exaggeration, unless a handful constitutes a trend.

In fact, the article gave just three examples of private apartments with outdoor showers, all penthouses, all out of the view of anything or anyone around them, and all

in the multimillion dollar range (one on the Lower East Side on Norfolk Street, one in the Village on Waverly Place, and one in Tribeca on Hudson Street); three luxury high-rise apartment buildings whose roof decks have an outdoor shower for all the building's residents (one in Times Square and two in Long Island City); and two hotels (the Bowery Hotel on the Bowery in NoHo where each room has a shower on its terrace and the Maritime Hotel in Chelsea on Ninth Avenue where only the penthouse's terrace has one).

Someone in the article is quoted as saying, "the outdoor shower bridges those worlds of necessity and pleasure." Okay, pleasure, maybe. Necessity? Doubtful. A Metrocard is a necessity. An outdoor shower—given the city's cold winter temperatures, air quality, and proximity to neighbors—is a frill. And since it seems to come only with a multimillion dollar penthouse apartment, an awfully expensive one at that.

Yep, you probably are the only guy who showers each morning outdoors. Or one of three!

Ode to an Outdoor Shower, by David Weinberger, blogger
Bird watching
Becomes
Birds watching

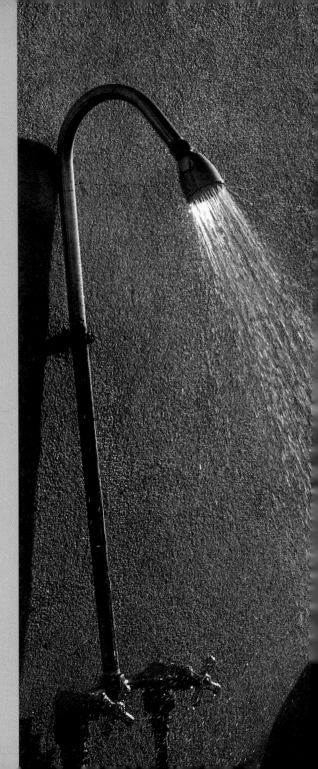

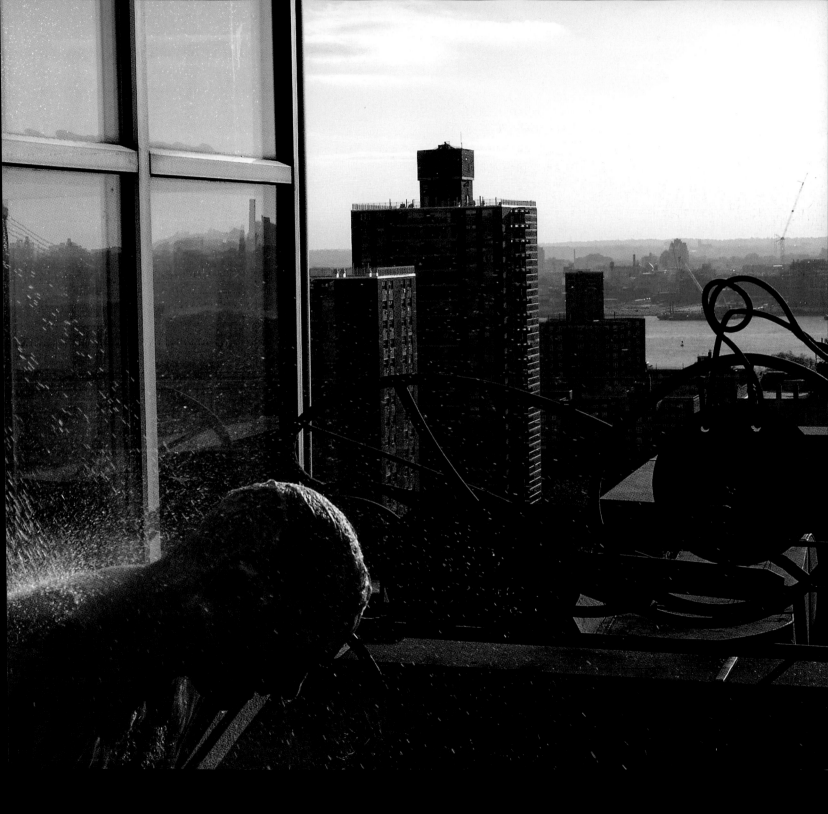

casitas

The *casita* (literally "little house") in the Rincon Criollo Cultural Center garden in the South Bronx (East 157th Street at Brooke Avenue) is called La Casita de Chema in honor of Jose "Chema" Soto, who inspired its construction on a then vacant, debris-strewn lot in the late 1970s. Now one of the oldest casitas in the city, it is one of about 40 or 50 still to be found in neighborhoods with substantial Puerto Rican populations: the South Bronx (Melrose), East Harlem (Spanish Harlem or El Barrio), the Lower East Side (Loisada), and Brooklyn (Williamsburg).

Casitas are one- or two-room shack-like structures found throughout Puerto Rico, usually in the countryside. They are typically built of wood panels (*casitas de madernas*), painted bright colors (so they can be seen at night), have shuttered windows, a porch with railings, and an open area in the front called the *batey*. Often there is a vegetable and flower garden as well.

Their replication in New York City neighborhoods is a conscious attempt by Nuyoricans (New Yorkers of Puerto Rican descent) to recreate and nurture their Puerto Rican roots and culture. They serve as community gathering places where like-minded residents hang out, partake in cultural activities (emphasizing music and dance), garden, celebrate religious and other holidays, and in a real sense fight the twin, often competing, forces of assimilation and urban isolation.

A report by the Brooklyn Historical Society on the borough's Hispanic communities talked about the casitas that once lined Columbia Street, just south of Atlantic Avenue and close to the waterfront (they were razed in the late 1980s and early '90s—to make room for new housing),

as an attempt at "ruralizing" an otherwise "bleakly urban setting." The tiny casita, juxtaposed to the city's high-rises and skyscrapers, was able to bring the big, bad, urban landscape down to a more human, manageable scale, bringing more bucolic values along with it.

Like bankruptcy lawyers, casitas appear to thrive during bad economic times. Their heyday seemed to be during the early 1970s. As a result of the widespread razing and burning of buildings throughout the city—particularly in poor neighborhoods like the South Bronx—New York became home to some 25,000 vacant lots, and it was on these lots that casitas like La Casita de Chema sprouted. In 1978 the City of New York initiated Operation Green Thumb, under which city-owned vacant lots were leased to community groups for use as community gardens for one dollar a year. Most of the casitas erected at the time were established in these Green Thumb facilitated gardens. Others, like the ones along Columbia Street in Brooklyn, rather than being established in sanctioned community gardens, were erected "illegally" on vacant lots not under Green Thumb's auspices, and, thus, those who built and used these casitas were characterized as squatters or, more benevolently, "pioneers."

Along with better economic times, particularly the housing boom of the 1980s and again in the late 1990s, the city-owned vacant lots became more valuable as lots for new housing than their continued use as community gardens, or so went the conventional thinking. The city auctioned off more and more of the lots they owned to developers. By the end of the 1990s, only about half of the previously city-owned vacant lots remained, and those that remained existed under the threat that they might be sold as well. (The city's community gardens, previously under the control of Green Thumb or the Parks Department, are now under the jurisdiction of the city Department of Housing Preservation and Development.)

Although the casita in New York City might not yet be extinct, it certainly is an endangered species. (It was recently proposed that at least some casitas be designated historic landmark buildings on the basis of their "cultural" significance.) Many factors have militated against their proliferation. Aside from the fact that so many vacant lots became too valuable for their continued use as community gardens, the city has become more stringent in enforcing building and other code regulations that impact casitas, which has led to the razing of many that did not meet code. Building Department regulations, for example, limit their size to 150 square feet. Recently, through the office of Operation Green Thumb, a "Gardenhaus" kit has been developed, which provides all the materials for the construction of a code-conforming casita. A prototype already exists in the Vogue Community Garden in the South Bronx at the corner of East 156th Street and Elton Avenue, although one may wonder whether a prefab casita kit contradicts the defiant spirit with which the original casitas were built, often illegally.

And, too, the Puerto Rican population of the city has dispersed at the same time it has decreased, limiting the phenomenon of Puerto Rican neighborhoods per se. Although Puerto Ricans still comprise the largest group within the city's Hispanic population—778,600 in 2007 (about 33 percent of all Hispanics) compared to just over 602,000 Dominicans (or about 26 percent of all Hispanics), the second largest Hispanic group, or to nearly 290,000 Mexicans, who at present are the fastest growing Hispanic group—there has been a dramatic decline from, say, 1990, when there were 897,000 Puerto Ricans in New York City (50 percent of all Hispanics).

As of the time of this writing, the city, like the rest of the country, is experiencing an economic recession. The housing market is depressed. Bankruptcy lawyers are again thriving. Maybe casitas will thrive as well.

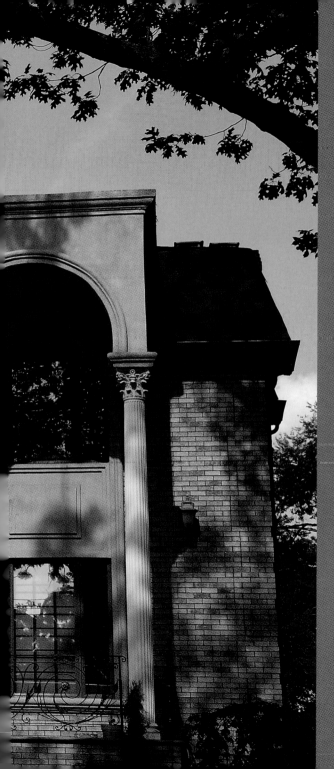

mMcMansions, or mega-homes—or, as some describe them, houses on steroids—long associated with newly developed subdivisions in New Jersey and like-minded places, have become a burgeoning phenomenon in many parts of New York City, despite the relative paucity of space.

Although these outsized homes on undersized lots (the result of either tearing down an existing smaller house or adding additions and extensions to it) can been seen in several outer borough neighborhoods (not so much in the Bronx, however), they have become a particularly divisive issue in two neighborhoods in Queens: Jamaica Estates and the surrounding areas of Holliswood and Hollis Hills, and Forest Hills, particularly in the Cord Meyer area and surrounding neighborhoods such as Kew Gardens Hills and Fresh Meadows.

What makes both Jamaica Estates and Forest Hills unique—and therefore, the matter of these mega-homes uniquely controversial—is that both neighborhoods were created as planned communities, with an emphasis on the word "planned." Both communities have homes in a

variety of styles (both with a majority of Tudor homes setting the tenor) and sizes (though all within scale for the size of the lots and the overall streetscape). The planning resulted not necessarily in a physical uniformity—it was no Levittown—but, rather, a uniformity of sensibility and tastefulness. And for this reason, the introduction of these new monster houses—out of scale and often with over-the-top architecture and materials that clashed with neighboring homes—in an otherwise planned and premeditated community makes for a particularly disruptive breach to the original plan and sense of order. Not to mention its historic character (both communities were built in the early 1900s), though neither Jamaica Estates nor Forest Hills has been designated a landmark historic district by the city.

Sometimes the new houses are so large they require more than a single building lot; in a few instances, three lots have been needed to accommodate the grandiose structures erected thereon. A house in Jamaica Estates, for example, has the depth of an entire block; it fronts on Midland Parkway and backs on Radnor Road, the parallel street just above Midland. The sign on the front lawn on Midland Parkway says "Mail and deliveries: 84–30 Radnor Road." Not surprisingly—well, yes, for New York City, surprisingly—the house comes with a three-car garage and an in-ground swimming pool.

Amazingly enough, despite the bottom falling out of the housing market, and despite the *Wall Street Journal* telling us that McMansions have fallen out of favor, new construction in Jamaica Estates and Forest Hills has continued unabated as if there never was a sub-prime induced mortgage crisis nor a recession that slowed new house sales and new home construction to a trickle nationwide. Not in these two Queens neighborhoods where on just about every block there is both a freshly built mega-home as well as some more new construction. (The building boom here is obviously related to the fact that "For Sale" signs have been scarce in

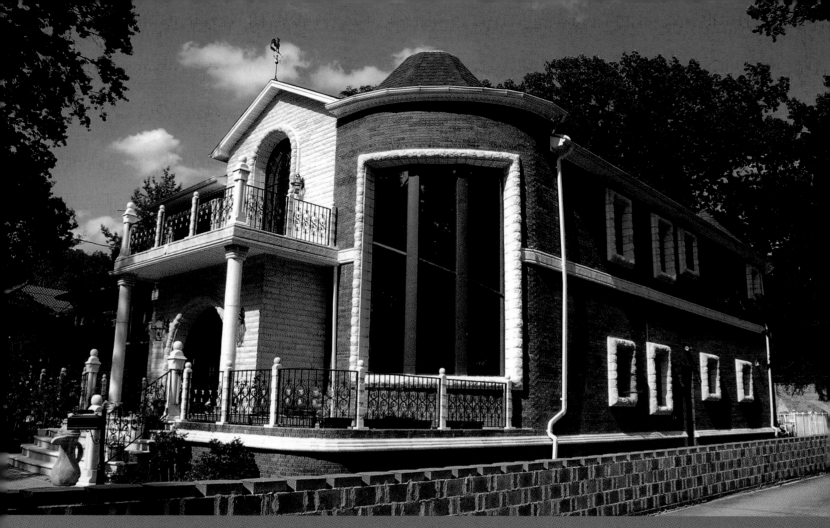

these two communities, even as elsewhere in the United States during the post-2007 housing slump seemingly entire towns were on the market begging for buyers.)

One in five buyers of homes in Jamaica Estates, according to an article in the *New York Times*, razes the existing house and builds a larger one on the same lot, causing many to fear for, among other things, the decimation of the neighborhood's tree population. According to a 2006

census by the city's Parks Department, there were over 5,700 trees in Jamaica Estates (oaks, maples, ash, chestnuts, elms), and the fear is that this number will be depleted as lots are cleared to make room for McMansions.

Powering this mega-boom of mega-homes is the new ethnic composition of these two areas. Always ethnically diverse (not only is Jamaica Estates like a little United Nations, a campus of Manhattan's United Nations International School is actually located here), newer immigrants—Chinese, Pakistani, Indians, Russians, Filipinos, Iraqi Jews, Bukharian Jews—often knock down existing homes or expand them to accommodate extended families under one roof, something more common among these newer close-knit immigrant families than the residents who preceded them in these neighborhoods.

Much attention recently has been focused on the Bukharian Jews (from Uzbekistan and elsewhere in Central Asia) who have become a huge presence in central and eastern Queens (upward of 30,000) and whose presence in Forest Hills—and to a somewhat lesser, though growing, extent in Jamaica Estates—has become a lightning rod of sorts. Bukharian Jews, at least the ones who can afford it, unabashedly admit to their love of large—even ostentatiously

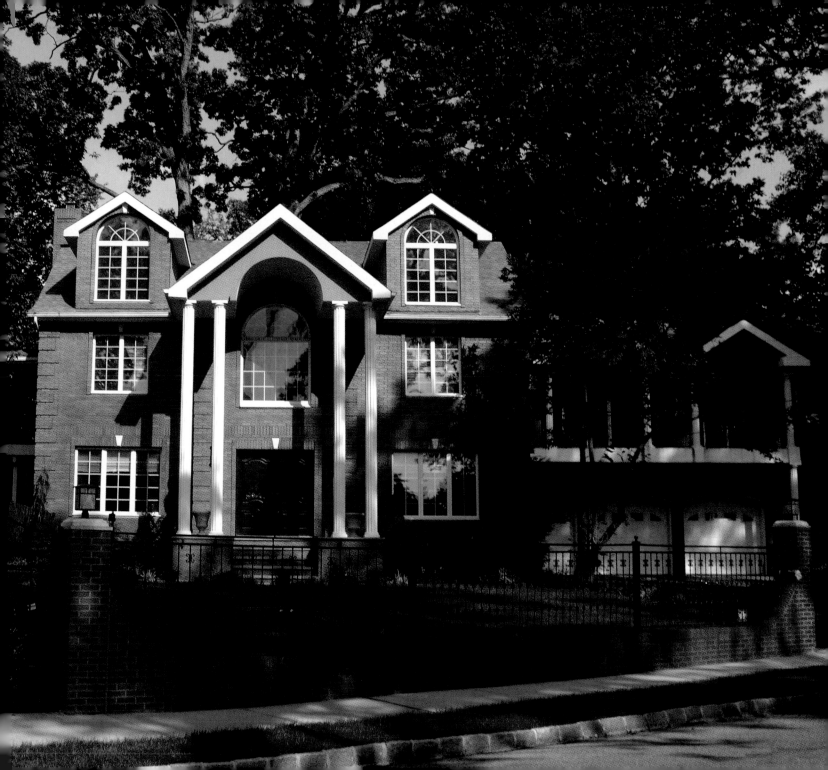

large—houses. A rabbi who heads one of the Bukharian synagogues in Forest Hills was quoted in the *Times* as follows, "We like to utilize every single square inch of land, every inch of territory." And then he added parenthetically, as if he really was at a loss to explain, "For some reason, people don't appreciate it."

Commenting on the fact that their homes often come with terraces and patios rather than lawns, the same rabbi maintained, "The Bukharian tendency to pave over everything is practical." A yard, he thought was "useless land" and "a waste of time." In tree-lined, verdant Forest Hills, such thought—and action—is characterized by some as a veritable call to arms. Unless, of course, said rabbi *was* trying to be provocative.

Some will argue that the controversy over the McMansions is just a matter of taste. Indeed, maybe the real issue is taste rather than size. One of the larger, still standing, older houses in Jamaica Estates, for instance, is the house once owned by Donald Trump's family—the house in which The Donald himself grew up. It's larger than most of the older houses, yet it is a lovely, stately, understated colonial totally in scale with its lot size and totally in keeping with the streetscape and the ambiance of the neighborhood. So when a Trump building becomes a model of good taste and proper scale, one has to believe that the offending houses must be beyond the pale.

If the city of New York had designated either or both of these neighborhoods as landmark districts, the issues raised by the building of these McMansions might never have arisen. Hint, hint. Or if rezoning limited the ratio of house size to building lot to make the building of these massive structures illegal, that too would have obviated the problem and the resulting controversy. Hint, hint.

Or, since no house could get built without the use of an architect, perhaps that profession could take some greater responsibility for serving the public interest—that is, preserving

streetscapes and neighborhood character, rather than just serving an individual client. Perhaps architects should not have abetted the building of houses that look like catering halls, for instance—size-wise and otherwise—of which there are more than just a few in both Jamaica Estates and Forest Hills. Maybe there could be an architect's version of the medical profession's Hippocratic oath. Just as doctors swear to the ethical practice of medicine, architects would swear to the ethical practice of architecture, and within that rubric would be the notion of the public's rights and needs alongside, and equal to, the individual's. Hint, hint.

nature

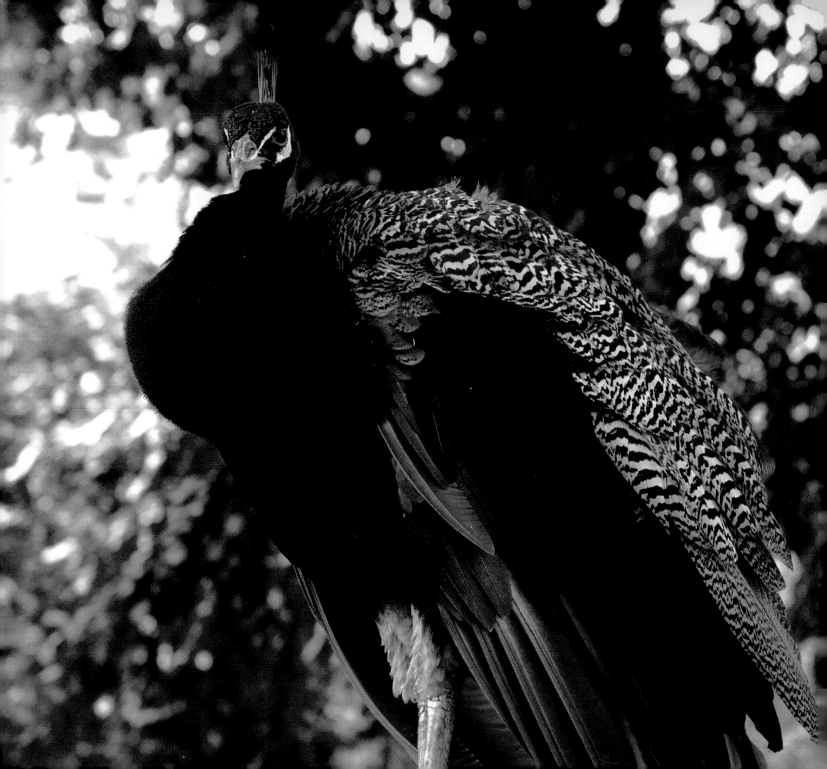

peacocks

Peacocks may be the national bird of India, but they have resided at and roamed freely on the grounds of the Cathedral Church of St. John the Divine on the Upper West Side of Manhattan since 1973. Soon after the then dean of the cathedral, the Reverend James Parks Morton, came to his position, the Philadelphia Zoo presented him with the gift of four baby peacocks. (To be precise, one should say peafowl, and in the case of babies, peachicks, for technically only males are peacocks. Females are peahens. Since the original four birds consisted of two males and two females—Matthew, Martha, Luke, and Joan—peafowls would be the proper way to refer to them.) By 1984, only two of the original four were left (peafowls on average live for about thirteen years), and this time it was the Bronx Zoo who presented the cathedral with peachicks; another three.

With no survivors left by 2002, the eighth-grade class at the Cathedral School made yet another gift of three peacocks, and since they were all male, they indeed were "peacocks"—two blue peacocks and one all white. These three, who are now about eight years old, presently grace the cathedral's grounds. True to its anthropomorphic tradition, the cathedral community has dubbed (christened?) the birds Jim, Harry, and Phil (Phil is the white peacock), named after former personages at the cathedral: James Parks Morton and Harry Houghton Pritchett, former deans of the Cathedral, and Phillip Foote, former head of the Cathedral School.

Peacocks tend to be somewhat high-strung, and they therefore do much better when allowed to roam freely in open spaces as they often do at various zoos. The 11.3 acres that comprise the campus of the cathedral, therefore, is the perfect setting for these birds, and they

do, for the most part, stay on the cathedral's grounds. If they wander, according to a member of the maintenance staff, whose duties include looking after the peacocks, they usually just go across the street to the community garden on the northwest corner of Amsterdam and 111th Street and are easily retrieved. Once, when much younger, one of the peacocks was reported to be on Broadway and 108th Street. Not so easily retrieved. Often there are calls from people reporting having seen the peacocks in Morningside Park—just to the east of St. John's and running north—but these calls have always turned out to be false alarms. What's been thought to be peacocks are invariably wild turkeys. But what do you expect from New Yorkers? Pigeons are our area of expertise.

The peacocks at St. John's are by now pretty accustomed to people, and they will approach visitors, especially when anticipating being fed. The two blues—Jim and Harry—are brothers, and thus can often be found together. Phil, on the other hand, is unrelated and tends to be more of a loner. Since white peacocks (white peacocks are *not* albinos, the former being a breed, the latter a mutation) are quite rare, comprising maybe only one percent of all peacocks, one might look upon them as an estranged, possibly discriminated against minority, and attribute Phil's loner traits to this fact. He is often to be found by himself in the vicinity of the large Peace Fountain in the front of the campus near Amsterdam Avenue, hoping some visitor will come and feed him. Jim and Harry, on the other hand, are more likely to be found behind the Cathedral School, near its kitchen, closer to an obvious and more reliable food source. The maintenance staff routinely feeds the peacocks a mixture of wild bird feed purchased online from "33rd and Bird," which looks like trail mix, and is mostly a mixture of seeds and nuts, including sesame seeds, sunflower seeds, and corn. The cathedral peacocks are said to go crazy over peanuts, in case you're interested in feeding them yourselves.

Although peacocks are considered ground birds, at least in terms of what they eat, they do roost in trees, and, therefore, the three peacocks at the cathedral can often be found aloft in any number of the many trees on the grounds. And for the most part, they sleep in these trees—year-round—although in frigid weather or on incredibly windy days, the peacocks can find warmth and shelter in the wood and wire mesh pen that has been built for them on the side of the cathedral towards the back. The pen is located next to the cathedral's boiler room, and heat from the boiler room is vented into the peacocks' pen.

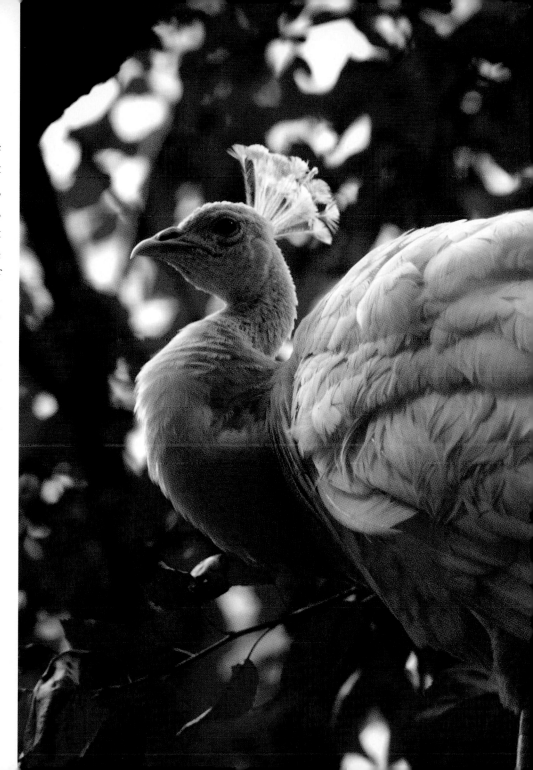

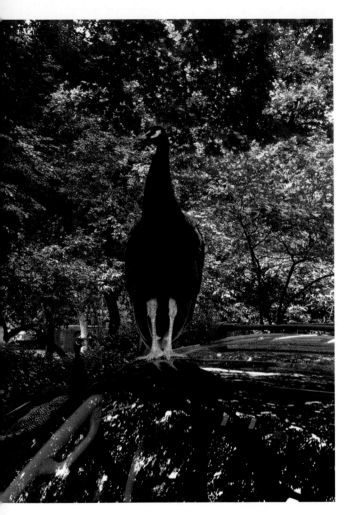

When all is said and done, the fact that peacocks live on the campus of the Cathedral Church of St. John the Divine is no more curious or fanciful than any number of other things one finds here. St. John's, the largest cathedral in the world (some refer to it as "Big John"), begun in 1892 and still not completed, is without doubt one of the most unabashedly liberal and progressive religious institutions anywhere in the city—or the world, for that matter. Long a part of the most liberal wing of the Episcopal church, and long a promoter of civil rights, gay rights, environmental justice, and the defense of the homeless and the poor, it has welcomed church attendees and visitors of every imaginable class, race, ethnicity, gender, and species. Its many community outreach and advocacy programs are aimed at the elimination of hunger and poverty. Its artist-in-residence programs include the likes of Philippe Petit (high-wire artist), Judy Collins (singer/songwriter), and Paul Winter (avant-garde saxophonist). It maintains a Textile Conservation Laboratory and, until recently, a Stoneworks Project, in which local young people were trained as stonecutters. And, of course, such events as its Native American Thanksgiving, Winter Solstice celebration, and New Year's Eve Concert for Peace all serve

to distinguish it from your garden variety church. And this is not even to mention its own gardens, which include the Biblical Garden composed of herbs and flowers appearing in the Bible.

But perhaps the most famous and distinguishing event of all is the annual St. Francis Day celebration when hundreds of animals enter the vast cathedral (approximately 600 feet long and 160 feet high) to be blessed. The original charter of the cathedral dictates that it be "a house of prayer for all people" (not just Episcopalians), and over the years "all people" has been extended to include "all creatures"—which not only explains the St. Francis Day blessing of the animals but also the tolerance of, and genuine affection for, the peacocks who have had a home at the cathedral now for over 35 years.

And although Jim, Harry, and Phil were indeed blessed on St. Francis Day the first year they arrived at St. John's, they have refused to participate ever since. Now each year, on the first Sunday of October, as hundreds of animals descend on the grounds of St. John's—dogs, cats, gerbils, and hamsters galore, but also elephants, camels, bulls, llamas, monkeys, reindeer, goats, boa constrictors, macaws, and mice, to name a few of the more exotic animal visitors—Phil and friends head for the hills. That is, the trees. The animals—especially dogs, with whom the peacocks have had some unpleasant encounters over the years—freak the peacocks out. So, if you're attending the St. Francis Day celebration and wonder where the resident peacocks might be, look up in the trees. Way up. Eighty feet up!

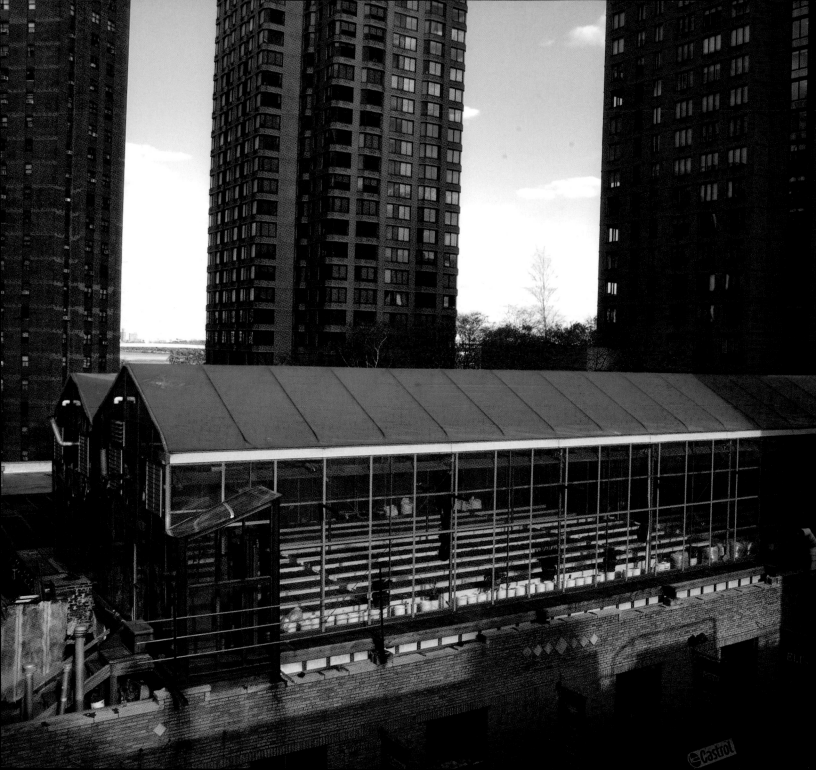

rooftop gardens

An urban agriculture blog (www.landscapeandurbanism.blogspot.com) has characterized the 22,000 square feet (about half an acre) of greenhouses that sit atop Eli Zabar's Upper East Side food emporium, the Vinegar Factory, as "one of the best productive roofs in the country." This may or may not be hyperbole, but it is certainly no exaggeration to proclaim it, at the very least, one of the best and most productive roofs in New York City.

First installed in the fall of 1997, and since added to, the greenhouses are constructed of plastic and plastic sheeting. One is on top of the Vinegar Factory (one of the original two here collapsed as result of a fire in the bakery below it in 2004) and another four are on its warehouse roof directly across the street on the south side of East 91st, between First and York avenues. Together, they provide fresh, truly homegrown fruits and vegetables to all of Eli Zabar's stores and restaurants (three food markets, three restaurants, and a cafe). This produce includes baby greens that are cut after about two weeks growth (arugula, lolla rosa, watercress, mache, mizuna, tatsoi, mesclun), herbs (basil, oregano), tomatoes (as many as 18 different kinds of heirlooms), radishes, peppers, raspberries, strawberries (including *fraises du bois*), dates, and figs.

The Vinegar Factory greenhouse is partially heated by the ovens in the pastry bakery, whose heat is vented up into the greenhouse, but the uneven heat proved insufficient for growing tomatoes year-round, the major impetus for installing the

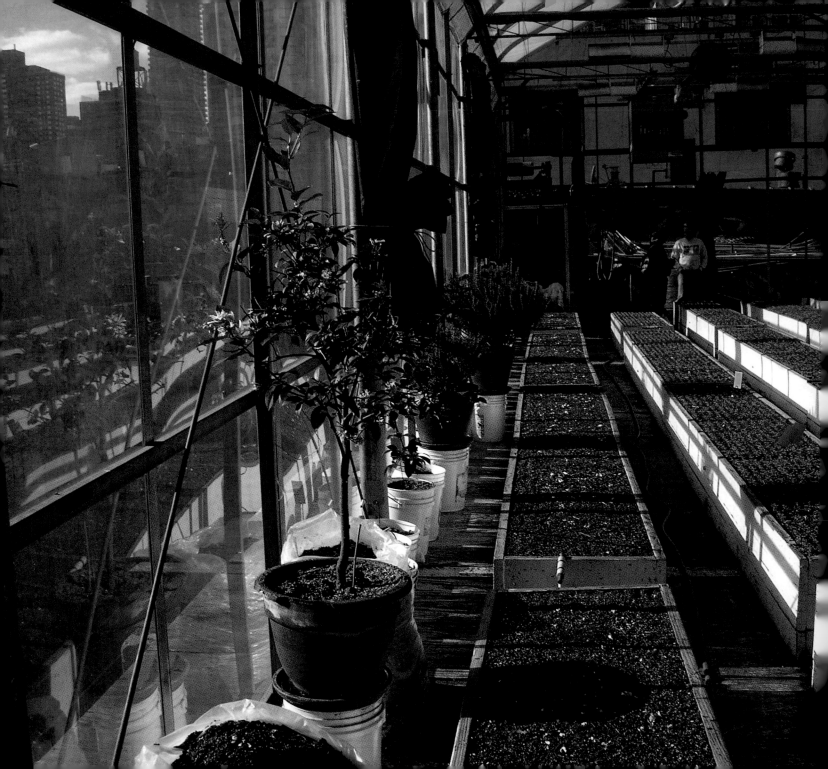

rooftop greenhouses in the first place. The temperature turns out to be perfect, though, for growing greens, which now dominate the greenhouse above the bakery. The tomatoes, grown all year, except December through February, are planted exclusively in the warmer greenhouse above the warehouse. And unlike most other greenhouse-grown tomatoes, on rooftops or elsewhere, which are almost always cultivated hydroponically, the Vinegar Factory tomato plants—which yield 40 to 50 pounds a day during the summer growing season—are grown in soil in elevated wood-framed beds. Which, of course, presents several problems of its own. To begin with, soil weighs a lot, and, in fact, the roofs had to be supported with extra steel. And two, the wood for the frames is pressure-treated with chemicals that have the potential of leaching into the soil. Since certain customers protested over the use of pressure-treated wood, as well as the labeling of the produce "organic," the beds have since been lined with plastic.

The existence of these rooftop greenhouses provides hope for urban environmentalists who envision the greening of cities, which would entail the pervasive use of New York City's rooftops for growing produce to feed the city's residents. Some large cities—Havana, Hanoi, and Singapore, among them—manage to produce much of their own food; New York produces almost none. The resulting truck traffic and pollution alone make a powerful argument for greater self-sufficiency. According to New York Sun Works, a non-profit group that promotes the idea of sustainable urban food production, there are 14,000 acres of unshaded rooftops in New York City, which, if used for rooftop agriculture, could supply food for as many as 20 million people! The group has established a floating greenhouse on the Hudson River, solar and wind powered, as a demonstration project. In 2007, the Upper West Side private school St. Hilda's & St. Hugh's established a rooftop greenhouse of its own, becoming the first school in the city to do so.

The idea of green roofs in general—planting roofs not necessarily for food production—is actually gaining some headway. Advocates of planting rooftops believe that green roofs can help reduce greenhouse gases; provide a cover that warms in the winter and cools in the summer, thereby reducing both heating and cooling costs and the demand for electricity; and capture rainwater and thus reduce runoff and its potential to flood sewers, which then pollute the East and Hudson Rivers.

To make this financially more viable to both developers and owners, tax abatements were created in 2008 for those installing green roofs, but the jury's out on whether those savings might offset the costs of greening. Con Edison recently covered the 10,000-square-foot roof of its Long Island City training center building with 21,000 plants! (Mostly sedum, an absorbent plant that usually grows in desert climates.) Also in Long Island City, the Silvercup Studio's roof has been heavily planted. Since the best potential green roofs are those on large, flat industrial buildings, it's not surprising that the largely industrial parts of Long Island City are prime territory.

Only time will tell to what extent the city's over 900 million square feet of rooftops will be greened. Money is just one of the many obstacles to be overcome. One doesn't even want to begin to think what hurdles the city's byzantine zoning and building codes present for turning rooftops into farmlands, orchards, gardens, and grasslands. Speaking to that issue just in terms of installing greenhouses, in his book *Fields of Plenty: A Farmer's Journey in Search of Real Food and the People Who Grow It*, Michael Ableman quoted Eli Zabar as saying, "It's an ordeal because there's nothing in the zoning code in New York City that permits this. I don't know what we got it under, but I do know that it was something other than greenhouse. There is nothing called 'greenhouse' in Manhattan. This is the gold coast in New York. The apartments go for millions of dollars here. This was an anomaly."

And oh, yes, in case you're interested—the Vinegar Factory was indeed once a vinegar factory. According to the *New York Times*, this block of 91st Street between First and York was undeveloped swampland until the mid-1880s, when the dumping of dirt from surrounding construction sites transformed the block from swamp to landfill. First there was a stone yard on the property where the Vinegar Factory now is, but in the early 1900s a copper factory was built here. In 1993, Eli Zabar bought the building, which had been converted into a mustard and vinegar factory. All of this history is still visible: original hooks and lifts from the copper factory remain in the Vinegar Factory, and old vinegar barrels, cut in half, serve as tables in its café.

Forewarned is forearmed. Don't blanch at the high price of the rooftop-grown produce. More than even the produce sold at various greenmarkets around the city, where prices are inexplicably high despite the elimination of some middlemen, here at the Vinegar Factory, where the rooftop greenhouses have eliminated all middlemen —farmers, truckers, wholesalers, retailers—the price tags still seem sky-high. This remains a veritable New York City conundrum.

teardrop park

Take 1,900 tons of bluestone, limestone, sandstone, and granite from the Catskills; add 65,910 trees, shrubs, perennials, ground cover, and bulbs, mostly native to New York State; invest $17 million—and you get the genius of Teardrop Park, a 1.9-acre gem in the middle of Battery Park City in Lower Manhattan. It doesn't quite reproduce the Hudson River Valley, from whose natural resources it was built, but it does evoke its spirit. And given the fact that this small park is nestled in between four 28-story high-rise apartment towers, that is no small accomplishment. That it even suggests an upstate country landscape is relief enough for urbanites who, with a little imagination of their own, can then allow themselves to be "transported" to this other place.

Although it's a reasonable assumption to think the park, completed in September of 2004, was named Teardrop in reference to, and as metaphor for, the World Trade Center, which was destroyed barely two blocks away, the name was actually given pre-9/11, and refers to the park's shape, though that is certainly not obvious inside the park. A helicopter ride over Manhattan may be necessary to confirm it.

The *pièce de résistance* of Teardrop Park is the 27-foot-high, 168-foot-long wall of New York bluestone. Created off-site and then recreated on-site, the bluestone slabs are assembled vertically rather than horizontally, resulting in something that is not only dramatic and imposing, but sculptural and unforgettable as well. Named the "Ice Wall" (with ten water spouts within it, it drips water during warm weather months, and indeed does have ice along its surfaces during the winter), it splits the park into two distinct, if not necessarily equal, sections, and a tunnel-like opening in the wall allows passage from one section of the park to another. (At the southern end of the wall is a vault, inside of which is all the plumbing and other devices necessary for the functioning and maintenance of the wall.)

On one side of the Ice Wall is the adult, quieter half, consisting of the Marsh (a veritable wetland created by rainwater collected in the park), the Hilltop Reading Circle (with stone slab "benches" to read on), and the Lawn Bowl. The grassy slopes, for sitting and sunning, are elevated and angled for maximum exposure to the sun. It was determined that for grass and other ground cover to survive, a minimum of four hours of sunlight a day is required. For that reason, when the adjacent Solaire—the nation's first "green" residential high-rise—went up, the developers agreed to lop off six inches from the roof to enable Teardrop Park to receive an additional half hour of sunlight daily.

The active or more child-centered half of Teardrop includes rocks for climbing, a sand area, a wading pool, and just about the steepest sliding pond you'll ever see, made all the more slippery and scarier by the application of sand or water. In the words of the main designer of the playground, "Teardrop is climbable, adventure packed, and potentially risky."

In fact, Teardrop was designed specifically to create a sense of adventure, and even mystery. Despite its relatively small size, one cannot really take in the entire park with one look or from any one vantage point. There are paths that are not immediately visible, and once discovered, don't necessarily lead to anywhere in particular—its design encourages, even demands, exploration.

The natural spaces and materials of Teardrop Park, as opposed to the more typical apparatus-filled flat asphalt playgrounds, are said to stimulate a child's imagination. In fact, researchers who have studied the relationship between children and nature, have found that green spaces "relieve the symptoms of attention deficit disorders, improve the quality of interaction between children and adults and, in urban play areas, reduce crime."

If all that's true, Teardrop Park may be a panacea for many of the city's problems.

the wild parrots of brooklyn

i n 1967 a shipment of parrots from Argentina was released from a container at JFK Airport. The parrots, destined for sale in New York metropolitan-area pet stores, were released, or otherwise escaped, and eventually found their way to Brooklyn College. (One assumes that was when Brooklyn College and the rest of the City University of New York still had open admissions.)

Or so the theory goes. Actually, there are many theories about these Quaker parrots, or Monk parakeets, as they are variously called. The birds were released by accident. Mafioso, who regularly broke into containers and stole merchandise, mistakenly opened the container with the birds in it. A truck carrying the birds for delivery overturned. Pet shops, glutted with too many, released the birds. And so on and so forth.

The accidental release from a shipping container at Kennedy still has the greatest currency, but in fact, it really doesn't matter how they got to Brooklyn College. More intriguing is the fact that they remain. In the four light towers that surround the soccer field, they have built nests and thrived happily since at least the very early 1970s. The light fixtures have proven to be the perfect structures on which to build their nests. The steel platforms on which they rest are strong enough to support the nests, which can weigh up to 100 pounds, and the grid-like mesh allows them to be securely fastened, invulnerable to the strong winds and other elements that could otherwise easily destroy them.

The Quaker parrot is indigenous to the southern region of Argentina, where the weather can get quite cold, and for that reason, these parrots do very well during the winter months in Brooklyn. Also, it should be said that the Quaker parrot is considered to be among the smartest of parrot species, second only to the African Gray. "Smart" is defined as the capacity to learn and repeat words.

This colony at Brooklyn College, consisting of 40 or 50 parrots, is among the largest and oldest in the New York City area. Another colony exists nearby in Green-Wood Cemetery, where the parrots have built nests in the gothic

spires of the cemetery's entrance. Parrot guano (unlike that of the pigeons they displaced) does not destroy the brownstone facade of the spires, and for that reason, cemetery personnel actually encourage these wild parrots to stay at Green-Wood. (By the way, the wild parrot guano at Green-Wood Cemetery figured in a past episode of the television program *CSI: NY*. In that episode the search for a killer is aided by the discovery of Quaker parrot guano on a tarp left behind at the crime scene. They figure, too, in Joseph O'Neill's *Netherland* (see page 66): "He was pointing back at the entrance gate, a mass of flying buttresses and spires and quatrefoils and pointed arches that looked as if it might have been removed in the dead of the night from one of Cologne Cathedral's more obscure nooks. In and around the tallest of the trio of spires were birds' nests. They were messy, elaborately twiggy affairs. One nest was situated above the clock, another higher up, above the discolored green bell that tolled, presumably, at funerals. The branches littered a stone facade crowded with sculptures of angels and incidents from the gospels...")

Smaller colonies than the ones at Brooklyn College or Green-Wood can be found elsewhere in Brooklyn—in Sheepshead Bay, Canarsie, and Marine Park—and also in the Bronx and Queens as well. But the colony of Quaker parrots on the campus of Brooklyn College is thought to be where the wild parrots in other parts of Brooklyn and surrounding areas originated and emanated (emigrated?) from. In the words of a self-appointed wild Brooklyn parrot *maven* who tracks and monitors their activities on a "Wild Parrots of Brooklyn" website—and who, incidentally, gives a guided tour at least once a month—"Brooklyn College is their Ellis Island." Embracing this notion, the children's playground directly across the street from the athletic field (Avenue H and East 21st Street) is graced by a metal fence whose motif is the wild parrots of Brooklyn—scores of them have been sculpted into the fence design.

Rarely do the parrots build their nests in trees. Nearby the Brooklyn College athletic field—on the south side of Glenwood Road, between East 21st and East 22nd Streets—there actually is one of their rare tree-based nests. The thorniness of this particular locust tree apparently allows it to be a suitable base for securing the parrots' large nest. But this seems to be the exception.

Otherwise, electrical towers and other high-up electric power structures appear to be their favored nesting place; a fact that has led to ongoing battles with local power authorities. (Power struggles?) Con Ed claims the nests can wreck their equipment (the nests trap heat that should otherwise be vented out of transformers and other devices) or else cause short circuits (when wet, the nests conduct electricity). In Whitestone, Queens, Con Ed has installed a battery-powered plastic owl atop one of its poles to scare off the parrots. The "owl" swivels its head and makes a "hooting" sound.

This ruse has proven to be somewhat effective in warding off the birds; until, of course, the batteries go dead and the plastic owl is discovered for the fake it is.

the chinese scholar's garden

Staten Island and Suzhou, China, located just north of Shanghai and famous for its canals (and therefore called the "Oriental Venice") have something in common, and it's not just that the names of both places begin with the letter "S." In fact, their one commonality makes them officially—well, maybe unofficially—sister cities.

Staten Island and Suzhou are both home to Chinese scholar gardens. Suzhou has dozens of them. Staten Island has one. But that one makes Staten Island special indeed, for while there are tons of Japanese gardens located all over the United States—they're a yen a dozen—there are only a handful of authentic Chinese gardens, and Staten Island's was this country's first. (The Chinese garden in Portland, Oregon opened soon thereafter. There is also one in Seattle, another in San Marino, California, a few in Canada, and that's about it for North America.)

It's not entirely clear how the idea to locate a Chinese scholar garden within the Staten Island Botanical Gardens was settled upon. The official literature seems to indicate that the idea was seen as a way to attract visitors to the under-visited, lesser known Staten Island gardens (compared to either the Bronx or Brooklyn botanical gardens). In short, it was to be a major tourist attraction, though "tourist" and "Chinese scholar" don't seem natural allies, and certainly not kindred spirits. For that matter neither do "Staten Island" and "Chinese scholar" seem to have a natural affinity. No knock on Staten Island, but despite its many fine educational and cultural institutions—and despite its public elementary schools scoring high on standardized math and reading tests—it is by almost all accounts not considered New York City's intellectual or cultural center.

Be that as it may, the idea for a Chinese scholar's garden was hatched in 1984 and implemented over the next fourteen years with the cooperation of the Landscape Architecture

Corporation of China in Suzhou, which provided both the design and guidance. In the spring of 1998, forty Chinese workers from Suzhou came to New York and spent six months at Snug Harbor building the scholar's garden. Not only did they use traditional materials shipped to Staten Island from China—including wood, rocks, stone, tiles, and so forth—they used traditional tools as well.

Opened officially in June 1999, the New York Chinese Scholar's Garden consists of eight pavilions (separate roofed structures, some enclosed, some open) connected by walkways, around a central pond all enclosed within an outer wall. Everything about the space is designed to encourage peaceful contemplation. Enclosed space to encourage intellectual contemplative thinking. Open spaces to inspire more spiritual musings. The abundant bamboo represents strength and resiliency; plum trees fill with blossoms (the national flower of China) in March.

The Chinese scholar garden has a long tradition in China, first appearing in the 15th century. Suzhou, in particular, is famous for these gardens, having been home to thousands of them over the centuries (60 remain today, 19 open to the public). Their purpose then and now was to provide intellectuals (who were also the class who rose to top government positions) a place to gain respite from the pressures of their workaday world—i.e., the "real world." They were to be places for rest and relaxation, but also for contemplation and other meditative pursuits. Achieving these ends was facilitated by applying Confucian principles to the building, plant, water, and rock design. On a piece of slate on the grounds of the New York Chinese Scholar's Garden it is written: "The conflict between scholarly civic duties and the desire to retreat from the world is called 'The Scholar's Dilemma.'" And so it is.

Although Japanese gardens derive many of their principles from the Chinese gardens that predate them, Japanese gardens do differ from these Chinese ones. It seems Chinese gardens

are somewhat more *representational* of the natural world, whereas Japanese gardens are more *of* the natural world. Buildings, for example, are essential elements to all Chinese gardens; in fact, it has been said that without buildings, the Chinese garden is not a garden. One blog, in fact, talks about how Chinese gardens are built, not planted. It might be said that there is more "garden" in the Japanese garden compared to the Chinese.

Botanical gardens are almost by definition a step removed from the urban fray. A Chinese scholar's garden within a botanical garden is two steps removed. And a Chinese scholar's garden within a botanical garden within Staten Island (which many New Yorkers will say is not really the city) makes it thrice removed. Given that a Chinese scholar's garden's main purpose is to provide an escape from the pressures of urban life, its location on Staten Island may be just right.

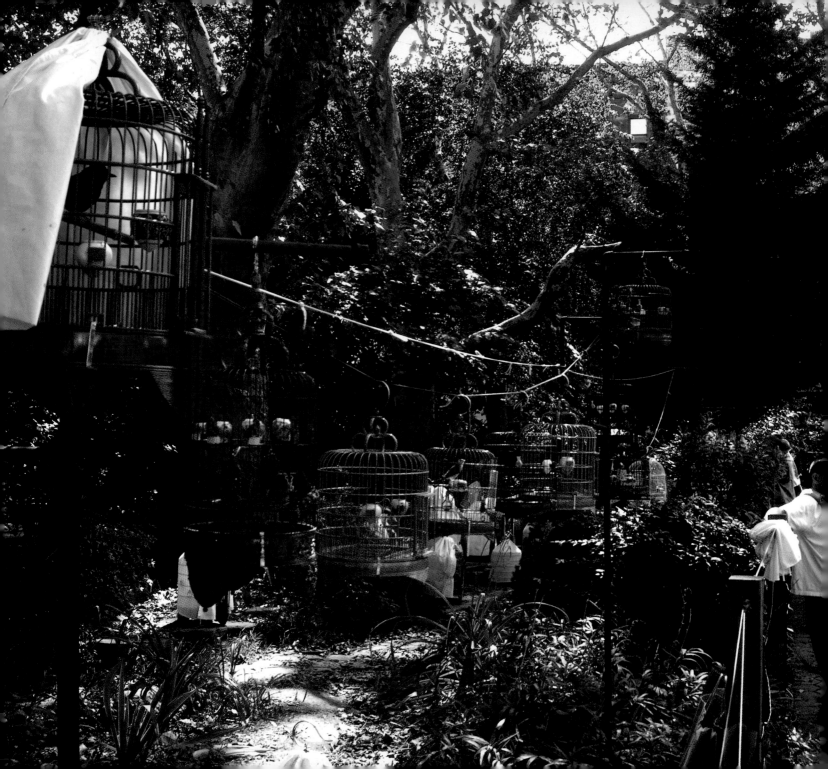

hua mei songbirds

One is likely to associate music and New York City with certain indelible images. Tin Pan Alley, Broadway, the Metropolitan Opera, Carnegie Hall. Street corner or subway musicians even. Or any number of other live music venues with everything from classical to jazz to rock to folk to blues to hip hop. It's doubtful, however, that anyone would think of the Hua Mei songbirds, who each warm-weather morning, in a small area of a park on Manhattan's Lower East Side, produce some of the city's sweetest and most euphonious sounds.

In the mornings, particularly on weekends, elderly Chinese men bring their birds to an area of Sara Delano Roosevelt Park at Delancey Street (a part of the Lower East Side into which Chinatown has spilled) that is now named the Hua Mei Bird Garden. Some mornings see as many as fifty or more cages, many draped in white to calm the skittish and apparently territorial birds, from whom song emanates, all at the same time if not necessarily all in the same key.

The Hua Mei songbird (Hua Mei means "painted brow" in Chinese, and it refers to the white and blue and violet markings that encircle their eyes) is indigenous to southern China. It is a

small bird of the thrush family whose body is a kind of tawny brown with areas of gray and yellowish green. It is said to be the loudest (and therefore most popular) songbird in China. Also, since keeping a Hua Mei is high maintenance and time-consuming, historically it was considered a good pet for men, as a way to keep them from certain vices: wine, women… and, well, obviously not song.

Although at one time Hua Meis could be sent or brought into the United States, a combination of an export ban (related to the bird being an endangered species) and an import ban (related to the Asian bird flu epidemic) has all but put an end to them being brought here from China. Now the primary avenue for obtaining a Hua Mei songbird in this country is via breeding, which is increasingly being done, for both fun and profit.

While the daily gathering of songbird owners along with their birds is a centuries-old tradition in China, in New York it seems only to be decades old. Although some remember the Hua Mei birds being brought to Sara Roosevelt Park as far back as the early 1980s, it wasn't until 1995 that the Hua Mei Garden was officially established by the Forsyth Street Garden Conservancy. Its use as a bird garden has thrived there ever since, with just one threat to its continued existence when someone or some group proposed to make the bird garden into a dog run. Fortunately, that idea was short-lived.

The songbirds and their owners are joined each morning in the nearby asphalt playground by an assortment of practitioners of Tai Chi and various forms of Chinese martial arts to create an interesting and truly foreign tableaux.

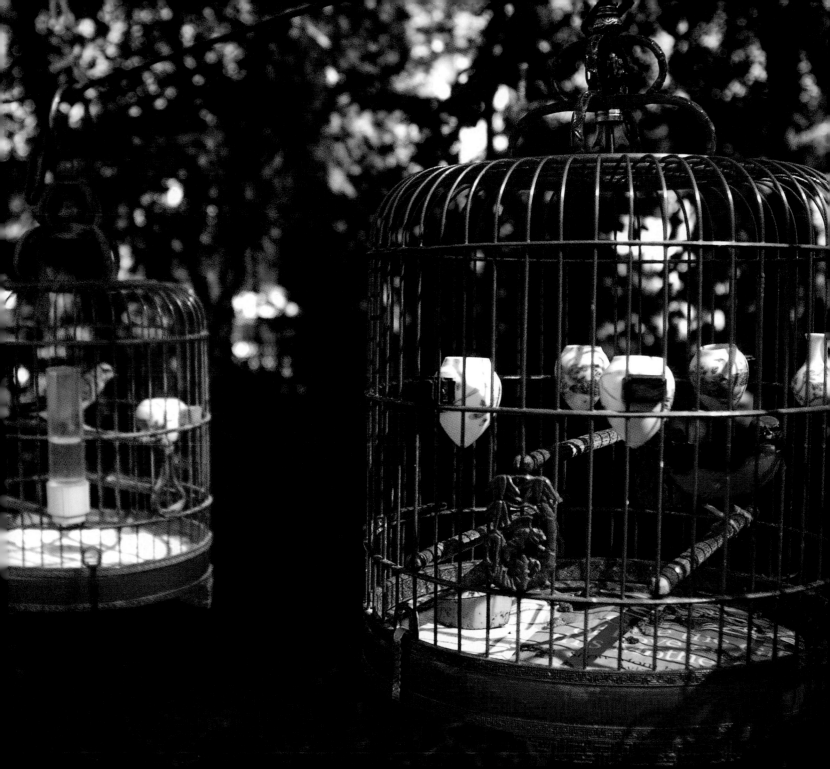

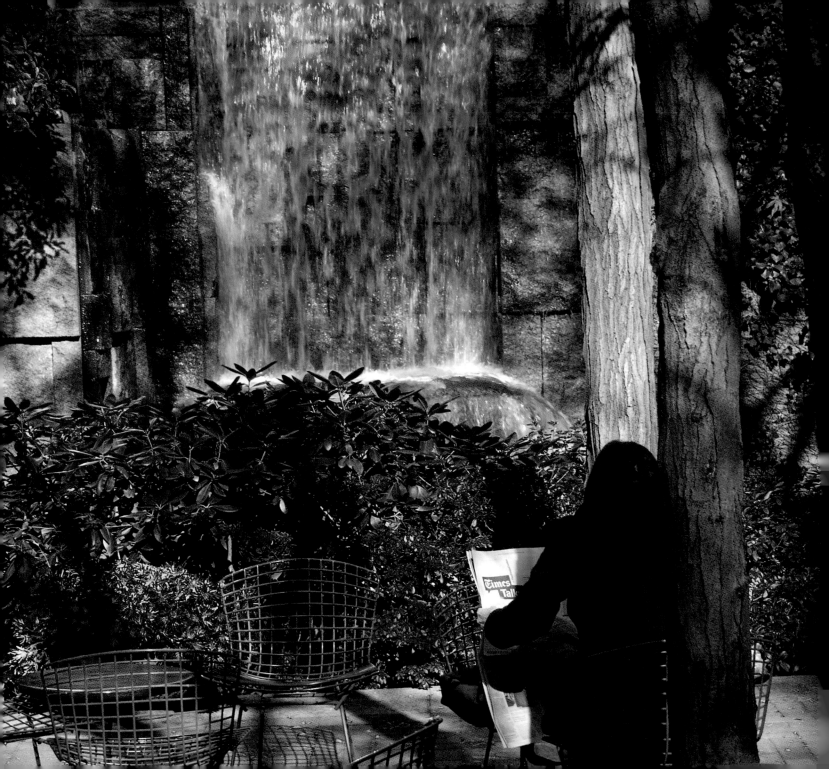

waterfalls

no one is likely to mistake the waterfall cascading down twenty-five feet of granite wall in Greenacre Park on East 51st Street (between 2nd and 3rd Avenues) in Manhattan, for the real thing. But if you stand up close enough to it, its height, volume, sound, and spray makes for an awfully good facsimile of a naturally occurring one. In fact, visiting Greenacre's waterfall accomplishes the same thing as visiting a natural and much larger waterfall: to wit, a certain sense of serenity that only moving, falling water can provide. And although Greenacre won't actually take you out of the city, its setting and its roaring sound will serve to block out the city—or, at least, the noise of the city, which is a pretty good thing in and of itself.

The waterfall in Greenacre Park, a privately owned vest pocket park open to the public ("A Private Park for Public Enjoyment" says the sign at its entrance), is by no means the city's only waterfall. Far from it. In fact, in the summer of 2008, "The New York City Waterfalls" display, a $15.5 million public art project funded by the public (though the city claimed it brought in $69 million worth of tourist and other revenues) and created by the Danish-Icelandic artist Olafur Eliasson (four 90- to 120-foot-high scaffolds from which 35,000 gallons per minute of water from the East River fell at different New York waterfront locations) was the occasion for the city to take stock of its waterfall inventory. It was discovered that there were many waterfalls throughout the city, indoor and outdoor, man-made and natural; indeed, waterfalls were all the more numerous the more one stretched the notion of "waterfall."

The inventory included, for example, outdoor waterfalls in Prospect and Central Parks (not nearly as high as Greenacre's); the Botanic and Botanical Gardens (that is, Brooklyn and the Bronx, respectively, which are also puny—6 feet and 13 feet—compared to Greenacre's); as

well as Morningside Park (at 30 feet high, taller than Greenacre's). There are also a plethora of indoor waterfalls—from the Trump Tower on Fifth Avenue, to the Olympic Tower, also on Fifth Avenue, to the Rosa Mexicano Restaurant on Columbus Avenue (a 30-foot-high waterfall!). And inside the Hillside Mausoleum in Brooklyn's Green-Wood Cemetery, not just one, but two five-story high waterfalls!

One article about waterfalls in the *New York Times* even included the sprays, and resulting cascades of water, from high-pressure hoses used to clean the facades of office towers. And if that was not stretch enough, the listing of "waterfalls" in New York City also included the rush of rainwater from the leak in the roof above the Newkirk Avenue subway station in Flatbush, Brooklyn! (What about street flooding as a result of overflowing catch basins? How about water main breaks?)

That the city is filled with all manner and types of man-made outdoor and indoor waterfalls should come as no surprise. Most are the result of developers filling public spaces—parks, plazas, atriums, and arcades—with fountains, pools, and, yes, waterfalls; not out of the goodness of their hearts, but rather as a result of a zoning resolution adopted in 1961 (and revised in 1975) that allows for what is known as incentive zoning. Under incentive zoning, the city gives additional floor area and other bonuses to developers of office and residential buildings if they agree to establish some space—either indoors or out—for the use of the public. Often the space is just open space or just access to, or through, a building. But the best of these "privately-owned public spaces" are thoughtfully designed, with serious money lavished upon them, resulting in public spaces that are esthetically pleasing and actually welcoming to the public, as opposed to offering just an indoor passageway through a building from one block to the next. (New York's 1961 incentive zoning resolution was the first such one in the country, which seems odd given the

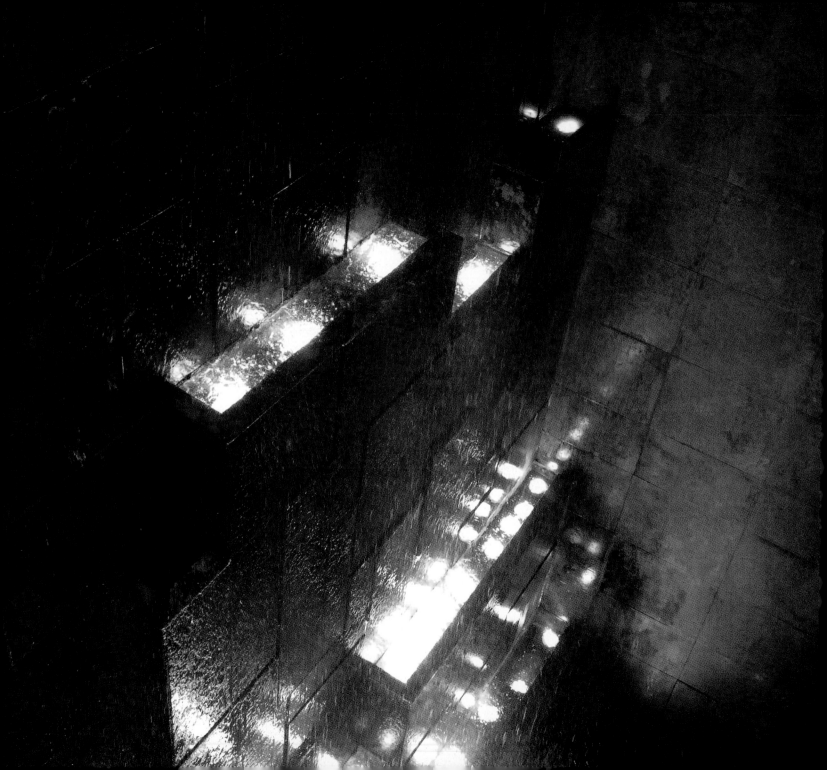

fact that New York had not yet established a landmark preservation law to protect its vast volume of unique, historic building stock. That didn't come until 1965, and much of the city's historic buildings were destroyed and lost forever as a result of that late-in-coming preservation law.)

Make no mistake about it, even the better privately-owned public spaces were spawned by the profit motive. So okay, Donald Trump adds a dramatic, crowd-pleasing five-story water wall to the public atrium of Trump Tower, but, as part of the bargain, was able to add some number of extra salable or rentable floors beyond what zoning laws would otherwise have allowed. In all, over 500 private-public spaces throughout New York City have been created as a result of this incentive zoning trade-off. Most, not surprisingly, are in Manhattan.

The 6,360-square-foot Greenacre Park distinguishes itself (as well as its "sister" vest pocket Paley Park on East 53rd Street between Madison and Fifth Avenues) from other private-public spaces by virtue of not having been built as a result of incentive zoning. Rather, it was the 1971 gift of Abby Rockefeller Mauze (granddaughter of John D. Rockefeller and daughter of John D. Jr.) for the purposes of giving New Yorkers "some moments of serenity in this busy world." It, along with Paley Park (which also has a waterfall, though somewhat smaller than Greenacre's), are considered to be among the most beautiful and successful public spaces in the city, and, in fact, both Greenacre and Paley parks were selected by the Project for Public Spaces, a non-profit group devoted to "making public spaces better," as being among the best twenty-four parks in the world.

John D. Rockefeller was in the eyes of many a robber baron at worst, and in the eyes of the Supreme Court, a monopolist at best, but it is with his money that his granddaughter created the foundation that built and maintains Greenacre Park. So, although one can say it was built *with* profit, unlike other privately-owned public spaces in the city, it was not built *for* profit.

backyard chickens

not only is it legal to keep chickens in New York City, since they are characterized as pets under the New York City Health Code (domesticated rabbits too, but not roosters, nor for that matter ducks, geese, or turkeys), but New York could very well be among the most chicken-friendly major cities in the country.

While New York places no limit on the number of chickens one can have, other major cities that allow chickens usually put a cap on that number: San Francisco (4), Miami (15), Baltimore (4), St. Louis (4), Portland (3), Houston (30), San Antonio (5), Salt Lake City (25), and Seattle (3). And even in those cities that allow for keeping an unlimited number—Los Angeles and Oakland, for example—minimum distances must be maintained between the chickens and what's nearby. In Oakland, chickens must be at least 20 feet from a neighboring dwelling, church, or school. In Los Angeles, not only must the chickens be at least 35 feet away from a neighboring dwelling, but also not within 20 feet of the owner's residence. In densely populated New York City, where residents raise chickens in their backyards, on rooftops, and in some instances in their very apartments, such restrictions would make the keeping of chickens prohibitively difficult, if not impossible. (For the record, it should be noted that Chicago and Memphis seem to have laws equally as liberal as New York's. Also for the record—the other side of the ledger—cities that completely prohibit the raising of chickens as pets include Boston, Washington, D.C., San Diego, Detroit, Pittsburgh, and Toronto.)

There seems to be no logic to the fact that the city allows for the raising of chickens but has only recently legalized beekeeping. Still, the city was voted by *Animal Fair* magazine to be the "Pet-

Friendliest Destination" in the country! True. At least when it comes to four-legged pets—particularly dogs, of which there are many. (Though it's unproven, an impressionistically strong observation is that the smaller the apartment a dog owner in New York City has, the larger the dog. Think about it.) New York won this accolade by virtue of its many dog-friendly hotels (the Carlyle, SoHo and Tribeca Grand, Hilton Times Square, among them) and restaurants, pet-friendly bars and stores (Time Warner Center, Bloomingdale's, Bergdorf's, and Saks) and tourist attractions (the Statue of Liberty). And the city's more than two dozen off-leash dog parks. Though it's not clear whether New York would have won *Animal Fair*'s designation had the May 2009 law banning pit bulls and large dogs (over 25 pounds) from all of the city's public housing projects been in effect at the time.

But back to chickens. Although probably some number of New Yorkers always raised poultry in the city, they probably came from rural backgrounds—the American South or the Caribbean, for instance—and were replicating what they were accustomed to. But more recently, raising chickens has moved beyond that demographic to include those just generally interested and involved in the sustainable, organic, locally-grown food movement; the same residents who grow produce in community gardens—or their own backyards, rooftops, and terraces.

Just Food, the not-for-profit that promotes sustainable farming programs, has had a City Chicken Project since 2005 that has encouraged the raising of chickens, particularly in community gardens. It publishes *City Chicken Guide* and also holds chicken raising workshops throughout the city. The head of Just Food's Chicken Project, in an interview on NPR, confirmed that chickens are being raised in all five of the city's boroughs, with thirty or more community gardens raising chickens, and that despite their ban, roosters are being raised as well—the abundance of fertilized eggs hatched a dead giveaway.

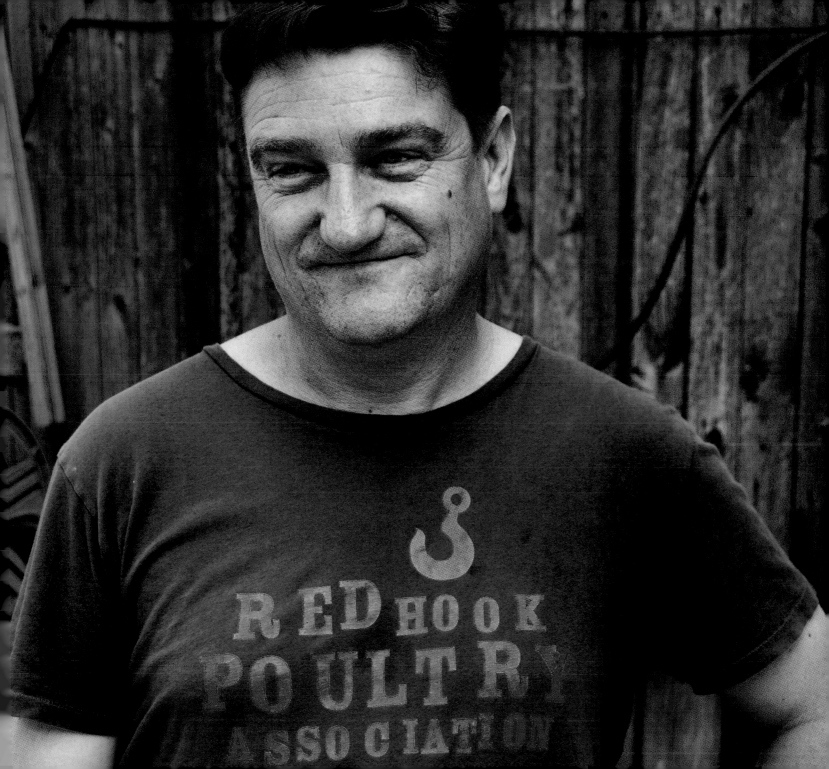

Those who promote the raising of chickens point out the following beneficial effects: chickens are low maintenance; they provide nitrogen-rich compost; they eat harmful bugs and insects; they eat food scraps that would otherwise be thrown away; they lay eggs (two every three days), often of lovely pastel hues (blue, green, chocolate brown) that are rich and flavorful with higher levels of omega-3 fatty acids but lower levels of cholesterol and, of course, fresher than store-bought eggs. And chickens are fun.

On the other hand, a real estate agent—on the same NPR program—asserted that having a chicken coop in one's yard reduces the value of the house next door by 10 to 15 percent. So it remains to be seen how much longer the burgeoning chicken-raising phenomenon burgeons. Will real estate values win out over the value of homegrown food? Real estate in New York City usually trumps all else. We'll just have to wait and see.

In the meantime, baby chicks can be easily purchased online from any number of hatcheries around the country. Murray McMurray Hatchery in Webster City, Iowa is often mentioned as a major source. Chicken feed—and, also, grit, which enables toothless chickens to grind up their food and then swallow—can be purchased from Animal Feeds, Inc. in the Bronx, the only animal feed store in the city. And prefab chicken coops are available for purchase from suppliers as well. A British designed coop, named the "Eglu," appropriately enough, is particularly popular.

When ordering chickens online, be careful. The minimum order is typically 25 chicks, and as one Brooklyn backyard chicken keeper confessed, "I wasn't paying close enough attention to what I was doing online, and I must have mistakenly clicked twice. I got 50 chicks in the mail instead of 25!"

Is that double clicking? Or double clucking?

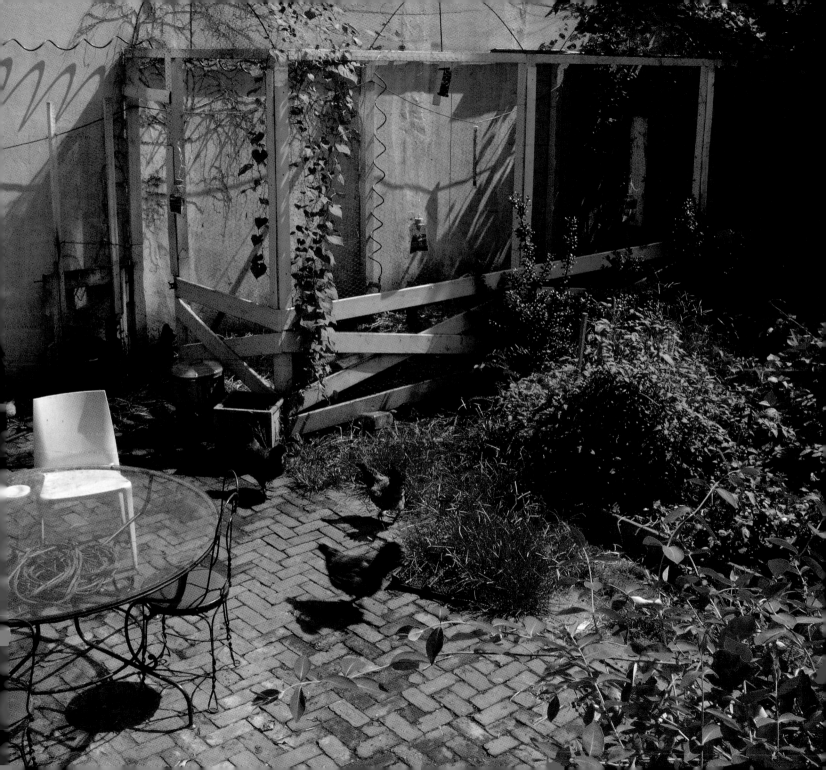

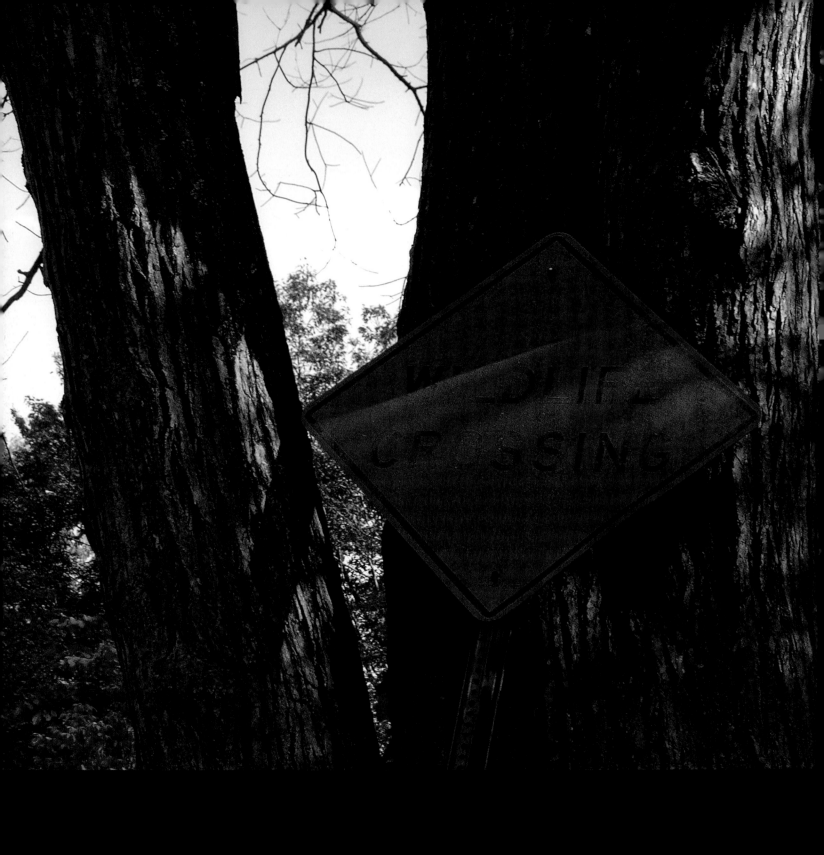

all the boroughs of New York City can claim to be home to certain wildlife—ducks, geese, squirrels—but only on Staten Island does one have to worry about hitting them with one's car. Staten Island alone has both a critical mass of animal life plus roads and highways near where they inhabit, which warrants the "Wildlife Crossing" or "Deer Crossing" signs one sees there.

Staten Island's flagship park—what Central Park is to Manhattan, Prospect Park to Brooklyn, Cunningham Park to Queens, and Van Cortlandt Park to the Bronx—is the Greenbelt. With 2,800 acres of contiguous, connected traditional parkland as well as natural areas (forests, wetlands, marshes), it is three times the size of Central Park and twice as large as Central and Prospect parks combined.

It is primarily on the roads in and around the Greenbelt that one comes upon the yellow, diamond-shaped "Wildlife Crossing" signs. Aside from the ducks and geese just mentioned, the "Wildlife Crossing" signs address—and therefore, hopefully protect—the following animals: turtles (painted, box, and snappers, including the alligator snapping turtle and red-eared sliders); raccoons; opossums; muskrats; groundhogs; the eastern cottontail rabbit; and wild turkeys.

Although it's questionable whether the wildlife signs had them in mind, an abundance of eastern chipmunks and gray squirrels can be found on Staten Island. And snakes of all kinds. Interestingly enough, although none of these snakes are poisonous (there are, in fact, no poisonous snakes indigenous to Staten Island), the Staten Island Zoo houses one of the largest collections of poisonous snakes in the country!

The signs warning of deer crossing can be seen along the West Shore Expressway, where it runs close to the Arthur Kill, the narrow body of water that separates Staten Island from

New Jersey. It is pretty much accepted knowledge that white-tailed deer from New Jersey swim across the Kill to Staten Island (there have been many sightings of them swimming), particularly at its narrowest points, like at the southern end of the island, around Tottenville.

One Staten Island official, noting that the time of greatest deer migration is in October, theorizes that since the deer hunting season in New Jersey begins in November, these deer en route to Staten Island are merely attempting to beat the gun (as opposed, say, to seeking better jobs or educational opportunities). This is just one man's theory. The coincidence of the migration and the hunting season might be just that: coincidence. In any event, there are indeed deer on Staten Island, and their numbers are ever increasing.

Though much of what one finds in New York City is unexpected, perhaps what is inexplicable surpasses what is unexpected. For instance, repeated attempts to find out who—what group, agency, or organization—was responsible for installing these wildlife signs proved fruitless. Inquiries to the Department of Parks and Recreation, the Greenbelt Nature Center and Conservancy, the Urban Park Rangers, Historic Richmond Town, the Staten Island Borough Office of the City Department of Transportation, the Staten Island Borough President's Office, and the State Department of Environmental Conservation yielded no answer.

Everyone knows the State Department of Transportation put up the deer signs, but the motive force behind the "Wildlife Crossing" signs remains a conundrum. "It could have been the city or the state. It could have been an official environmental group," said the same city official who theorized about the deer. "Or it could have been one of those 'private, radical, self-serving environmental groups.' Who knows?"

All of which tells you what it might be like trying to fight the proverbial city hall in New York. Finding "city hall" could be a greater challenge than fighting it.

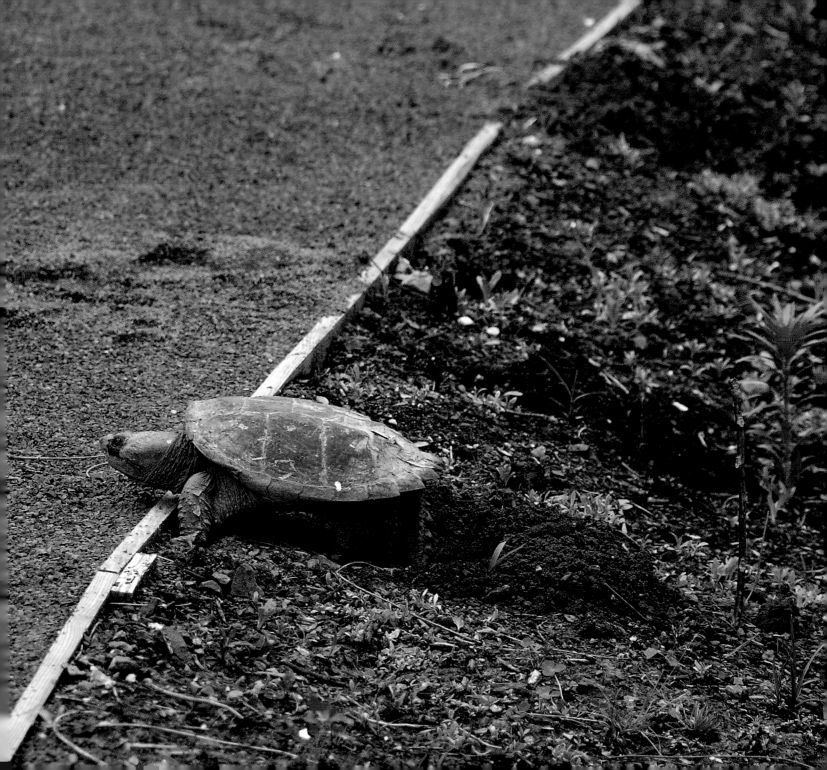

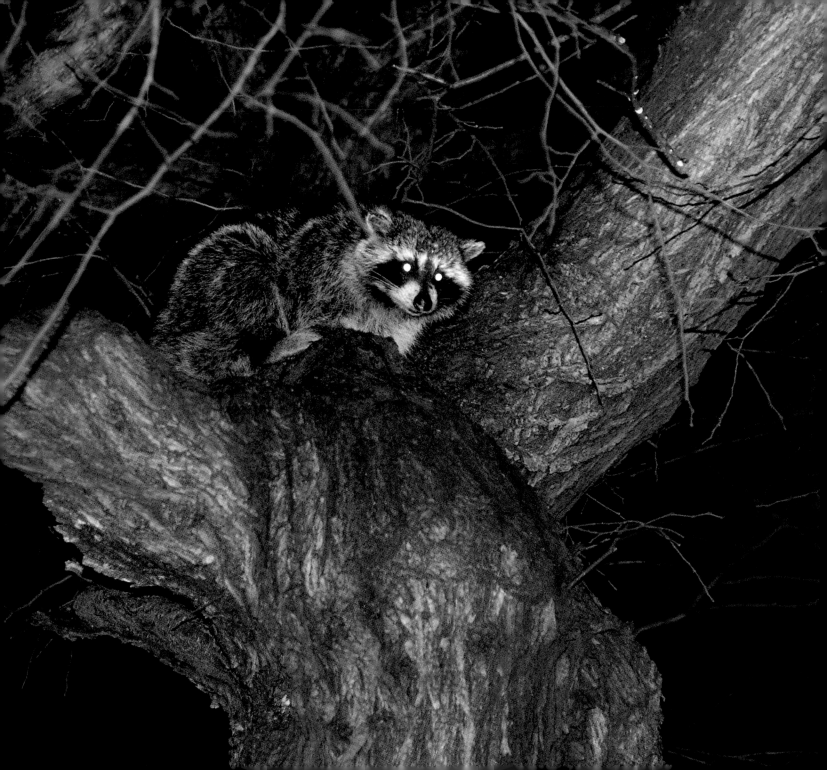

raccoons

anyone who has lived in New York City for even a short length of time has probably encountered a raccoon or two in their perambulations around the city, particularly in or near a park. So, it's no surprise to natives that the city is home to these nocturnal omnivores, though it might come as a revelation to a visitor.

What will probably come as a surprise to both New Yorkers and visitors alike, however, is the fact that the highest density of raccoons in the entire state is here in the city. Though, if you think about it, raccoons are ever adaptable, and as omnivores can thrive on garbage, of which there is no dearth in the city.

No one can know the exact number, of course, but consensus has it that hundreds of raccoons live in Central Park alone. (At the rather tony address of Central Park West and 93rd Street, just as one enters the park, a tree just north of the entrance will almost certainly yield a raccoon sighting or two or five.) Others of the city's parks, such as Prospect Park in Brooklyn, also seem to have become "natural" habitats for the city's raccoon population. Brooklyn's Green-Wood Cemetery, too, appears to be a favored location; since the early 1990s, over 500 raccoons have been caught there. Once caught, though, they are generally released or relocated, since possessing or killing a raccoon is illegal. At least it is without a license. (Technically, according to the state's Department of Environmental Conservation, which grants hunting licenses, the raccoon-hunting season in New York City is from November 1 to February 1, but somehow it seems far-fetched to think a license would ever be granted to hunt raccoons in, say, the Botanic Gardens!)

It also seems to be agreed that whatever the actual raccoon population of the city is, it has been increasing in recent years. One sign is the uptick in the number of raccoon sightings reported to the city's 311 telephone number. And, surrendering to their seeming omnipresence, in 2007 the city's Center for Animal Care and Control stopped accepting raccoons, unless there is some indication that they might possibly be rabid. In any event, the average density of raccoons in New York state is thought to be around 50 raccoons per square mile. Given that the area of New York City is just over 300 square miles, and that we already know it has the highest density of raccoons in the state, we're talking thousands, or even tens of thousands.

Aside from the ready availability of garbage—often not contained in cans—raccoons get additional nourishment from people feeding them. It is well known, for example, that at the "luxury raccoon residence"—the tree at the West 93rd Street entrance to Central Park—almost nightly someone leaves bits of chicken for the raccoons. Marie Winn, author of *Central Park in the Dark: More Mysteries of Urban Wildlife*, responding to someone bemoaning the large number of raccoons near the pool in the northern part of the park said, "They've been there for years, both the raccoons and the feeders—that Russian lady in the wheelchair who brings bushels of macaroni and cheese and old pizzas has been feeding her little raccoon pack for five years or more, and that father and son who bring 25-pound bags of peanuts in the shell are also old-timers."

She went on to urge people not to feed the raccoons if they were concerned about their growing numbers. She did, however, stop short of advising something akin to the park's "Geese Police," who have been attempting to rid Central Park of its large number of Canadian geese. "I wonder if the population could be controlled somehow?" she mused. "But not via a ridiculous mechanism like the Geese Police—a profoundly useless waste of money if I've ever seen one! Talk about sheltered employment—and all they ever seem to chase away properly are the wild ducks!"

New Yorkers seem to fall into two camps: those who love the little critters, and those who don't. The latter considers them nuisances at best (upsetting cans and ripping through plastic bags of garbage, destroying gardens, digging up lawns, and scaring the bejeezus out of unsuspecting souls) and carriers of rabies at worst, although the incidence of rabid raccoons is not exceedingly high (somewhat over 200 cases citywide since 1992; eight in the first half of 2008), and in recent years, those reported were primarily on Staten Island or in the Bronx; none in Manhattan. And, apparently, there has never been even a single case of human rabies from a raccoon reported in the city.

As for the position of those in the "we love those cute, bushy-tailed, masked little marvels" camp? "They're essentially oversized cats," one such person tells us. "They've managed to survive in this tough city like the rest of us," another chimes in admiringly. "People need access to wildlife in urban areas. I consider it a bonus," yet another booster argues. And, as for those still not convinced of their intrinsic value, one is reminded that where there are raccoons, there are *no* rats.

Finally, lest one become overly exercised over the city's large raccoon population, consider the perspective provided by New York City's Parks Commissioner, Adrian Benepe, who was once quoted as saying, "They were in the parks before they were parks."

none of the above

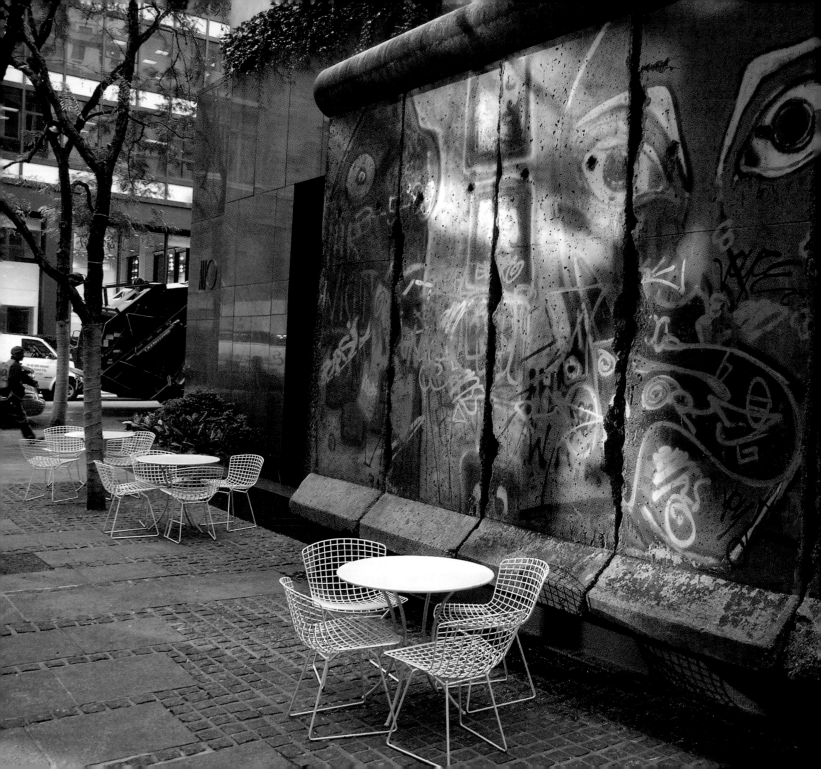

the berlin wall

If these concrete slabs look like they could be pieces of the Berlin Wall, it's because they *are* pieces of the Berlin Wall! When the Wall came down in 1989, the German Democratic Republic offered to sell 360 of the Wall's 45,000 sections. (Other fragments were sold by non-governmental sources—that is, demolition companies and private citizens.) Five of these sections wound up in Paley Park in midtown Manhattan, on East 53rd Street between Fifth and Madison Avenues. Paley Park, named after William Paley, the former chairman of CBS, was in 1967 the first of the several vest pocket parks in the city. Not surprisingly, it's located next to the Museum of Broadcasting, which Paley also founded.

Each of the five slabs of the wall in Paley Park is just under 12 feet high and 4 feet wide and weighs over 6,000 pounds. These sections come from the fourth generation of the 96 miles of the Berlin Wall that completely surrounded West Berlin. When the wall was first established in August 1961, it was basically barbed-wire fencing. In 1962, a second generation of wall, a second barbed-wire fence about a hundred yards behind the original fence was installed,

creating a no-man's land in between called the "Death Strip," where potential escapees from East Berlin were trapped, captured, or worse. (As many as 170 potential escapees were killed during the years between 1961 and 1989.)

In 1965, a concrete wall, the third generation, was added, and, then, in 1975, the original concrete wall was replaced by the fourth generation of the wall, constructed of reinforced concrete topped by a steel tube, to make scaling it more difficult. During the life of the Berlin Wall some 10,000 escape attempts were made nonetheless, and as many as 5,000 were successful. Among the more famous successful escapes were those accomplished by tunneling under the Wall and flying over it in a hot-air balloon.

It is from the reinforced concrete incarnation of the Berlin Wall that the pieces in Paley Park come. The graffiti art that graces the facade was pervasive throughout the length of the wall, although, not surprisingly, only on the side that faced West Berlin.

That a piece of the Berlin Wall resides quietly, mostly unknown and unnoticed, in midtown Manhattan is unlikely. But no less so than any of the other locations in the United States—CIA Headquarters, Microsoft's cafeteria, or the Civic Center of Rapid City, South Dakota among the approximately twenty US locations—Manhattan looms no more unexpectedly than anywhere else (and there's actually another Manhattan location: the Intrepid Sea, Air & Space Museum). Most unexpectedly of all are sections of the wall in Las Vegas installed inside the men's room of the Main Street Station Hotel and Casino. The urinals are attached to the wall, so patrons can literally urinate against the Berlin Wall, which elevates it to a very powerful, albeit tasteless, site-specific, message-art installation.

hells angels headquarters

ention motorcycle clubs and Hells Angels is undoubtedly the first one that comes to most people's minds, though New York City is probably not the place most people associate with them. Nonetheless, here they are in the middle of the East Village in Manhattan, where they've been a fixture since 1969.

Their headquarters, in a six-story tenement building that they own—clubhouse on the ground floor and apartments above—is located on East Third Street, between First and Second Avenues. It is a block of mostly early 20th-century tenement buildings (which, these days, doesn't necessarily make apartments in them inexpensive), although the signs of upscale new construction and renovation are becoming more and more obvious, making the Hells Angels' presence on the block progressively more anomalous. It is a block on which the sometimes pugnacious and pugilistic Angels coexist with unlikely neighbors: Maryhouse, a "hospitality house" of the non-violent, pacifist Catholic Workers movement just a few doors down and a new student residence for New York Law School right next door. Not to mention the block's hookah bar and spiritual advisor.

Though there are more than a hundred Hells Angels chapters in 29 countries, it is California with which they are most identified. After all, it was in Fontana, in San Bernardino County, where the Hells Angels were founded in 1948 and where the strongest chapters still exist. California's climate and roads are perfect for motorcycling. New York City, by contrast, must be considered highly imperfect. The weather here, particularly in winter, speaks for itself. And, as for the city's cycling highways and byways? Well, there really aren't highways and byways, but, rather, gridlocked, crowded, potholed streets and arteries. To make matters worse—for motorcyclists, that is—unlike most every other place in the country, New York City has refused

to allow motorcycles to use the high-occupancy-vehicle (HOV) lanes (on the Brooklyn-Queens Expressway or the Long Island Expressway, for example) despite a federal law that allows it. The feds say yes, but the city's Department of Transportation says no, so get caught riding a motorcycle in an HOV lane and expect to be ticketed.

Despite all this, the New York City chapter of the Hells Angels not only endures, but inexplicably even thrives. It has been stated in articles about the Hells Angels that some actually consider the New York City chapter to be the strongest in the nation after Oakland (though strength, of course, is in the eye of the beholder).

As elsewhere, the character and reputation of the Hells Angels is hard to pin down. To say that the mythology and press around them is filled with hyperbole is an understatement. Thugs and outlaws in the minds of some. Good guys as long as you give them respect and don't mess with them, in the minds of others. As for the New York's Hells Angels, their neighbors on East Third Street have similarly divided opinions—probably depending on whether one ever accidentally knocked over one of their bikes or took one of their parking spots—though it is almost universally acknowledged that their presence there makes the block one of the safest in the city.

One gathers that for the most part, they're pretty good neighbors. Of course, as Hunter S. Thompson suggested, if you accidentally hit one of their cycles with your car, don't expect them to settle the matter with an exchange of insurance information. That they take matters into their own hands, eschewing the legal mechanisms available, is well known, but that doesn't seem to be the case when fighting the city of New York or the NYPD.

Since 1999, the Hells Angels have sued the city and collected hundreds of thousands of dollars in settlements. There were two major cases, both involving what the Angels claimed were illegal raids by the NYPD. A 1998 raid of their headquarters, for which the Angels

claimed the police had a warrant to search the ground floor only, resulted in the city settling the case for $450,000 plus legal fees and other costs (a total of $565,000), while a raid in 2000, in which there was no warrant, resulted in a $194,000 settlement plus fees (a total of $247,000).

Batting a thousand, the Hells Angels threatened to sue the city after its most recent raid in 2007. A woman who had been at a bar on the block was found beaten and in a coma in front of their building. As part of the NYPD's investigation, the police cordoned off the block and brought in upward of fifty officers—including a canine unit, hostage negotiators, snipers, an armored personnel vehicle, an emergency medical unit, and a low-flying helicopter—before conducting a search of Angels headquarters. Again, the Hells Angels claimed the search went beyond the scope of the warrant. And although it's not clear whether or not that threatened suit was ever filed, or, if it was, whether it's been resolved, the threat—real or imagined—seems to have discouraged any police actions since.

Previously, in the early 1990s, the city had tried a different tactic. It attempted to seize the East Third Street building under a federal law that allows the government to take property that is used in drug trafficking. The basis for the suit was a 1985 raid during which methamphetamine and cocaine were found, leading to multiple arrests and convictions. After a three-week trial in 1994, the jurors (whose identities, not surprisingly, were withheld throughout the trial) ruled in favor of the Hells Angels, rejecting the government claim that their building was used for drug dealing.

So if you need a good lawyer, ask the Hells Angels for a referral. Final score: Hells Angels 3, City of New York 0.

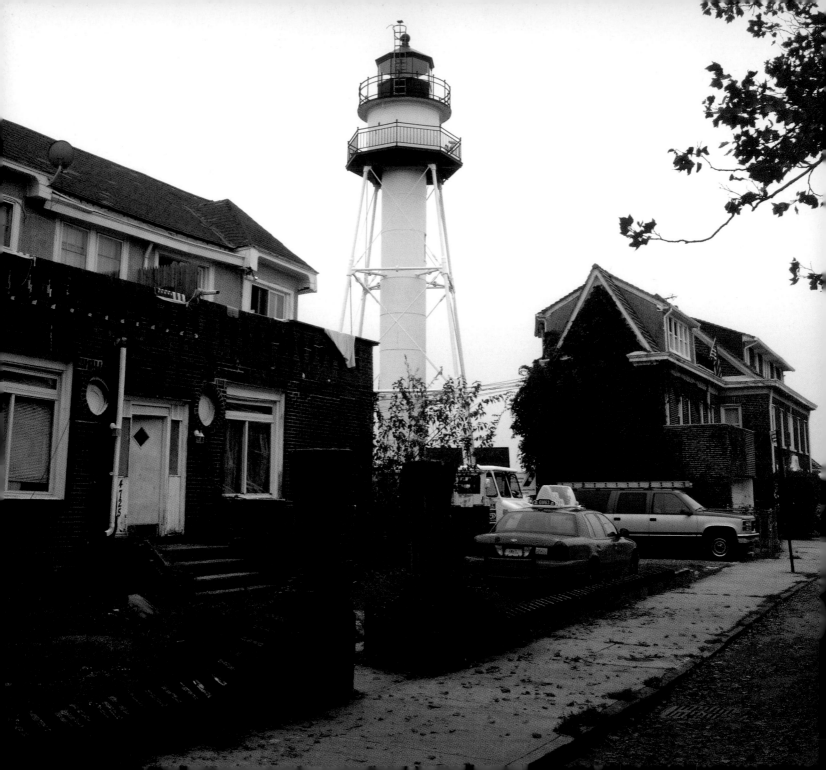

the coney island lighthouse

m ost think of lighthouses as being on promontories, crags, spits of land, or offshore islands. More than likely, one imagines them along the rugged New England coast or in the Pacific Northwest. The Coney Island Lighthouse, on the westernmost tip of Coney Island, Brooklyn—in the private, gated community of Sea Gate—defies these expectations. Located in the middle of a residential neighborhood, albeit two feet from the ocean, at the end of a nondescript block crowded with houses of all manner of shapes, styles, and sizes, it looks like it sits in someone's backyard. An above-ground plastic swimming pool would be less incongruous than the 80-foot, 87-step-high lighthouse.

But a quaint Maine coastal village Sea Gate is not. Populated mostly by Russians, Orthodox Jews, and the elderly, it is home to at least four synagogues. Walk around on a Saturday afternoon—the Jewish Sabbath—when the streets are filled with people in Orthodox garb walking to and from temple, and you absolutely know you ain't in Kennebunkport.

The Coney Island Lighthouse was erected in 1889. By that time, Coney Island had already become a popular destination, first as a resort and then as an amusement park, and it was decided that a lighthouse was needed to insure safe travel for the increased ferry traffic bringing visitors there.

Today it remains one of about ten active lighthouses in New York City, although at one time there were even more. Indeed, originally even the Statue of Liberty served as an official lighthouse, its lighted torch serving as a navigational aid for ships entering New York Harbor. (It was under the jurisdiction of the Lighthouse Board by order of President Grover Cleveland from 1886 until 1902.) And, at one time, there was even a lighthouse that was not a

lighthouse! Built during the Second World War in Breezy Point, Queens, a 50-foot-tall watchtower was made to look like a lighthouse, but was in fact a lookout tower for any enemy ship that might enter New York waters.

Nowadays, like most all of the city's lighthouses, the Coney Island Lighthouse is not given much thought. At least it has the excuse of being closeted away in a residential neighborhood—a private, gated one at that. Others of the city's lighthouses are in plain view, but they too are not paid much heed. You can bet there are New Yorkers who have driven up and down the East Side Highway (FDR Drive) hundreds of time and have never noticed, for example, the unusual looking stone, Gothic-style Blackwell Island Lighthouse that sits at the northern tip of Roosevelt Island. It is eminently visible if only one thought to look. (It, unlike the lighthouse in Coney Island, is no longer active, having been decommissioned sometime in the 1940s, though in 1975 it was designated a historic landmark.)

That the existence of lighthouses in and around New York seems to come as a surprise to most New Yorkers, despite the fact that the city is surrounded by water and is a major port city (if less so now than before), may be explained by the curious relationship New Yorkers have to their waters. Perhaps no other major waterfront city in the world gives so little thought to its waterfront and access to it. Baltimore had its waterfront retail and entertainment center—Harborplace—long before New York had South Street Seaport. In most places—Los Angeles, for example—the closer you live to the water, the hipper the neighborhood. Here, the hippest

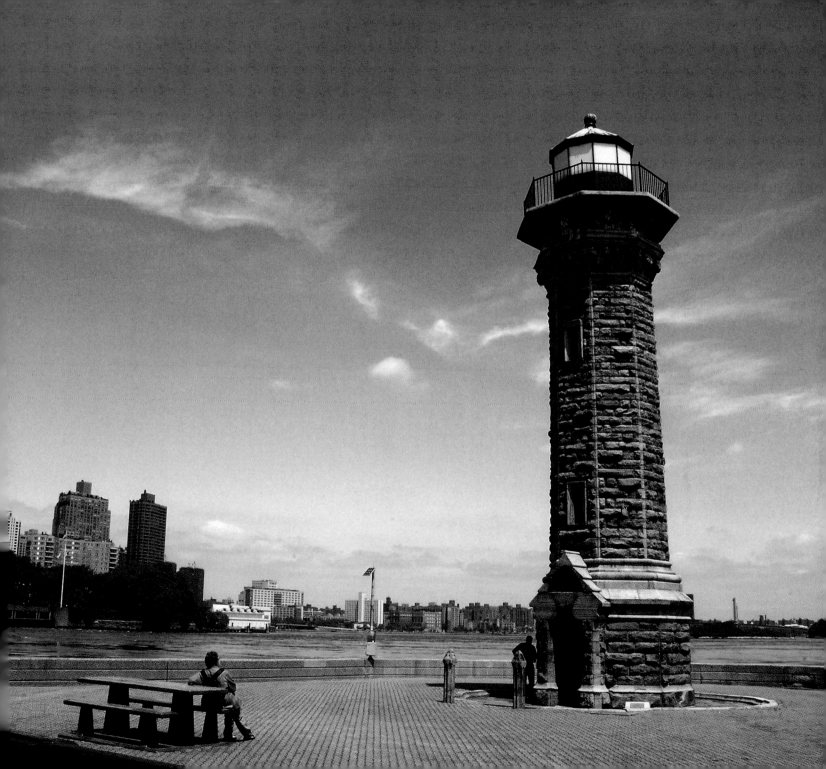

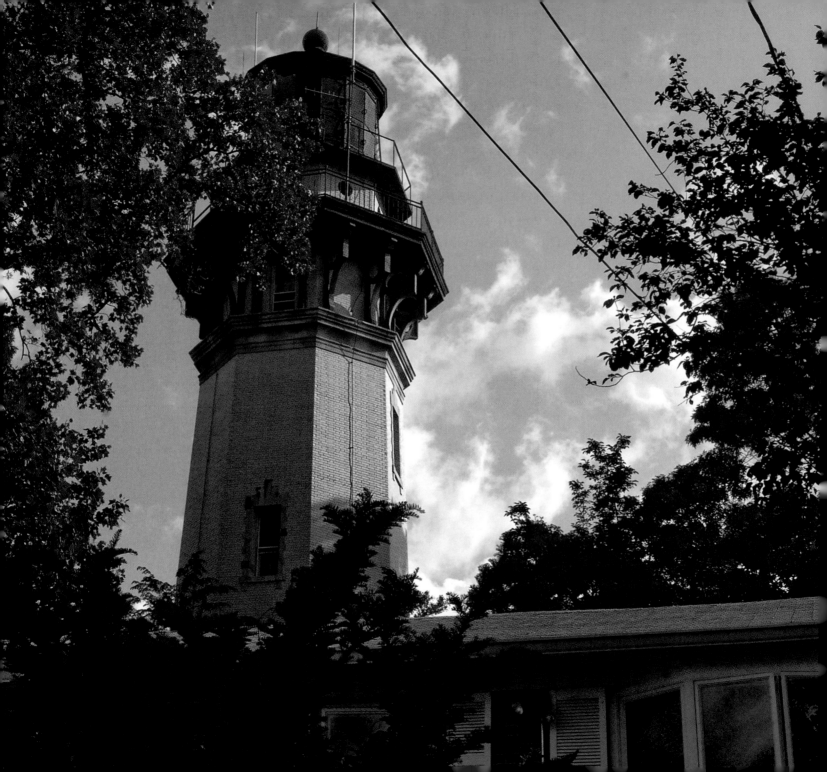

neighborhoods have nothing to do with proximity to the shore. For hipness, SoHo trumps Far Rockaway. And whereas Chicagoans make use of their Lake Michigan waterfront on a daily basis in their natural comings and goings, it has only been in recent years that New York's waterfront has become more accessible and more in the consciousness of city planners and park designers. Waterfront bike lanes have sprouted, waterfront park plans abound, but still much of the city's waterfront—Brooklyn's, for example—lies moribund.

Perhaps the city's best-known lighthouse is the Jeffrey's Hook Lighthouse, better known as "The Little Red Lighthouse," which lies in the shadows underneath the George Washington Bridge, just off Fort Washington Park in Upper Manhattan. It was made famous by virtue of being the subject of the children's picture book, *The Little Red Lighthouse and the Great Gray Bridge*. And, of course, every Staten Islander is aware of the Staten Island Lighthouse, which stands atop Lighthouse Hill in the Richmond Hill neighborhood.

If the Coney Island Lighthouse is among the lesser known of the less-than-well-known New York City lighthouses, it is no less distinctive. Up until 2003, when its keeper died, it was one of only two lighthouses in the entire country that was still manned, and the only one manned by a civilian. (The other manned lighthouse, in Boston, was maintained and operated by a member of the Coast Guard.) Frank Schubert was Coney Island's lighthouse keeper from 1960 until the end of 2003, when he died at age 88. Although the Coney Island Lighthouse was automated in 1989, as were all other 400+ active lighthouses throughout the United States starting in the 1970s, he remained as the Lighthouse's keeper, although that keeping was more in the nature of house and lawn care. His only lighthouse-keeping responsibility per se was resetting the automated light mechanism after storms. In that year, 1989, in honor of his fifty years of lighthouse service (it began in 1939 tending two other lighthouses prior to

Coney Island's) he met the first President Bush (speaking of Kennebunkport!) at a White House celebration. According to Schubert, he "was nuts about lighthouses."

In 1998, Staten Island was selected to be the location for the National Lighthouse Center and Museum. As of today, the museum's physical presence has yet to be established. If it does ever come to be, perhaps it will help in making New Yorkers, and others too, more aware of both the city's maritime past and present, including the place lighthouses have, and have had, in that history. Then again, given New Yorkers' blasé, take-it-for granted attitude toward its waters—except when paying premium rents and prices to view them from high up in apartment buildings and office towers—maybe not.

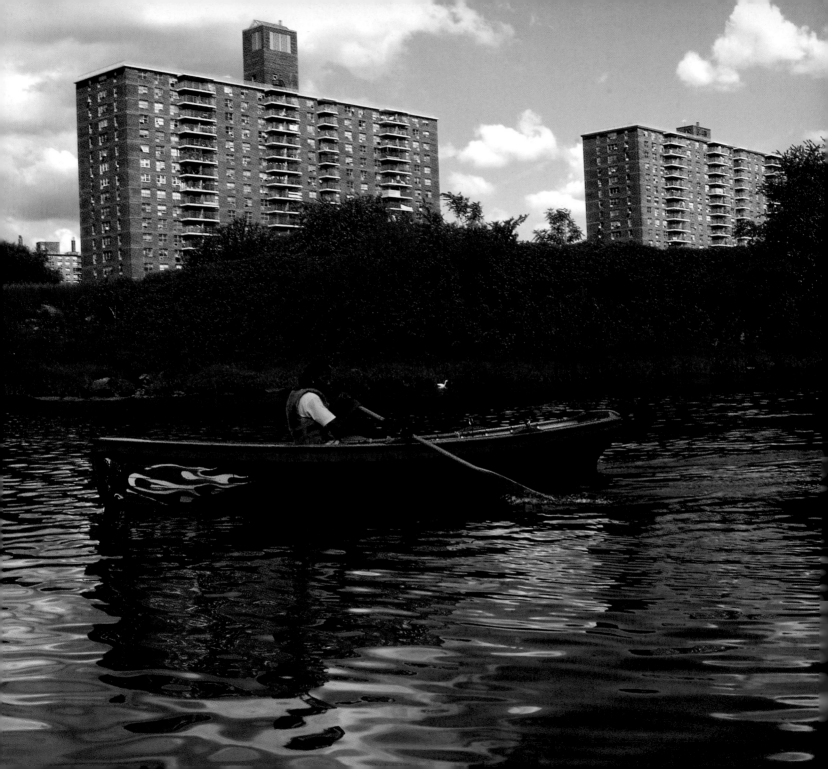

boat-building

most people seem surprised to learn that Rocking the Boat, a boat-building, water skills, environmental education and reclamation program for teenagers, is located in the heart of the South Bronx. Its founder and executive director, Adam Green, maintains that its existence as well as its location makes perfect sense—nothing could be more logical.

"I'm a boy who grew up on an island," says he, a native New Yorker. "New York is surrounded by water. That's how we got here. Look at all the bridges in and around the city. Well, before there were bridges, there were boats."

Rocking the Boat, established in 1998, morphed from a boat-building project Adam led as a volunteer in an East Harlem middle school during a semester off from college. Its success—a boat was built and launched in the school's swimming pool—prompted him to start his non-profit boat-building project after he graduated. Based originally at Hostos Community College, it lived for nearly a decade on East 174th Street in the Mt. Eden neighborhood of the South Bronx, before moving in 2009 to its present location in Soundview Park on the shores of the Bronx River.

"Boats are as essential as it gets," he maintains. "Boats have this basic connectedness to just about everyone." And it is this kind of primal connectivity that makes Rocking the Boat's location in the South Bronx in particular so perfect. The teens who build the wooden boats (most of the nearly 25 boats built since the program's inception are modeled on rowing boats used throughout New York Harbor in the 18th and 19th centuries) come from families who are originally from island locations themselves, the Caribbean especially, where boats and boating were an integral part of their daily lives. Thus, through the medium of boating and marine activities, kids are able to reconnect with their parents' pasts.

A student from Trinidad teaches the technique of hand-casting fishing nets in a water skills class, and in this way is able to connect to and then pass on a part of his family's culture. Kids connecting to their parents' past also allows parents to relate to their children's present. This works perfectly, given the demographics of the South Bronx.

As unlikely a body of water as the Bronx River might seem as the focal point for Rocking the Boat (many New Yorkers might not even know there was a Bronx River but not for the fact that they know there is a Bronx River Parkway)—as opposed to the more famous and cleaner Hudson or, even, the Harlem River upon which local crew teams train and race—it too turned out to be the perfect place. "We had built our first boat and I was looking for a place to launch it," Adam Green explains. "What initially attracted me to it was its accessibility. Also, although it was not pristine, it wasn't nearly as polluted as the Gowanus or Newtown Creek in Greenpoint. Unlike those and other waterways in the city, the Bronx River has no real active businesses on it (only two businesses remain, a metal and plastics recycling company and a cement plant), so it was safe. Also, it's completely protected by land, and the current is not very fast. There is no time of year that I can't go out onto it. Basically, I was just looking for a good place to have kids use the boats we built and not have them be hundreds of feet up or down the river because of tides."

The Bronx River is 23 miles long. It starts in Westchester and enters the Bronx just after Mount Vernon at 242nd Street, running through the Bronx Botanical Gardens and Bronx Zoo, emptying out at Clason's Point into the East River, where it meets the Long Island Sound. Among its many distinguishing features, it lays claim to being the only freshwater river within New York city limits.

While it was initially selected for its accessibility and safe waters, the Bronx River has turned out to be not only a great place to use the boats built by Rocking the Boat's students, but it has also turned out to be the perfect classroom for teaching kids how to reclaim the environment. Not to mention the fact that it provides a place for recreational use for South Bronx residents,

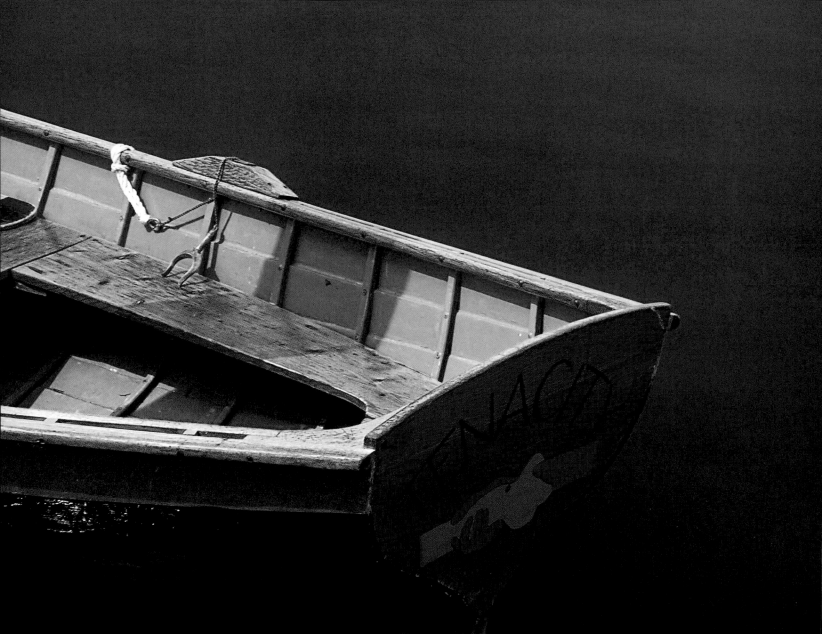

a much needed resource in this part of the Bronx, which has less parkland than any other neighborhood in the city.

Utterly polluted during the 1970s and '80s by virtue of factory and sewage waste (oxygen levels in the river had dropped to near zero), the river has in the past couple of decades been substantially restored ecologically. Initially through the efforts of the Bronx River Restoration Project, and now continued by the Bronx River Alliance in partnership with other groups like Rocking the Boat, native trees and shrubs have been planted and tons of garbage hauled out. And although no one's ready to eat the oysters that have been introduced into the river for their filtering capabilities, oxygen levels in recent years have risen dramatically. Proof of this improvement in the river's ability to sustain marine life was the discovery in 2007 of a beaver in its waters.

Even more recently and significantly, the alewife has returned! The alewife, a fish once native to the Bronx River, hadn't inhabited it for centuries. In the mid-2000s, Rocking the Boat helped release 600 adult alewives into the river with the intent to monitor them. The theory was that the offspring of these adults would leave the Bronx River, make their way to the ocean, but come back to their birthplace to spawn, as is the wont of the alewife. Right on cue, in the spring of 2009, a full-grown, nine-inch alewife was discovered by Rocking the Boat.

Maybe the time for being able to eat those oysters is not so far away.

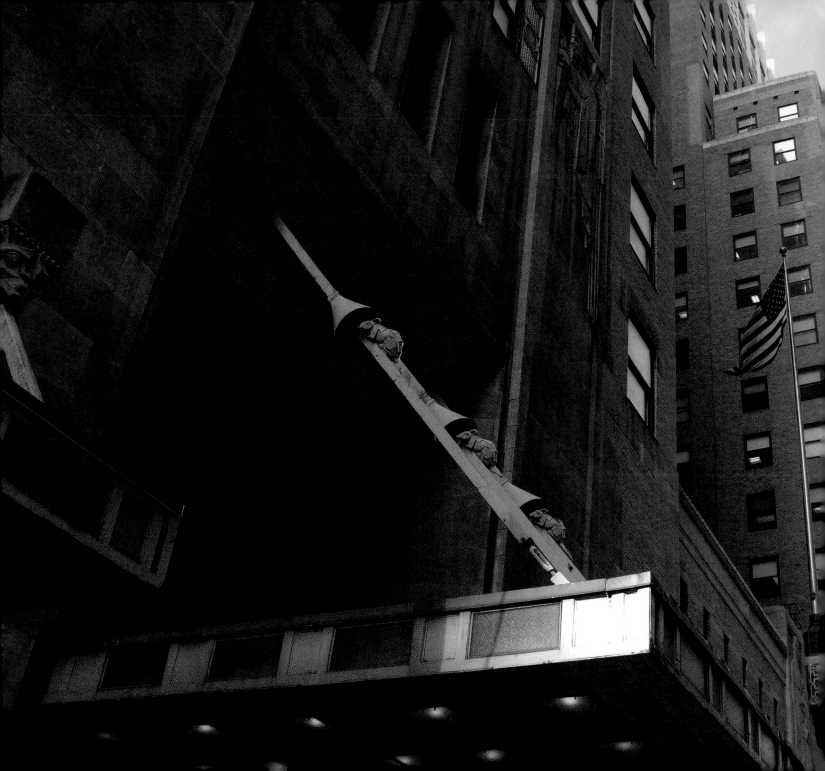

nautical ropes and rats sculpture

above the entrance at 420 Lexington Avenue to the Graybar Building, which abuts Grand Central Terminal (and serves as one of its many entrances), is a rain canopy supported by three metal rods meant to simulate the nautical ropes (called hawsers) that moor ships to docks. And along each of these hawsers is a metal rat (probably cast iron) whose progress up the rope is blocked by an upside down cone. And, at the end of each of the rods are rosettes whose perimeter design is not floral, but rather, comprised of eight additional rats!

These conical devices (called baffles, as in to block or impede) are found on ship lines and serve to prevent rats from climbing all the way up a tie rope, thereby getting onto the boat. What's baffling about these baffles is, well, one has to ask: Why are they on this building in midtown Manhattan, far from the waterfront and next to a train station rather than a ship terminal?

The architectural firm for the Graybar Building, Sloan & Robertson (and for the nearby Chanin Building and Fred F. French Building as well) apparently used nautical motifs on other of their projects during the 1920s and '30s, to reflect the fact that New York was then a major maritime city. (In 1927, the year the Graybar Building was competed, the Maritime Association of New York, to accommodate its burgeoning membership, constructed its own 35-story headquarters in lower Manhattan, though apparently sans nautical motifs—hawsers, baffles, or otherwise.)

It's a good bet that not more than one in a thousand New Yorkers, including those who enter Grand Central through that door every day, are even aware of the existence of these rat sculptures. One can easily walk in and out and never be aware of what's on top of the canopy, blocked from view by that very canopy. That, at least, is explicable. What's more curious is the

fact that the Graybar Building (named after Elisha Gray and Enos Barton, whose electrical parts distribution company, Graybar, was headquartered there) itself is hardly given a thought or a mention in the discussion of New York City architecture. *One Thousand New York Buildings* (2002) does not include it. And the supposedly comprehensive *AIA Guide to New York City*? Nary a word. This despite the fact that at the time of its completion, it was among the largest of the Art Deco skyscrapers built in the city during the so-called Art Deco Era from about 1925 through 1945.

At thirty stories, the Graybar Building was not nearly the tallest building in New York, but with over one million square feet of office space (1,243,000 square feet to be precise), at the time, it was the largest office building not just in New York, but in the world! Perhaps being

located across from the iconic Chrysler Building has relegated it to obscurity. Or, maybe, as Francis Morrone suggests in his *Architectural Guidebook to New York City*, "[its] very invisibility is a tribute to this building. The Graybar is fit so snugly into the complex of buildings that includes Grand Central Terminal and the Grand Hyatt Hotel that this complex seems to be a single megastructure." Is it too perfect for words? Is more less?

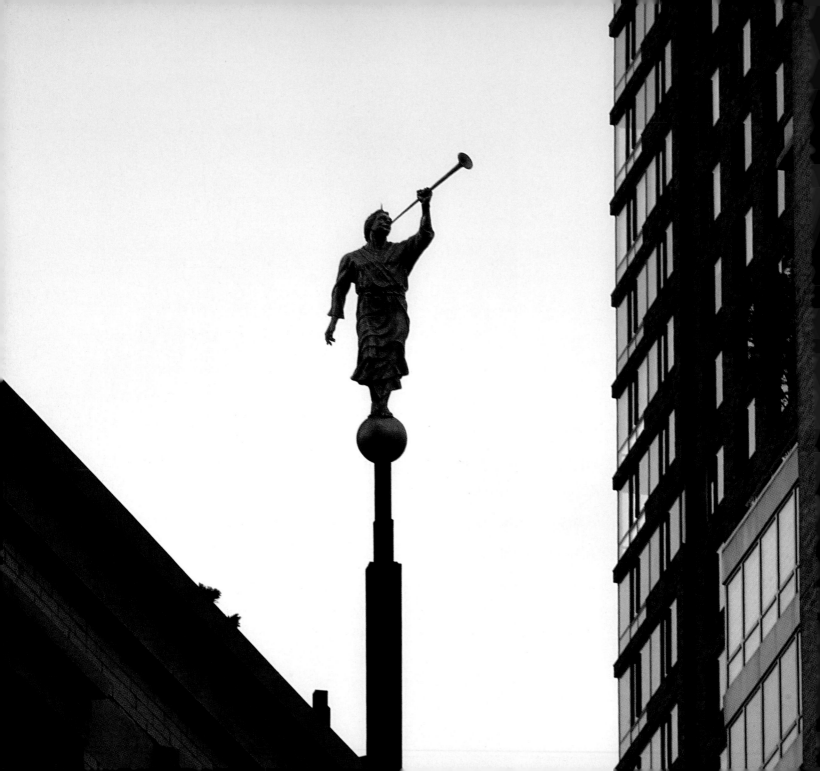

mormon temple

here are two Mormon temples in New York State. One is located upstate, in the Finger Lakes region; the other on the Upper West Side of Manhattan. There are about 130 temples operating worldwide, with 70 of them in the United States, and of those, a dozen in Utah. The temple in upstate New York, in the town of Palmyra, makes a certain amount of sense, since Joseph Smith, the founder of the Church of Jesus Christ of Latter-day Saints, lived in Palmyra, and the temple is actually located on land that was part of the Smith family farm.

That a Mormon temple be located on Columbus Avenue at 65th Street in Manhattan, in the heart of one of the city's more politically progressive, liberal, left-leaning neighborhoods, seems to make no sense at all. After all, the Latter-day Saints are among the more conservative religious groups. The Mormon religion, for instance, proscribes alcohol, tobacco, caffeine, drugs, and premarital sex, to name just a few of its prohibitions. Hardly the defining ethos of the Upper West Side.

For this reason, when the church announced its plans in 2002 to construct a temple on the site of what was then a Mormon meeting house (the temple was completed and dedicated in 2004 and now occupies four of the building's six floors), many commentators noted the unorthodox setting for such an orthodox religious congregation. One writer observed the irony of the temple being located in the middle of what many Mormons surely must characterize as a "den of iniquity," or in the words of another writer, "a spiritual Babylon."

Most of this country's five plus million Mormons live in the West or Midwest (there are about 13 million Mormons worldwide), and most all of its temples are freestanding, outsized edifices on large plots of manicured land. Not high-rise buildings scrunched in between other

buildings in a high-density urban setting. (Hong Kong's, apparently, is the only other Mormon temple in the world located in a high-rise building.)

Be that as it may, the church hews to a policy of establishing temples and churches (although there are relatively few temples, but thousands of churches or meeting houses, the former being used for the most sacred religious rites) when the population warrants it. According to a church spokesperson, "We build chapels where members are, not in hopes that they will come," so the church must have decided that the Mormon population of New York City had reached critical mass. Upward of 45,000 Mormons live in the New York metropolitan area (including Long Island, and parts of Connecticut and New Jersey), and probably more than 30,000 live in the five boroughs of New York City, though probably not much more than 5,000 in Manhattan. So, it is still unclear why Manhattan was chosen as the site for the temple, as opposed to, say, Staten Island or Long Island, where a freestanding building could have been erected. (The Upper West Side temple has been completely soundproofed within, thus being able to be in Manhattan while at the same time blocking it out.)

If the reason for locating a temple in Manhattan remains a mystery, the particular locations of several of the scores of Latter-day Saint churches and meeting houses throughout the city is even more enigmatic. Take the Mormon congregation in what had once been the hiring hall for the International Longshoreman's Association, in Carroll Gardens, Brooklyn, a neighborhood, then and now—though somewhat less so now—heavily Italian and therefore Catholic.

And, of course, there is the five-story Latter-day Saints' church in the middle of Harlem, at the corner of Malcolm X Boulevard (Lenox Avenue) and 128th Street, built in 2005 in what had previously been an apartment building. (This congregation originally met in the back of Sylvia's, the famous Harlem restaurant.) Its location presents perhaps the biggest conundrum

of all, given the Mormon church's history of racial prejudice. Church teachings maintained that blacks were descendants of Cain, killer of Abel, and thus cursed. For more than a hundred years—not until 1978—black males were not allowed to become priests nor be baptized, and black women could not be members. Somewhat inexplicably, blacks are now among the fastest growing membership group in New York City's fast expanding Mormon population. Perhaps 20 percent or more of the city's Mormons are black. Go figure.

Finally, if the politically conservative Church of the Latter-day Saints didn't have misgivings about locating their temple on the liberal Upper West Side when they first decided to do so in 2002, they may have had second thoughts by 2008. In November of that year, a week after Proposition 8 was passed in California, thereby making same-sex marriage illegal, thousands of protestors demonstrated in front of the Upper West Side Mormon temple because of the church's strong support of the amendment. It has been estimated that church members (as opposed to the church itself) raised more than $20 million in support of Proposition 8.

Given the church's right leanings and the Upper West Side's left, it's hard not to imagine many future demonstrations in front of the temple, around any number of political issues on which the church and the neighborhood clash. Which leaves open the original question of why the Church of Jesus Christ of Latter-day Saints would choose to locate on the "Upper Left Side" in the first place.

Maybe it's on a mission!

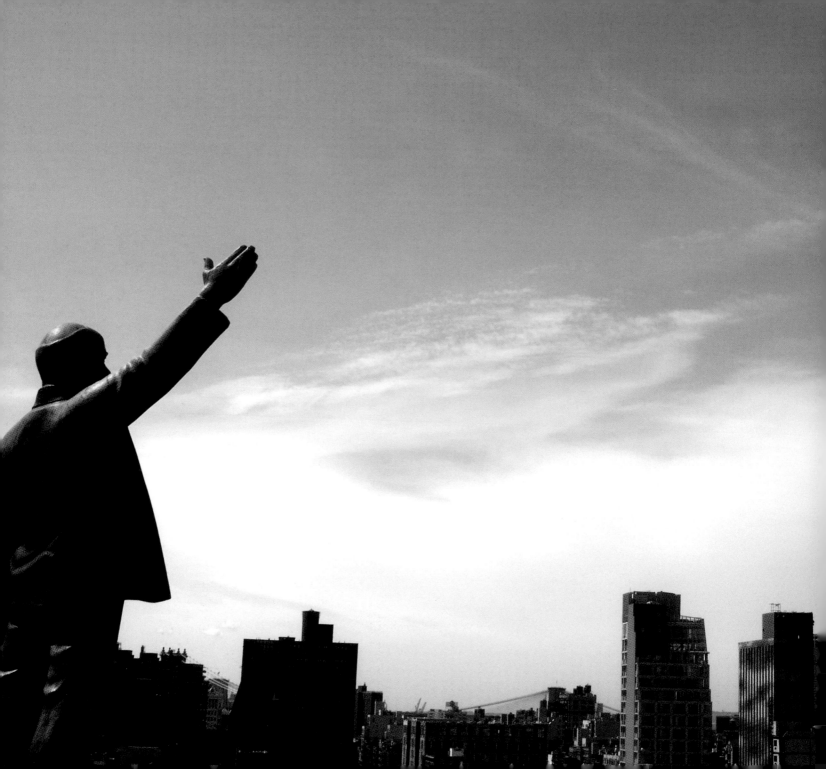

lenin statue

If there were to be a monumental statue of Vladimir Ilyich Lenin, Bolshevik revolutionary and Communist leader, anywhere in Manhattan, it would predictably be here on East Houston Street between Avenues A and B, where two of the city's historically most progressive and activist neighborhoods—the East Village and the Lower East Side—meet. With their histories of radicalism, protest, and rebellion, and class, racial, and ethnic struggles, it makes sense, or at least, more sense, that such a statue be located here than just about any other New York City neighborhood.

Not so predictably, this particular three-meter-high Lenin statue sits atop a thirteen-story high-rise apartment building, and it's visible from the street if one happens to look skyward from far enough away, and at just the right angle.

The notion of such a statue fits into the original conception for the building's design and motif, or theme, if you will. From its inception, the building was named "Red Square," both as homage to the developer's and neighborhood's progressive, left-leaning tendencies, as well as a straight-out, blatant marketing tool. In the words of the developer, "I wanted to pick a name that was strong, but one that also reflected the nature of this neighborhood. Also, one that was playful." It also happens to be a reddish and squarish building if one chooses to be literal-minded.

The building's construction coincided with the demise of the Soviet Union in 1989, and with that serendipitous confluence of events came the opportunity to purchase a statue of Lenin commissioned for a Moscow square before the fall of the Soviet Union—and then decommissioned, or junked, as it were, afterward. Three artists in Manhattan who dealt in Russian art were able to unearth the statue, which was lying abandoned in some field near Moscow, and arrange for its sale to Red Square's developer. In his words, "I bought it for next to nothing. It cost more to transport it, take it out of port, and hoist it onto the top of the building." That was in 1994.

Lenin is situated in the southwest corner of the building's roof, looking out in the direction of—and either pointing to or waving at—Wall Street. "I could have gotten a Lenin cast in Brooklyn," says the developer, "but I wanted one cast in the old Soviet Union, representing that particular empire of thought as opposed to that of the new capitalist Russia, and I wanted him waving to Wall Street. It's all about the undefined magic of symbols; when the same symbol means a multiple of things to different people or even to the same person at different times. I never thought about hurting or insulting people, though admittedly, at the time, the name of the building, and then, the Lenin statue on top, was flabbergasting. But now, it's just a building, and the statue is just a statue, which is how all of life is. Isn't it?"

Aside from whatever discomfort or criticism the name and statue may have caused, the building's very size and luxury rental status also ruffled community feathers in 1989. With 130 units, it was out of scale with the surrounding neighborhood and also out of the price range of most of the residents of the East Village and Lower East Side, though times and incomes have changed since. In his defense, the owner of the building reminds his critics that the neighborhood was in a dire condition in the 1980s, having been ravaged by the economy and by massive fires that had depleted both its housing stock and its population. "This neighborhood

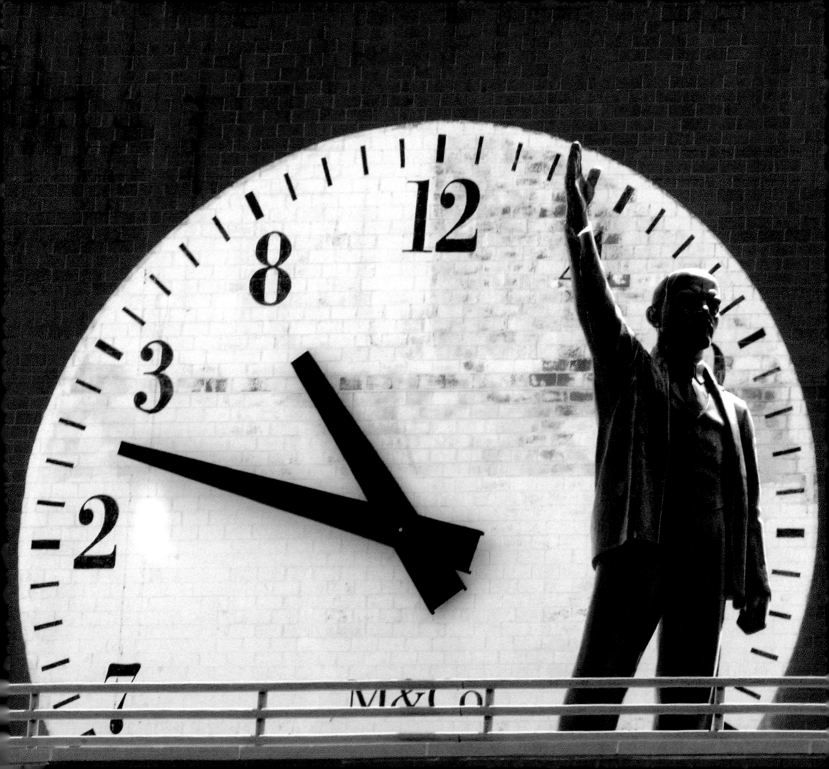

burned in the 1970s and the population plunged by 70 percent," he reminds us. "It was the first time in thirty or fifty years that someone had put so much money into this neighborhood." Today, twenty years and several incarnations later (the owner now spends his time as a community organizer, leader of a non-profit group, and writer), he admits that he would not encourage such a project. "Red Square is a bad high-rise model for street life. And the strip mall [attached to the apartment building] is also evil."

But that was then and now is now. Nowadays, the clock on the side of the structure that houses the building's water tower and elevator shaft gets as much attention as the statue. The clock's numbers are randomly placed rather than being in the sequential order of 1 to 12 as they are on most all clocks—but despite this "mis-ordering," the clock does tell the correct time if you focus on the position of the dial hands rather than the numerals per se. The *Askew Clock* was apparently modeled after a clock of that name and design that was in the Museum of Modern Art collection.

Before any New Yorker boasts that a Lenin statue in this country could only exist in New York, something the writer, Tom Wolfe, would refer to as New Yorkers' "big-league complex"—that is, we have the best, the biggest, the only—you should know that another, even bigger, Lenin statue sits smack dab in the middle of Seattle!

But does it point in the direction of the Microsoft or Starbucks headquarters?

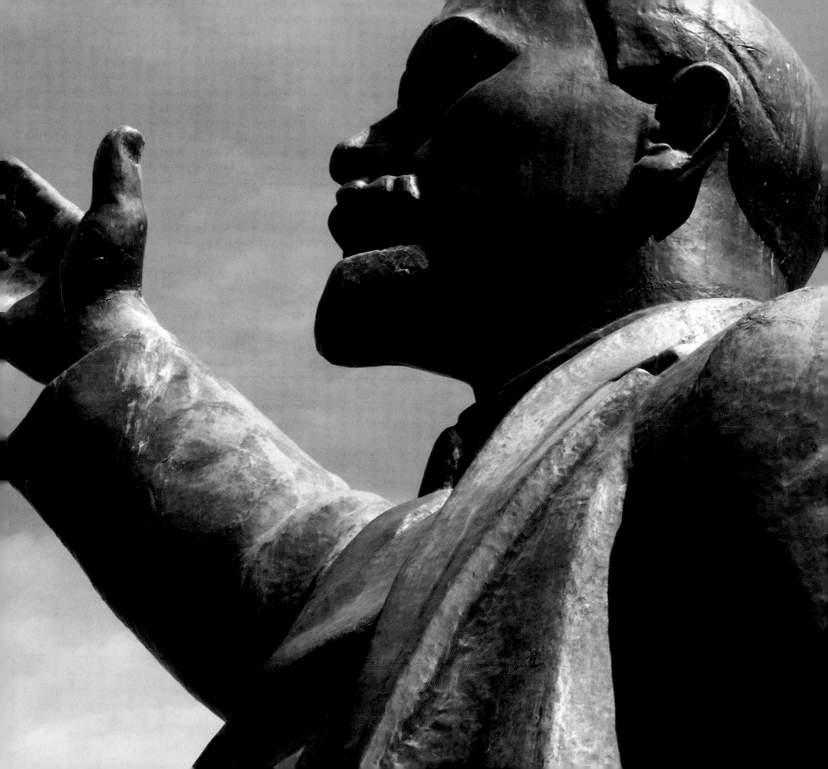

robert e. lee and stonewall jackson statues

Whether viewed singly or together, it certainly seems odd, or at the very least curious, that these large bronze busts of Robert E. Lee and Stonewall Jackson, two proud sons of Virginia and the Confederacy, be located in New York City. In the Bronx, no less! It makes somewhat more sense when one realizes that they are but two of the ninety-eight busts of famous Americans enshrined at the Hall of Fame for Famous Americans on the campus of the Bronx Community College. (Originally this was the uptown, or University Heights, campus of New York University, for whom the Hall of Fame was created in 1901, but was sold to the City University of New York in 1973. The Hall was part of the package.)

The Hall of Fame for Great Americans, this country's first hall of fame of any kind, was the brainchild of the president of NYU, Henry Mitchell MacCracken, who also came up with the "hall" in the title, which became the precursor of many "*halls* of fame" to follow: baseball, basketball, broadcasters, rock and roll, etc. It was created "to honor prominent Americans who have had a significant impact on this nation's history," which explains

265

Robert E. Lee's and Stonewall Jackson's inclusion, whose impact can't be questioned, albeit presumptively negative.

The idea was for a College of Electors, comprised of one hundred members (at least one from each state), to select the honorees. When the Hall opened in 1901, there were twenty-nine original inductees (George Washington being not only the first but also the only unanimous choice then or since). To date, 102 famous Americans have been selected, but only the busts for 98 of them have been installed (by category, e.g., authors, educators, military leaders, judges, statesman, etc.).

Up through about the 1960s, the Hall was a major tourist attraction, but sadly is no longer. In fact, the last year any new members were elected was 1976. They included Andrew Carnegie, Clara Barton, and the horticulturalist, Luther Burbank. Of the last seven inductees, only three have had their busts installed. FDR was the last one, in 1993—and that took twenty years, since he was elected in 1973.

Despite its waning luster and fall from tourist destination grace, the Hall of Fame is worth seeing if for no other reason than its architectural splendor and setting. The 630-foot-long, semicircular, Neoclassical colonnade was designed by Stanford White, as were the three campus buildings that surround it. It is set atop what is said to be the highest point in New York City, providing great views of the Harlem River, the Hudson, and the Palisades.

And there is always the fun of finding out who is in the Hall of Fame, and even more interestingly, who is not. One can test one's knowledge of US history by seeing how many busts one even recognizes. The ten presidents included are easily recognizable. So too are the likes of Benjamin Franklin, Washington Irving, Edgar Allan Poe, Patrick Henry, Wilbur Wright, Susan B. Anthony, Thomas Edison, Oliver Wendell Holmes. But Simon Newcomb? Charlotte Cushman? Augustus Saint-Gaudens? Or Matthew Maury?

Commenting in a *New York Times* article about the Hall of Fame, a former African-American president of Bronx Community College, on whose campus the hall resides and whose enrollment is overwhelmingly non-white, said, "In terms of who is in and who is not, I'm ashamed to be associated with it. Of the 102 people in the Hall, there are only eleven women, two blacks, one Jew, and no Catholics."

He's got a point. The two blacks, incidentally, are George Washington Carver and Booker T. Washington. The one Jew is Louis Brandeis, though no bust of his has been installed, even though he was elected in 1973.

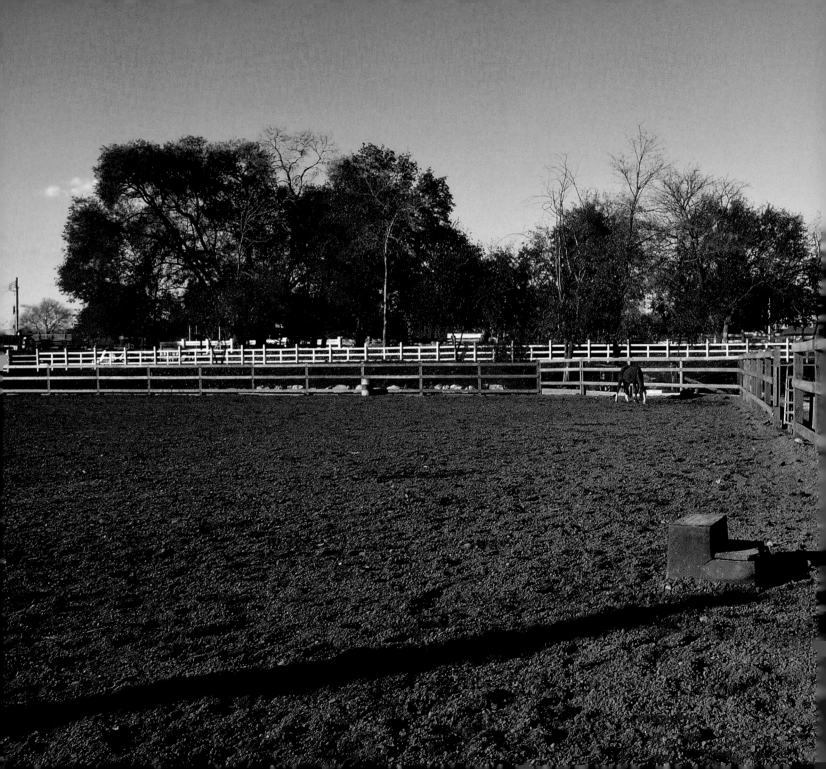

the federation of black cowboys

if there is anything more anomalous than black cowboys based in New York City, well, nothing immediately comes to mind. Horses, stables, corrals, campfires, rodeos, and the like would be unlikely enough as New York phenomena, but that they are all associated specifically with black cowboys dedicated to recalling and preserving the legacy of the African-American cowboy's role in the settling of the West, is a particularly unlikely New York thing. Texas has a large organization of black cowboys, which somehow doesn't seem that farfetched. That Queens, New York does too is an entirely different matter.

Be that as it may, the Federation of Black Cowboys, a non-profit organization created "to share and promote knowledge of the 'Black West,'" has nonetheless existed here in Howard Beach, Queens, since 1994. With about forty members (who have nicknames like "Tex," "Curly," "Little Red," "Black Red," "Arkansas Kid," "Wash," "Blue," "Painter," and "Saddle Tramp") and an equal number of horses, on about 25 acres of land leased from the Parks Department, just off the Belt Parkway on South Conduit Boulevard, the Federation pursues its mission of keeping alive the history of the otherwise forgotten black cowboy primarily through its programs with kids to whom—along with this history—they teach horsemanship and proper horse care. Throughout the year, the black cowboys hold rodeos and other cowboy-related shows, participate in

parades, picnics, and other public affairs and otherwise welcome the public to visit its stables and accompanying facilities, one of which is a recently renovated trailer that is intended to house a museum celebrating the achievements of black cowboys.

It seems that the Federation evolved out of a group of like-minded black horsemen, mostly from the South, many working in law enforcement, who grew up riding horses and who came to New York City looking for a stable where they could continue to keep and ride horses. Recognizing their common racial identity, love of horses, and fondness for the history of the Old West, they came to realize that blacks played a huge role in the settling of the West. One out of every four cowboys is believed to have been African-American. In fact, some surmise that the very name *cowboy* was first used to describe black *cowhands*. In other words, racial prejudice may have been responsible for putting the "boy" in cowboy.

And although the names of white cowboys, fictional and otherwise—and cowgirls too— are all too familiar to the general public (Roy Rogers, Gene Autry, Wyatt Earp, Bill Hitchcock, Bat Masterson, Butch Cassidy, Dale Evans, Annie Oakley, Calamity Jane), the names of black cowboys remain ciphers to most.

The original band of black "cowboys" of Brooklyn, therefore, decided to create the Federation to make the general public—particularly blacks—aware of those African Americans who were important personages in the history of the American West. Black men and women such as Ben Hodges (a card shark upon whose gravestone in Dodge City, Kansas the epitaph reads, "Self-Styled Desperado"); Nat Love, a.k.a. Deadwood Dick (champion roper and shooter whose winning exploits at these endeavors in Deadwood, South Dakota won him his nickname); Bill Pickett (outstanding rodeo performer who invented the sport of bulldogging, which entails jumping from a horse onto a steer and wrestling it down); Jesse Stahl (who protested being denied a first-place finish at a rodeo because of racial prejudice by

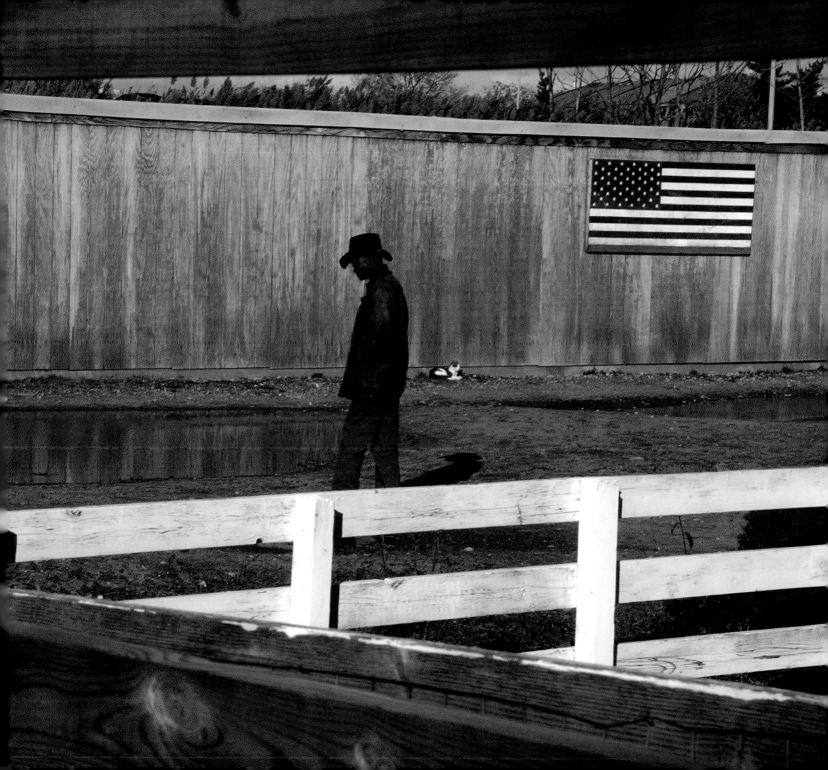

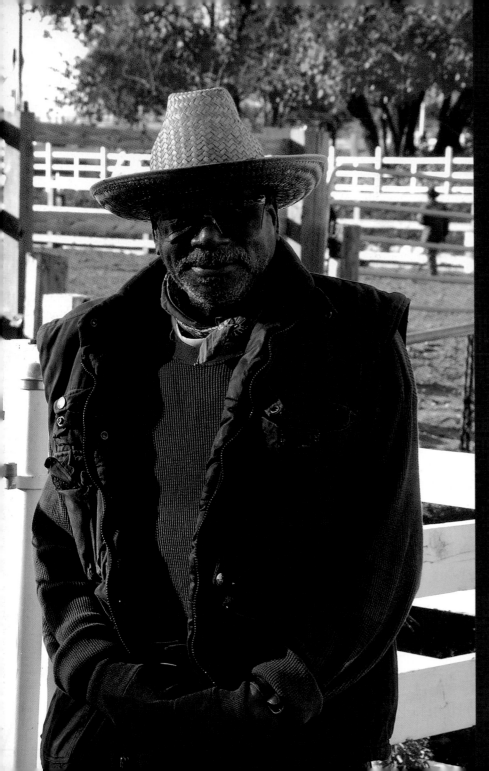

proceeding to ride a bucking bronco facing backward and at the same time holding a suitcase in one hand); and Mary Fields, a.k.a. Stagecoach Mary (who, indeed, ran a stagecoach and mail route, first delivering goods for a convent and then for the US Postal Service).

That the Federation of Black Cowboys would establish itself in Howard Beach has an irony not lost in New York. Mention Howard Beach to a New Yorker, and the first thing that comes to mind is the "Howard Beach Incident," the racially motivated attack on three black men by a group of white men in 1986. Twenty-three year old Michael Griffith was struck and killed by a car on the Belt Parkway while trying to escape from the men chasing him. (Yet more irony: in 2006, not far from where Michael

Griffith was killed, a horse from the Federation's Cedar Lane Stables bolted into the intersection, jumped onto the roof of a cab, and was also killed.) Although it's unlikely that Howard Beach will become disassociated from the incident anytime soon, one has to admire the Federation of Black Cowboys for helping to expunge that particular unfortunate legacy.

Whoopi-ty-aye-oh. Whoopi-ty-aye-yay. Back in the saddle again.

rolling mosaic benches

if the seventeen mosaic benches—350 twisting, undulating feet of them—surrounding Grant's Tomb (122nd Street and Riverside Drive) look suspiciously like something out of Antonio Gaudí's Park Guell in Barcelona, it's because that's exactly where the inspiration for them came. Pedro Silva, the Chilean-born, New York artist who designed the benches unabashedly admits to it. He went to Barcelona, saw the Gaudí benches in the park there, and was moved to create similar colorful, whimsical, fanciful, and fantastical mosaic benches here.

The resemblance to Gaudí mosaic work is unmistakable, but the images on the Grant's Tomb benches are very much of and about New York City. To be more accurate, one could say the benches look like the work of Gaudí with a little of Red Grooms's *Ruckus Manhattan* thrown in. There is, for example, one bench in the shape of a car; another contains the mosaic image of a cop giving a ticket to a cab driver.

The benches, sometimes referred to as the "Rolling Benches," were produced by the non-profit group, CITYarts, Inc., under a 1972 grant from the National Park Service, which administers Grant's Tomb (officially known as the National General Grant Memorial) as well as other national monuments. Over the next two years, under the direction of Pedro Silva and CITYarts, upward of 2,000 artists, community people—including children, visitors to the city, and sundry others worked on what at the time was the largest public art works project in the country.

Grant's Tomb was built in 1897 as the burial place of President Ulysses S. Grant and his wife Julia. Grant retired to New York City after his presidency, so the choice of location for his mausoleum was either New York or his birthplace in Galena, Illinois. Also, it should be noted, Grant and his wife have been placed inside two black sarcophagi, so technically they are entombed

rather than buried at Grant's Tomb, making the answer to the ubiquitous question, "Who is buried at Grant's Tomb?," "No one!" It was once the country's biggest tourist attraction, with 700 visitors a day. But by the 1970s it was one of the lesser visited tourist sites in the city. Underutilized and under visited, it became an obvious target for vandals, including graffiti artists.

The rationale behind the bench project was that it would put an end to this destructive activity. The thinking was that if something beautiful was created by and for the neighborhood, the community would be invested in the property and its maintenance. No local would dare destroy something that in a real sense they had created. Or, so the thinking went.

What looked like a win/win situation—beautify the park surrounding the monument and at the same time discourage vandalism—was not, however, without controversy. The issue became whether or not the playful mosaic benches were incompatible with the somber granite monument and the final resting place for one of the country's most admired generals and presidents. Artists and community people were pitted against architectural historians and Civil War buffs.

The community people and their allies maintained that the benches represented perhaps the finest example of folk art to be found anywhere in the city. It was beautiful and joyous and brought people to an area they would otherwise stay away from. "What we're trying to do here," said Silva, "is to liven up this monument so that people may indeed enjoy and appreciate history better."

There is, among the many zany and whimsical images, one mosaic image of a couple lying nude across the bench; a bench, according to Silva, that is referred to as the "lover's bench," and, apparently it, indeed, has been used for that purpose.

It was an insult to the solemnity of the monument, countered the architectural purists and the Civil War buffs. Arguing for their removal in 1979, Ralph Newman, the president of the Ulysses S. Grant Association and founder of the Civil War Round Table, was quoted in the *New York*

Times as saying: "The fanciful benches and arches are 'anachronistic.' It's like having a roller-coaster ride running up and down the Lincoln Memorial. It may be fun, but it's not history."

Even one of Grant's great-granddaughters chimed in. "I thought they [the benches] were entirely inappropriate," she said. "They might be all right somewhere else, but they certainly clash with that severe and dignified building." And some even argued that the installation of the benches was against the law. The former curator of Grant's Tomb maintained that the mosaic benches violated the 1966 Historic Preservation Act, which forbids altering national landmarks with modern additions.

Paul Goldberger, then architectural critic of the *Times,* countered the benches' critics. Writing in his book, *The City Observed*, he concluded, "At least as good as anything Duncan [the monument's architect] wrought… are the recent benches in bright mosaic tile surrounding the monument. … [T]heir color and movement are just the right counterpoint to the humorless monument. The benches are full of laughter, but they are set far enough back, so that rather than poking fun directly at the building, they offer a more welcoming alternative."

And so on and so on. Back and forth. Back and forth.

Since the benches still stand, having withstood two major attempts to have them removed (once in 1979 and again in 1997) and having twice raised funds for their restoration (once in 1994 and most recently in 2008), the community has obviously won out over the purists and the buffs.

And as to the purpose of their installation in the first place—that is, to prevent vandalism and graffiti on Grant's Tomb? Well, by all accounts, the benches themselves have been singularly free of graffiti since their installation; the monument, less so.

Perhaps Grant's Tomb should be swathed in playful and colorful mosaic tiles, too.